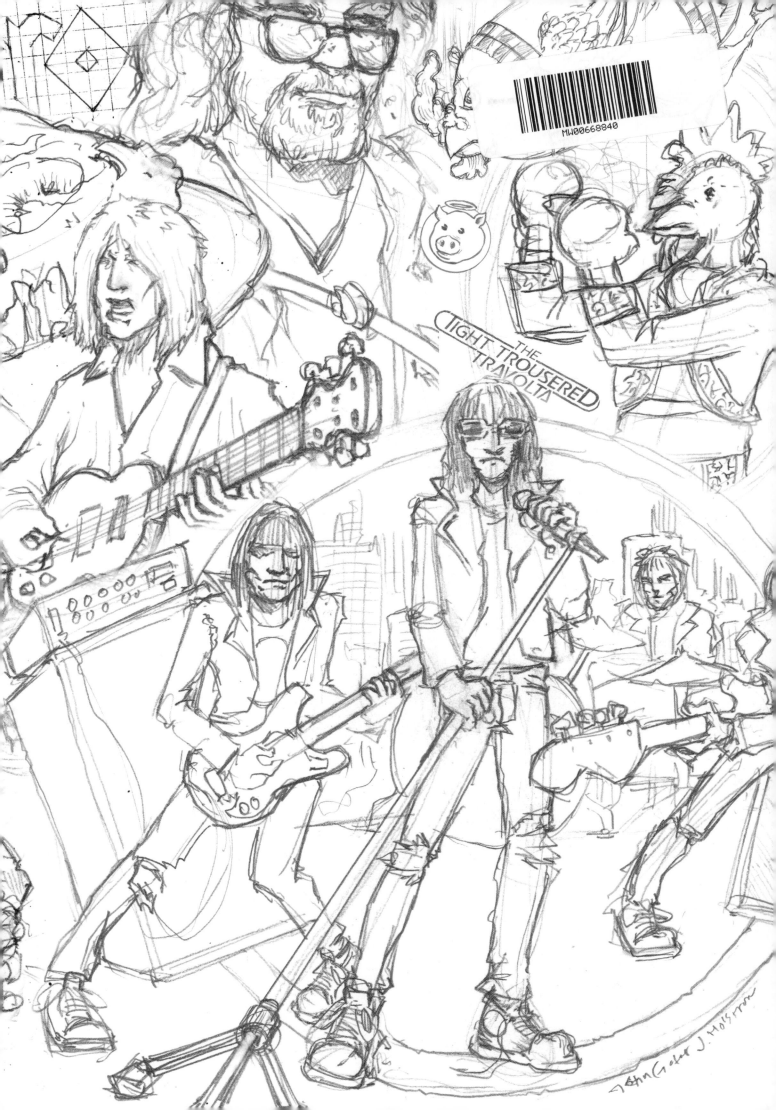

THE TIGHT TROUSERED TRAVOLTA

SANDWICH ANARCHY
THE CULT CULINARY POSTERS OF MELT BAR & GRILLED

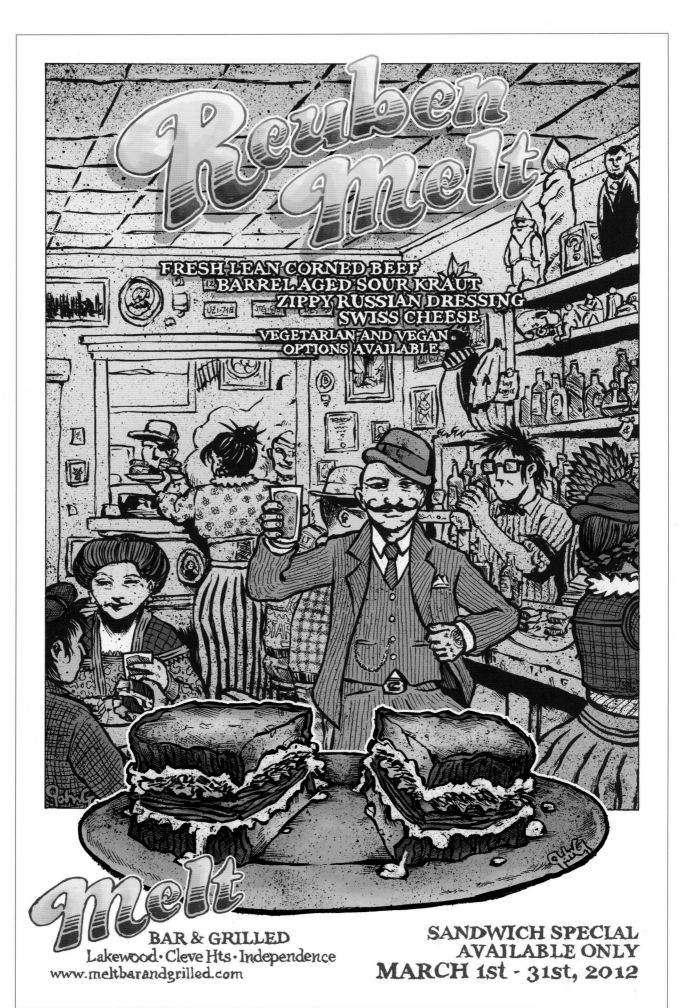

Based on the theme song of the iconic TV show. The initial Melt location in Lakewood, Ohio feels just like the bar in *Cheers*, "Where Everybody Knows Your Name."

SANDWICH ANARCHY

THE CULT CULINARY POSTERS OF MELT BAR & GRILLED

JOHN G

1984 PUBLISHING

By the end of 2008, I was creating so many gig posters that there were weeks where Clevelanders could go to rock shows for which I designed posters nearly every night. It was a lot of fun, but not necessarily great for paying bills.

Around that time *Cleveland Scene Magazine* asked me to draw the cover and interstitial art for their "Best Of 2008" issue. Melt Bar & Grilled, a local spot serving grilled cheese sandwiches in endless incarnations, won a best restaurant award after being open for only two years. I drew Melt into the issue since I was a fan (see image below), and when Melt owner Matt Fish saw the illustration he called *Scene* to purchase the original sketch.

A few months later I developed a "Month of Posters" concept to expand my portfolio, a project where I would draw daily posters not only for bands, but also various businesses and nonprofit organizations. I had two main goals here: 1) to get paid for as many posters as I could, and 2) to branch out a bit from the music market.

I sent out a mass email to bands and business owners, including Matt Fish. He replied immediately, saying he loved gig posters and wanted to be involved, but didn't know how Melt could use such an image. So I suggested, "Why don't I create a poster for the March sandwich special to kick off the project?" The wheels were turning and we immediately clicked.

I treated that first poster for the Reuben Melt (see page 6) as an audition. I had a feeling that if I played my cards right, I could turn this into something longer term. I buckled down and drew my ass off. The day I turned it in, Matt asked me how much I would charge to draw a poster every month and reformat it for Melt's weekly ad in *Scene*.

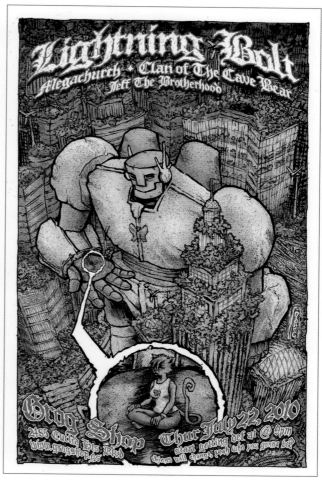

So, I gave Matt my rate and – this never happens – he told me it was way too low. He offered me double what I asked for, plus a line of monthly credit at the restaurant. We were off.

It didn't take long to recognize how charged the creative dynamic was between Matt Fish and I. He would send me sandwich descriptions and I would fire back names or ideas for how to present them in a visually compelling way.

All of this coincided with Melt's rapid expansion. Within that first year of posters, the East Side location opened to immediate success and then we teamed up with Cleveland Cinemas to sponsor their Late Shift cult midnight movies by offering "limited time only" tie-in sandwich specials like the Troll 2 Fried Bologna Melt (page 129) and The Brat Pack Breakfast Club Melt (page 88).

Before we knew it, Melt was on the TV shows *Diners, Drive-Ins, and Dives* and *Man v. Food*, and notables of all types (from Mastadon to Weird Al) were dropping by unannounced. My little sister even called me from Alabama saying she had seen my posters on TV.

Eight and a half years later and we're 250+ posters deep. Melt is opening its 11th location and counting. This has overlapped with me creatively expanding, including the development of *The Lake Erie Monster* comic series with my friend Jake Kelly, illustrating LP record covers, and still drawing the occasional rock show poster.

When I think back to those early days, shouldering my way into the chance of doing one poster and then folding that opportunity into a monthly gig, it seems crazy.

Essentially, I made up a job for myself and then figured out a way to get paid for it. I never could have predicted that this opportunity would help to define the visual identity of a breakout restaurant, eventually leading to the book in your hands.

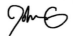

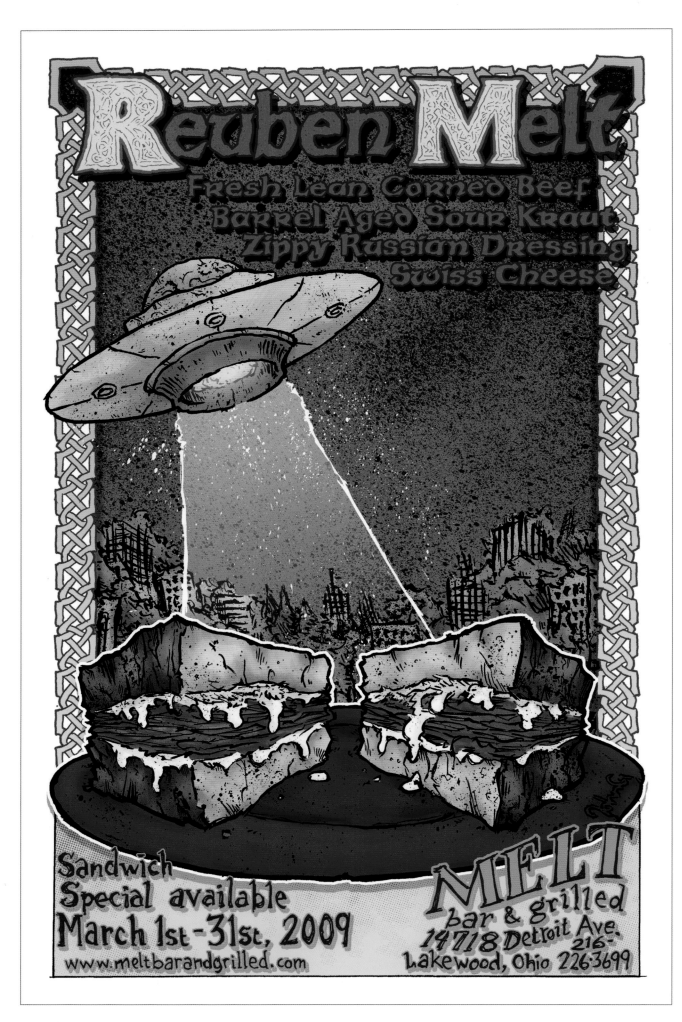

The very first Melt poster, as discussed in the introduction. More than 250 followed – and counting! I knew owner Matt Fish would be a great collaborative fit when he didn't flinch at the nonsensical UFO in the image.

Meant to mimic St. Patrick's themed stained glass windows that appear in Catholic churches around the world. With a Rust Belt landscape in the background, of course.

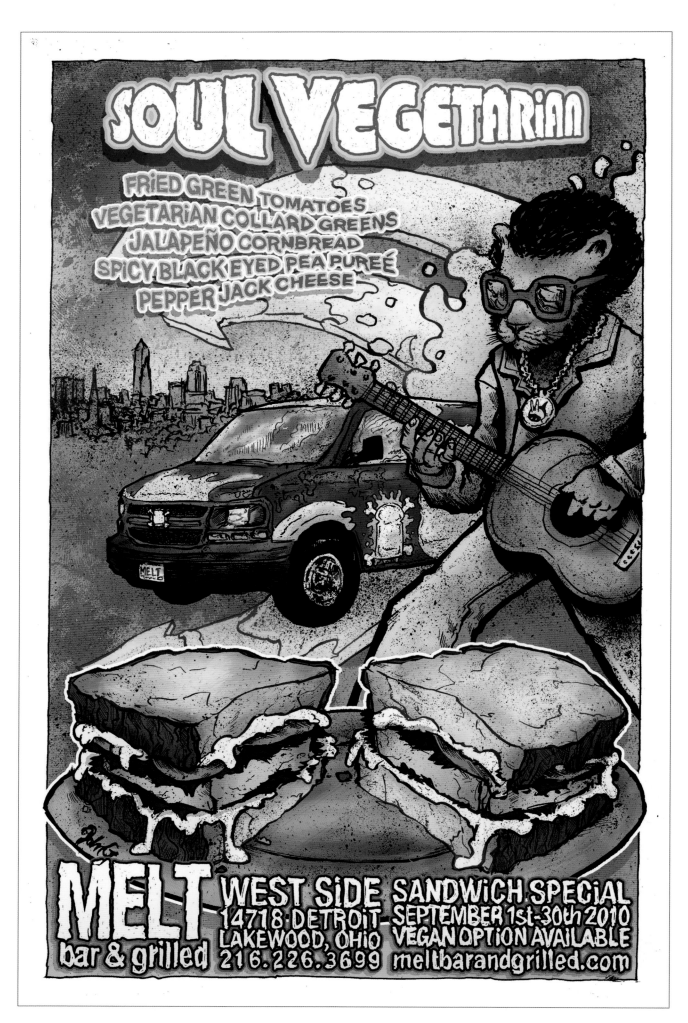

Meant to be framed together, this diptych is based on '60s exploitation film posters and the actual Melt delivery van. The character above pays homage to legendary musician Bobby Womack (RIP).

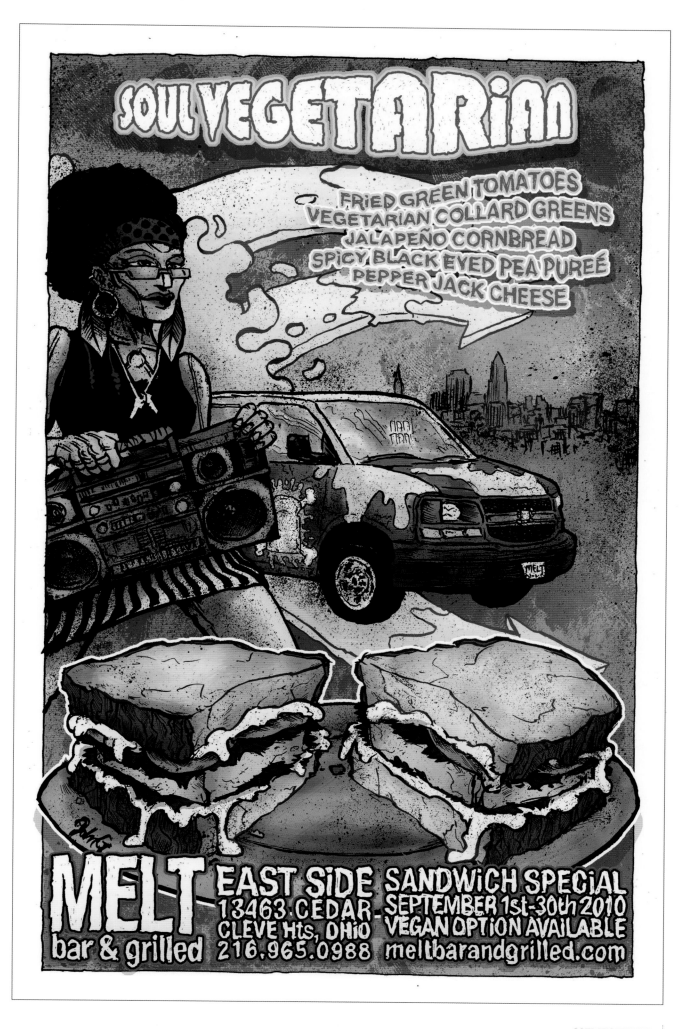

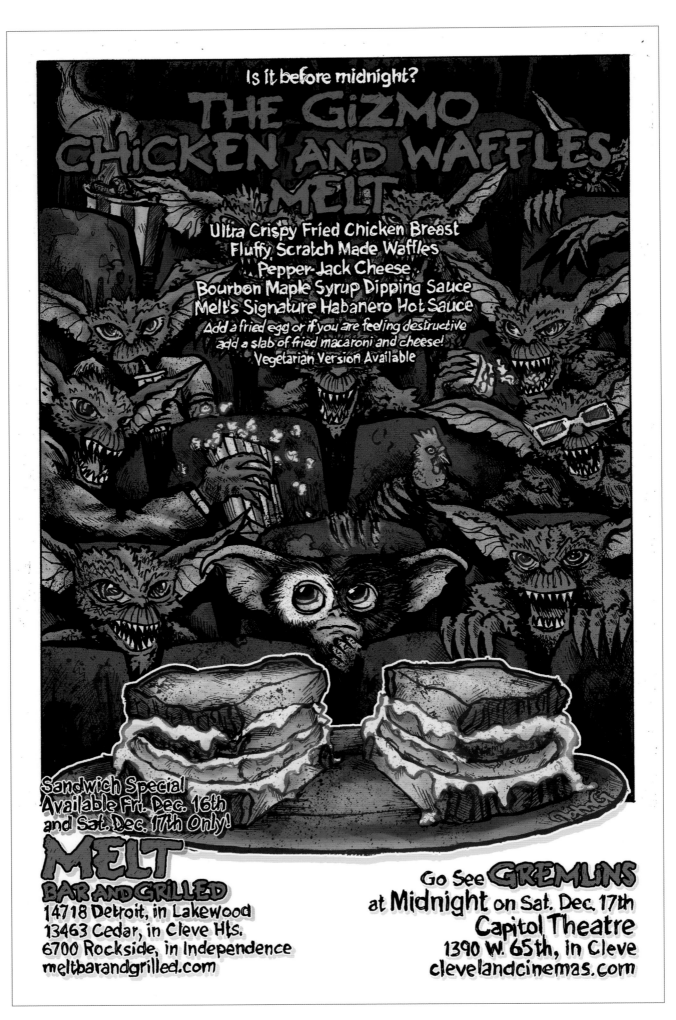

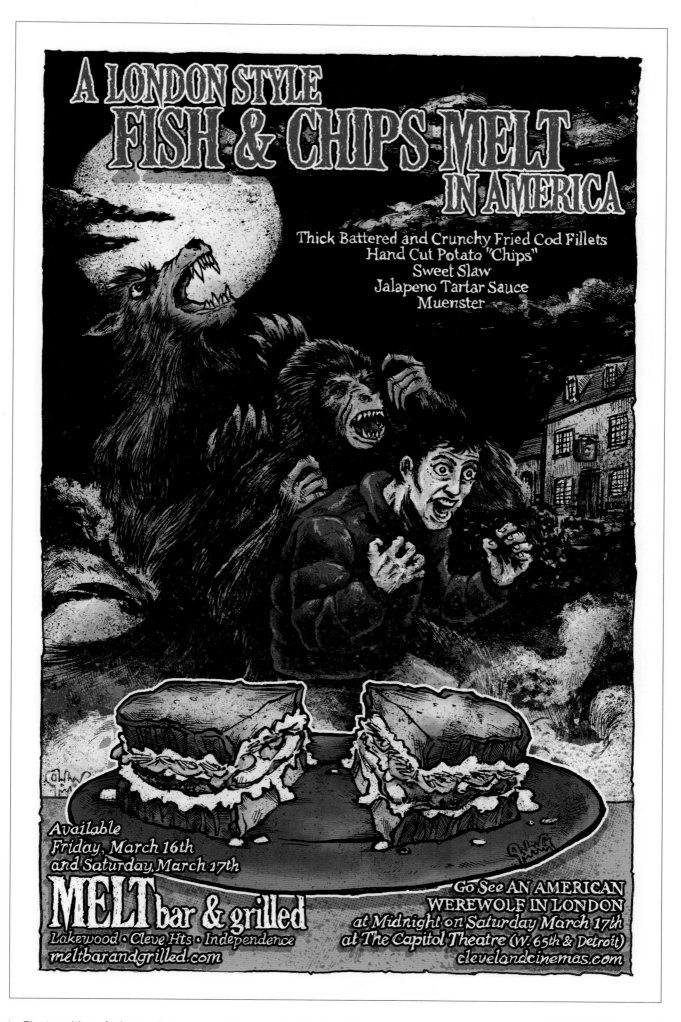

The transition of a human into a werewolf, as seen in John Landis'
An American Werewolf in London. Includes a UK nod to fish and chips.

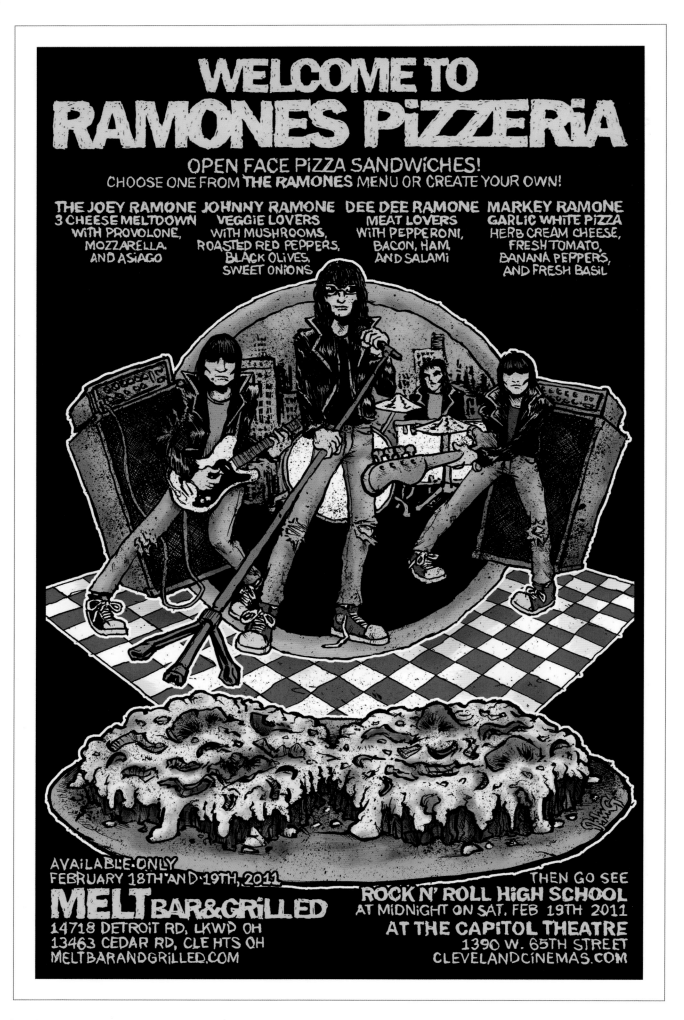

Cleveland has music in its veins. This poster was based on The Ramones' *Road to Ruin* LP cover by *Punk Magazine* co-founder John Holstrom. It's also the only open-faced special sandwich Melt has ever created.

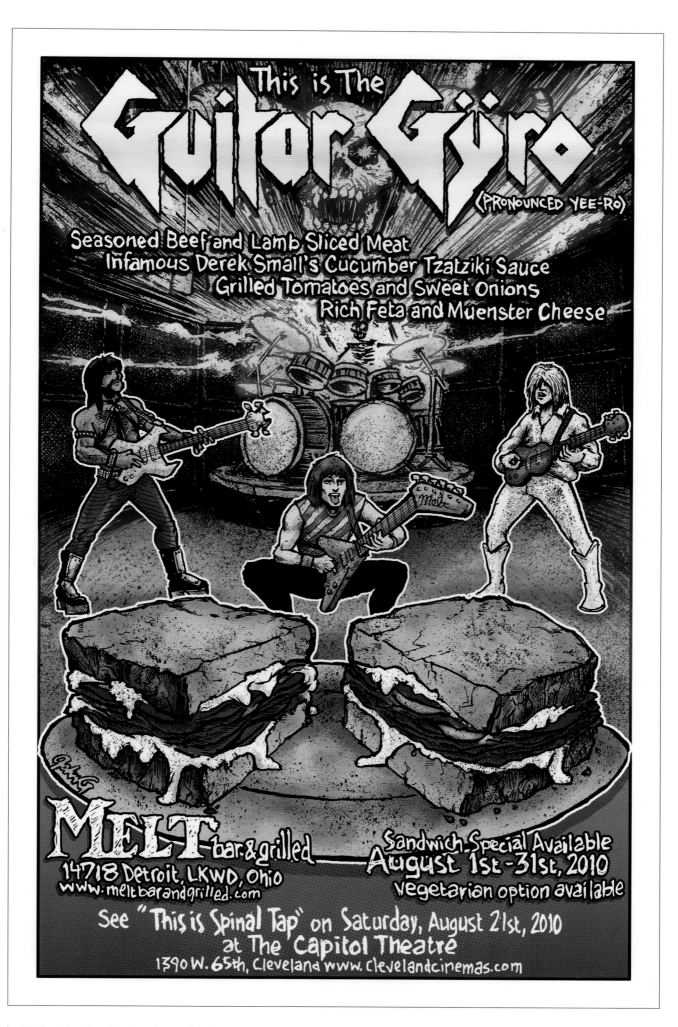

"Hello, Cleveland!" - Derek Smalls. *This is Spinal Tap* is arguably the best mockumentary of all time. Includes a reference to the band's exploding drummer (RIP), which is rarely noticed in this piece.

GUITAR GŸRO

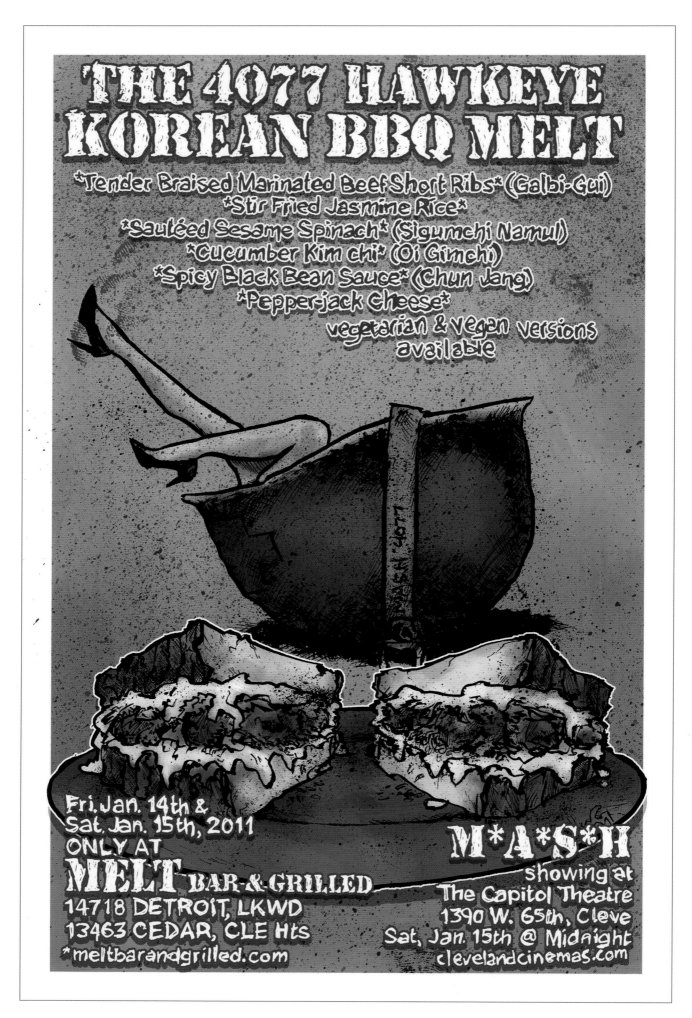

A tribute to both the film and the iconic television show *M*A*S*H*, about finding humor during the Korean War.

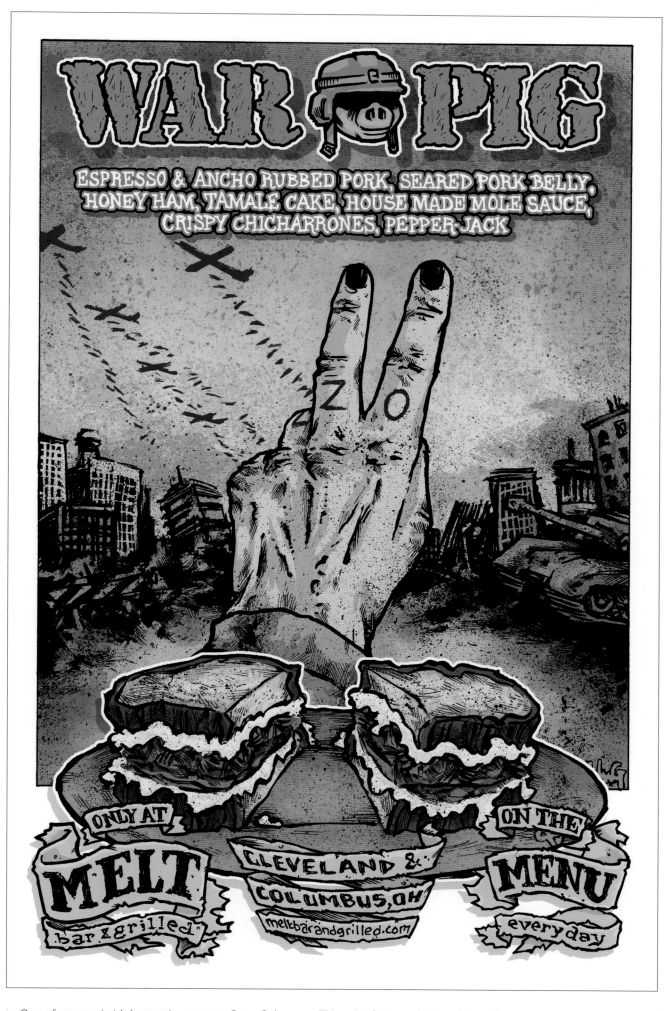

One of my music idols growing up was Ozzy Osbourne. This print features his iconic hand tattoo and references Black Sabbath's 1970 song "War Pigs." This sandwich evolved into the pork-centric permanent menu items The Korean War Pig and The Cuban War Pig.

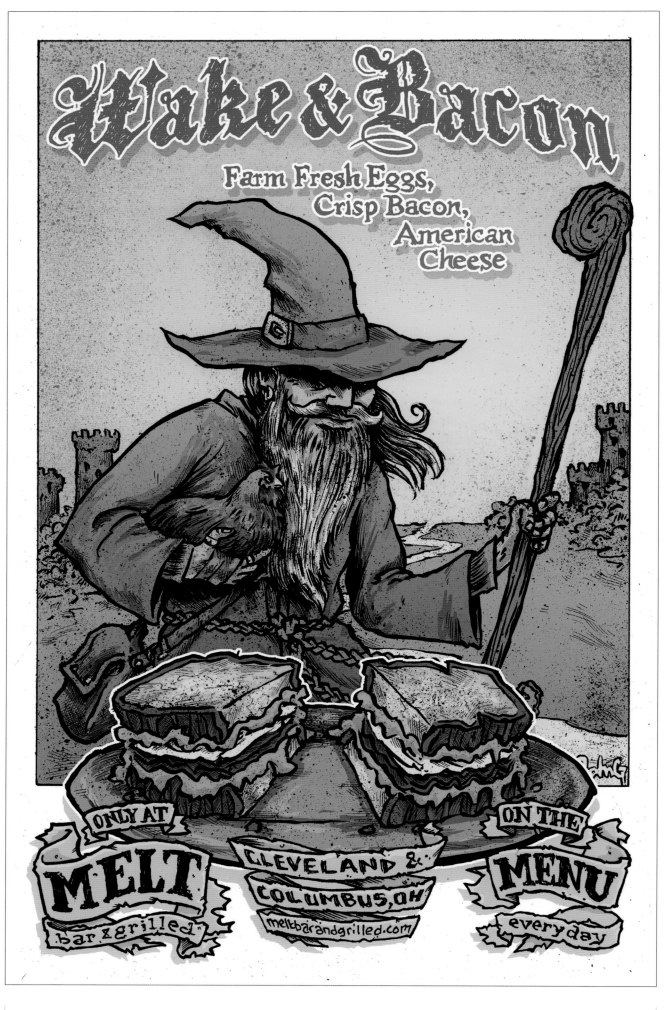

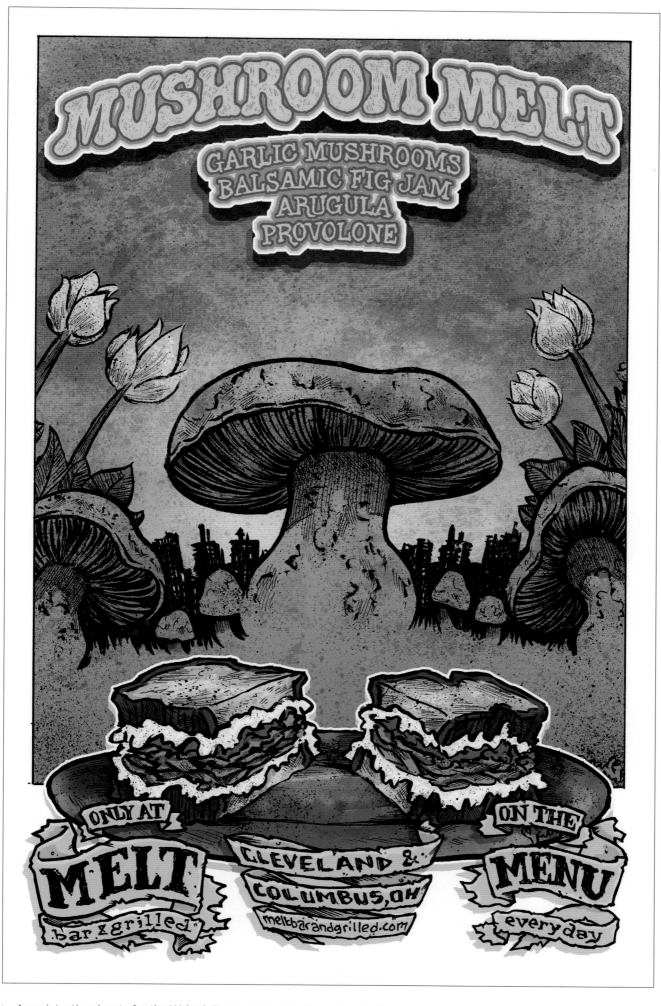

An unintentional mate for the Wake & Bacon poster, the Mushroom Melt was most definitely created with psychedelic supplements in mind.

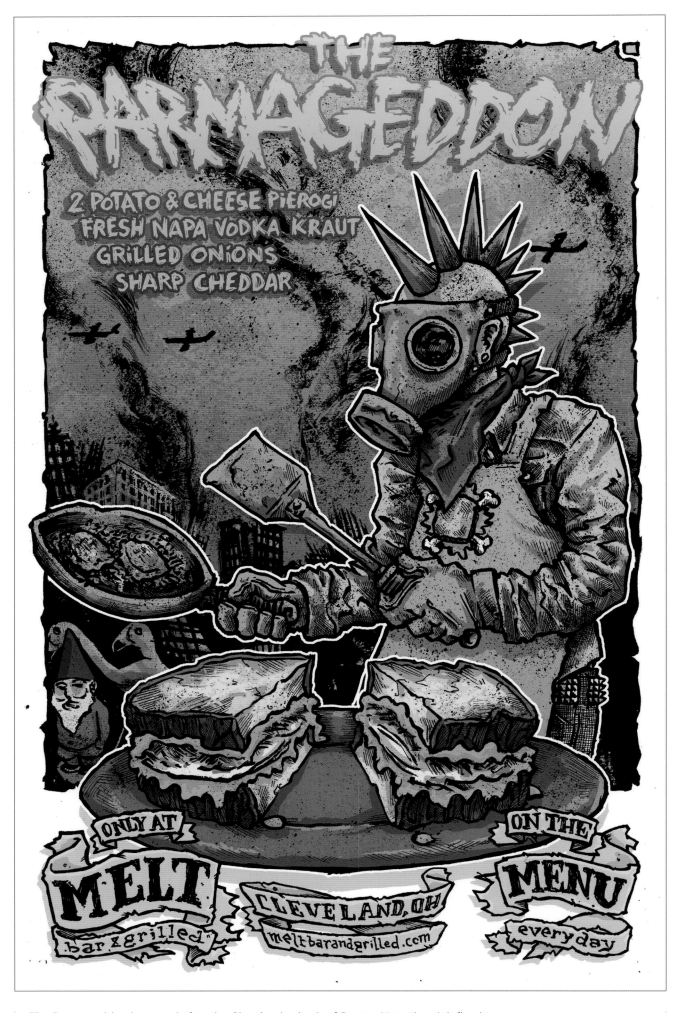

The Parmageddon is named after the Cleveland suburb of Parma. Note the pink flamingos and garden gnomes, a stereotype of the city. This is Matt's favorite poster, and was featured in the *Diners, Drive-Ins, and Dives* book series.

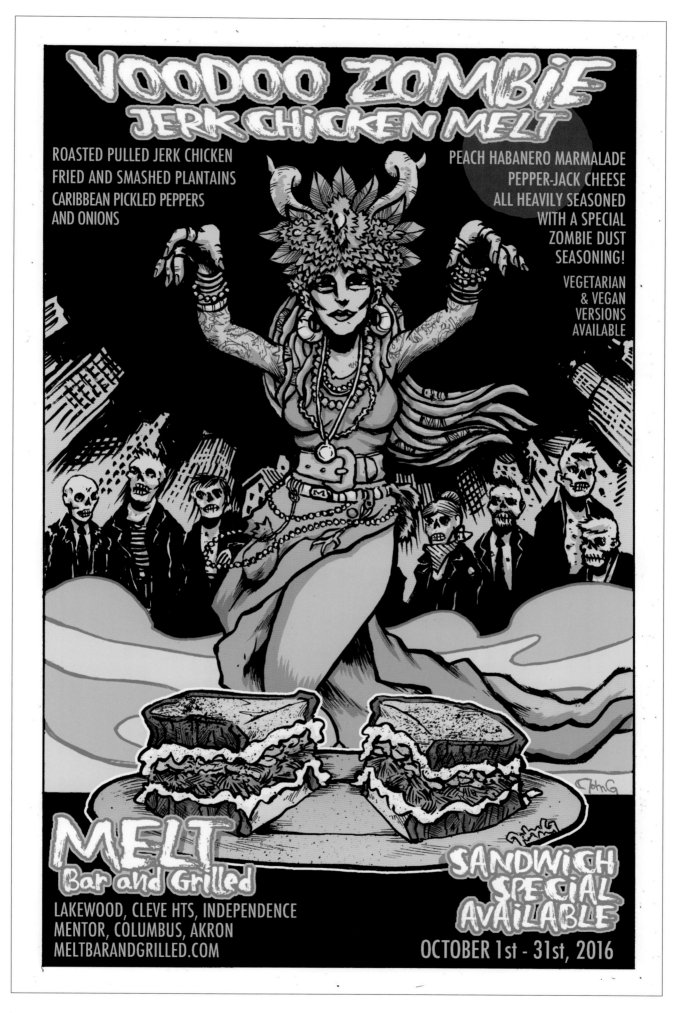

My interpretation of Marie Laveau, a Louisiana Creole Voodoo priestess from New Orleans. Plus a group of zombies.

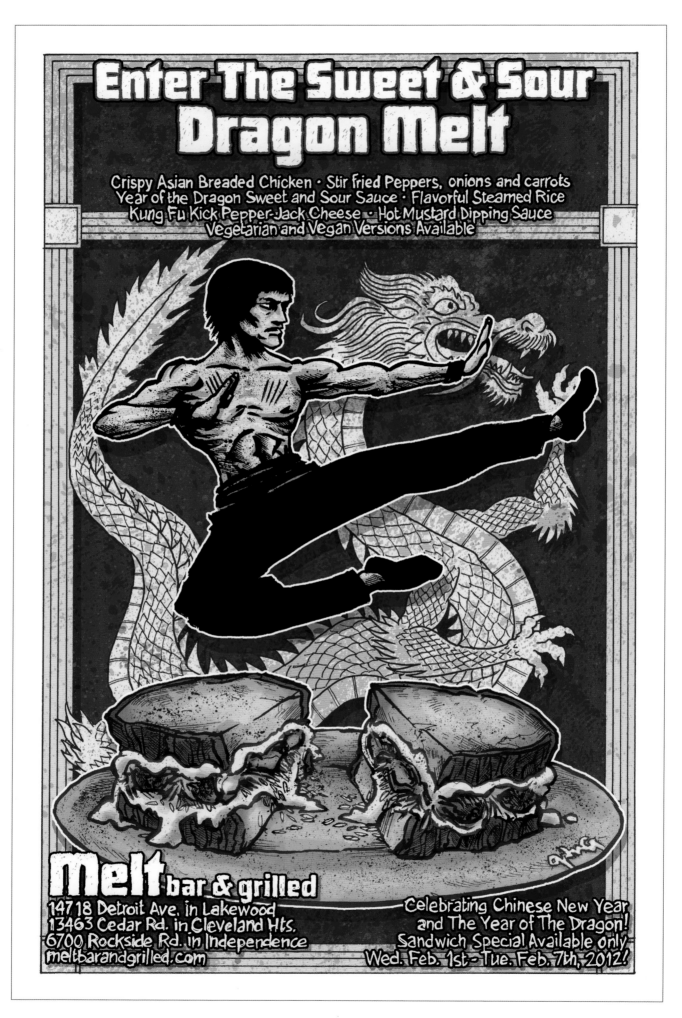

Martial arts legend Bruce Lee, showcasing his iconic flying kick. The background and Bruce were two separate drawings superimposed in Photoshop.

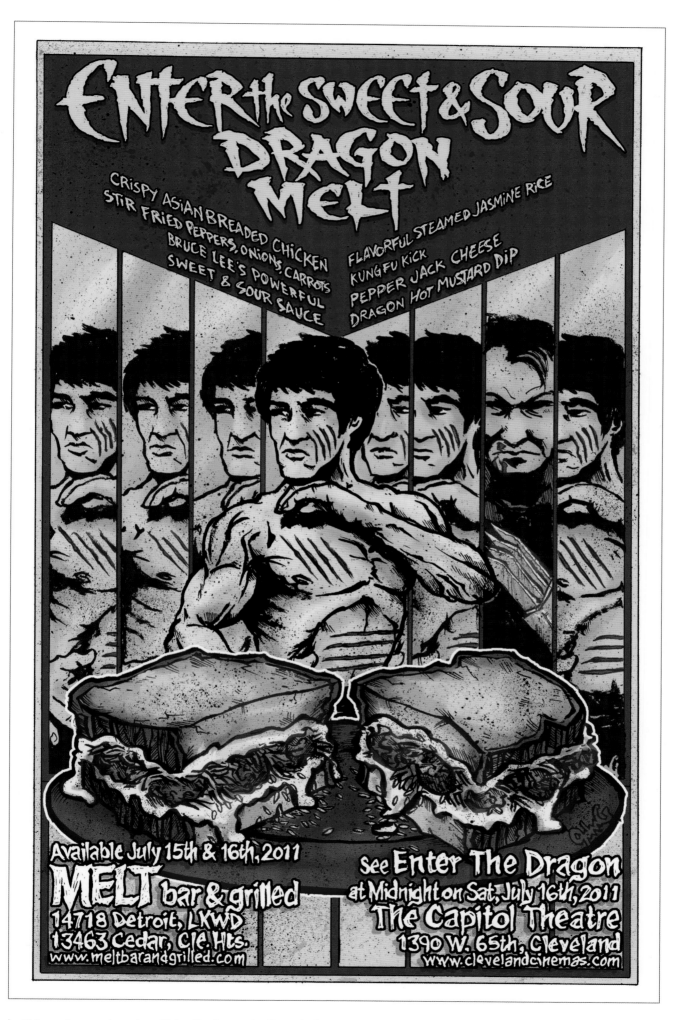

This poster was based on *Enter the Dragon*'s climactic fight between Bruce Lee and Han, "Destroy the image and you will break the enemy." Note the W in the title, a nod to the Wu-Tang Clan logo.

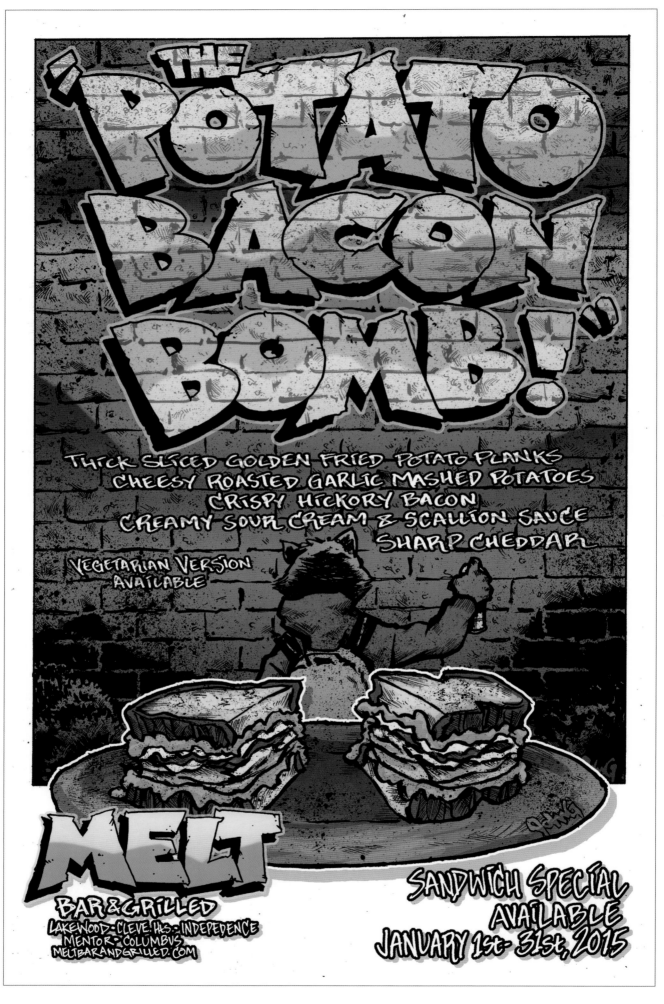

The text here was patterned after the typography of two iconic '80s hip-hop films, *Wild Style* and *Krush Groove*. The Fat Boys' "All You Can Eat" might as well be an unofficial song for Melt.

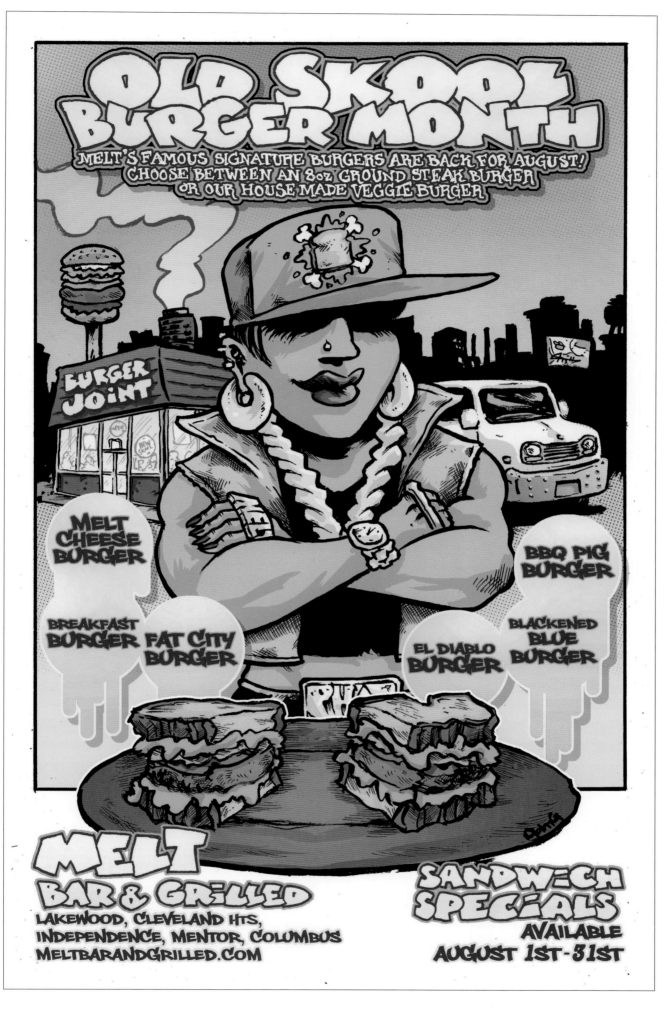

Saturday morning cartoon-style, imagining Melt as a burger joint where the '50s meet the '80s, complete with a "PHAT" belt buckle.

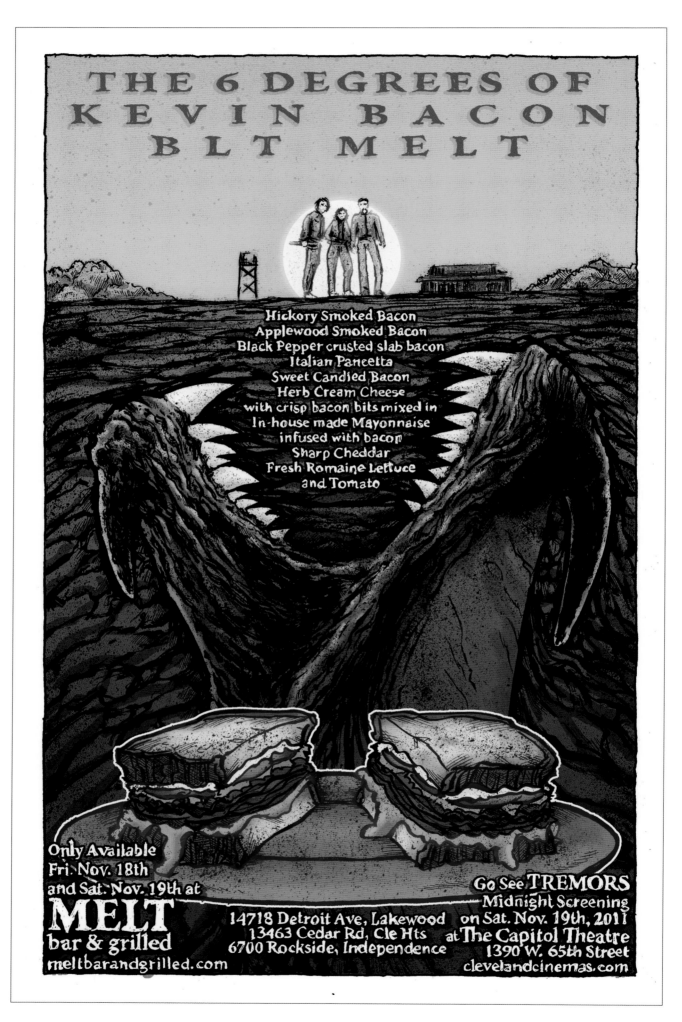

One of Melt's most requested specials. This poster was obviously based on one of Bacon's better films, *Tremors*. "Be advised, however, that there are two more, repeat, two more motherhumpers."

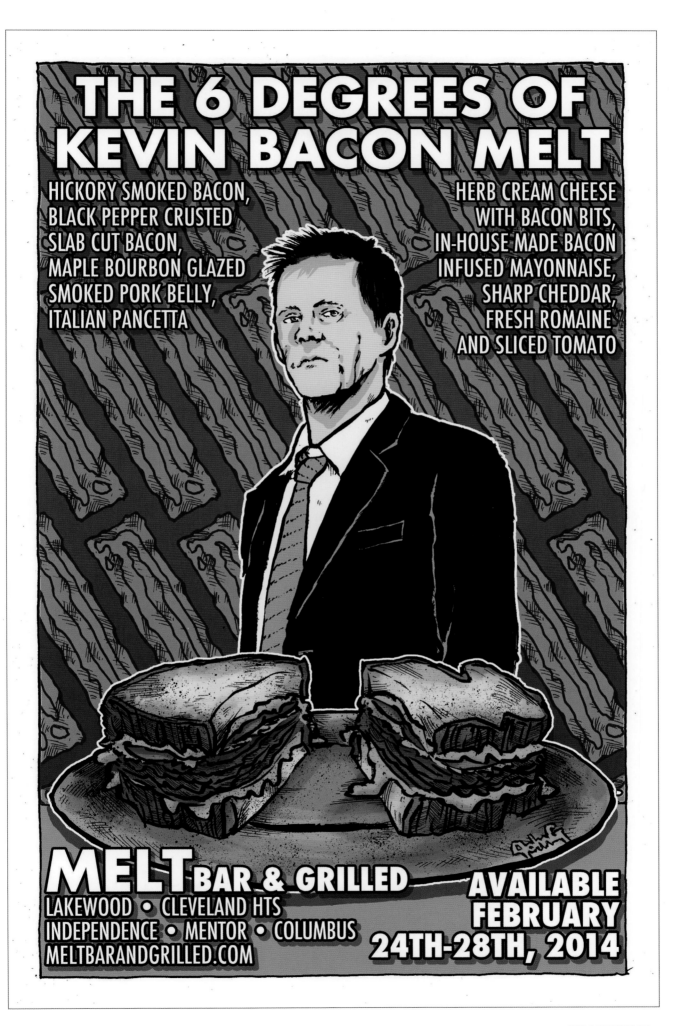

To date, Kevin Bacon-related posters are easily the most popular with Melt guests...and also the most heavily stolen from walls at the restaurants.

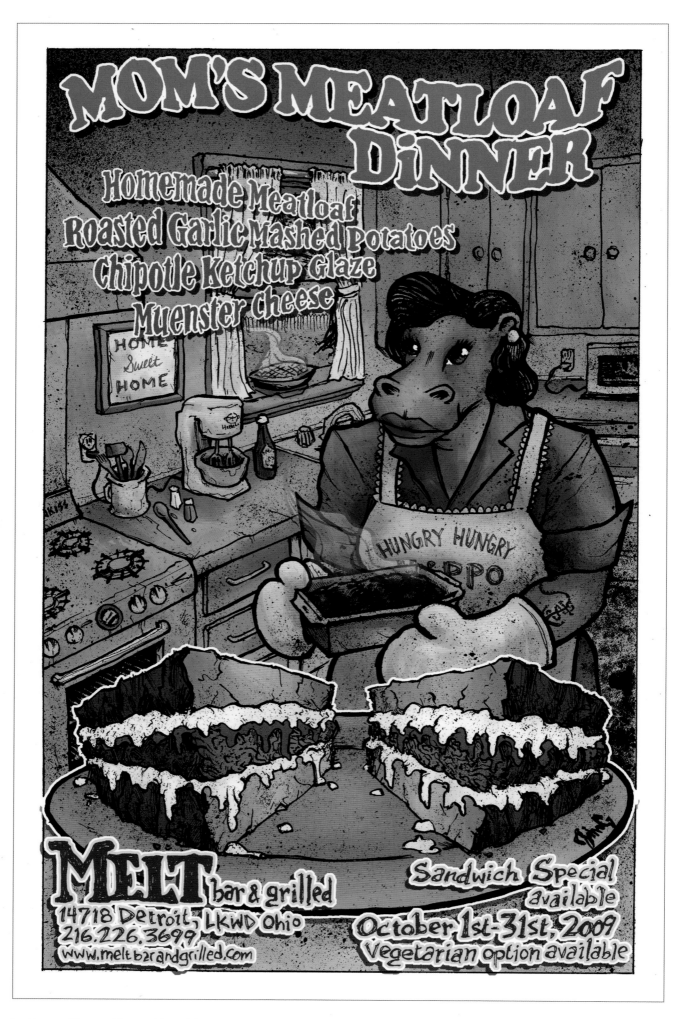

Hungry Hungry Hippos (the tabletop game) comes to life! Minus the marbles and racket.
I also switched the color of the hippo to purple (i.e., the game sadly only had red, orange,
pink, and green to work with).

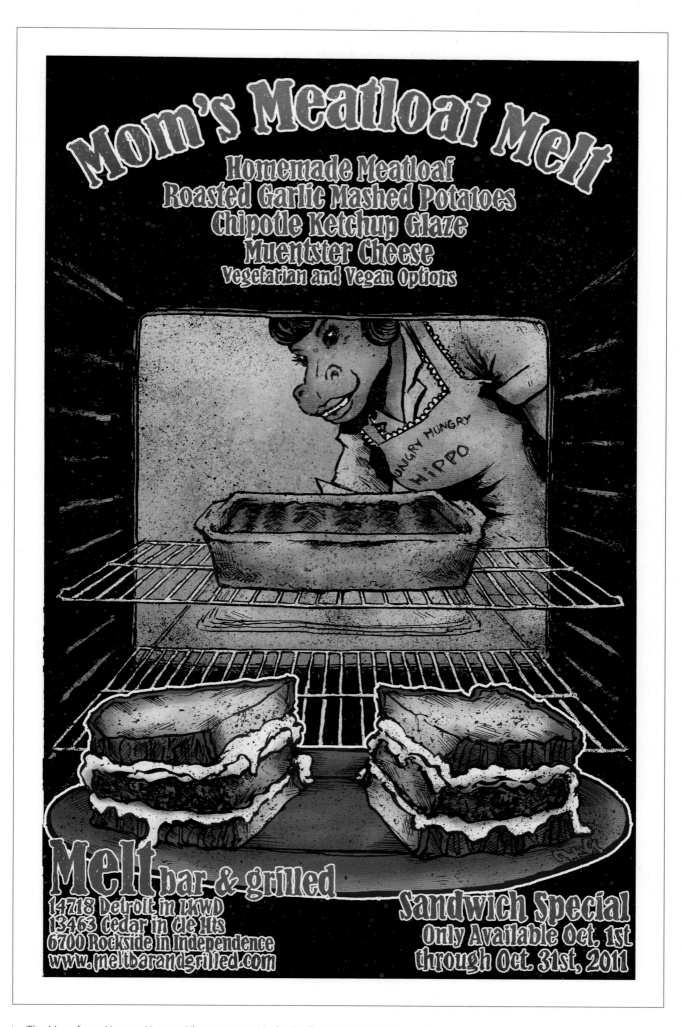

The Mom from *Hungry Hungry Hippos* returns! I physically squeezed inside my home oven to take reference photos for this piece. The gas was off. Thanks for asking.

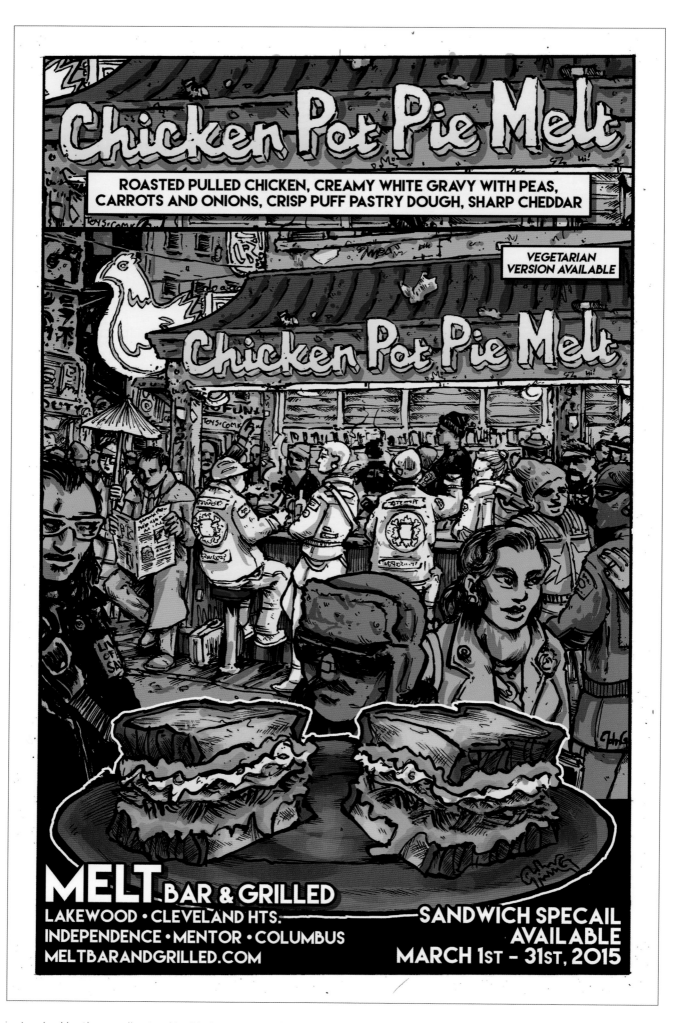

Inspired by the noodle stand in *Blade Runner*, with my friend Lawrence poking his head in on the left (that's him with the glasses). The design here references a typical comic book page layout.

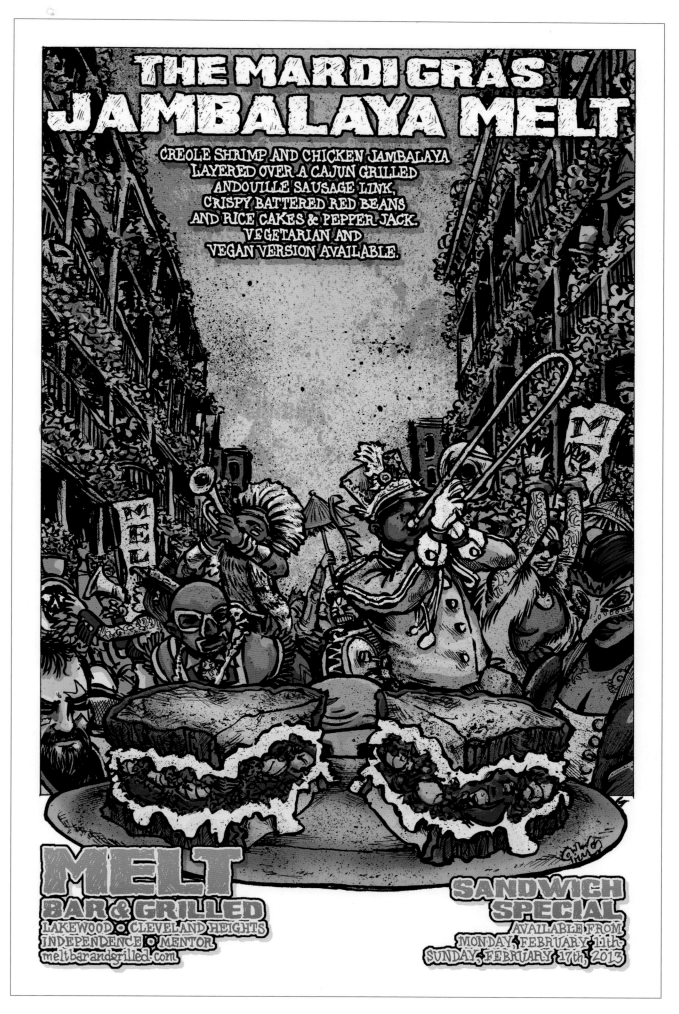

I love drawing crowd detail, and this street scene of a New Orleans Mardi Gras celebration was the ideal opportunity to showcase this skill.

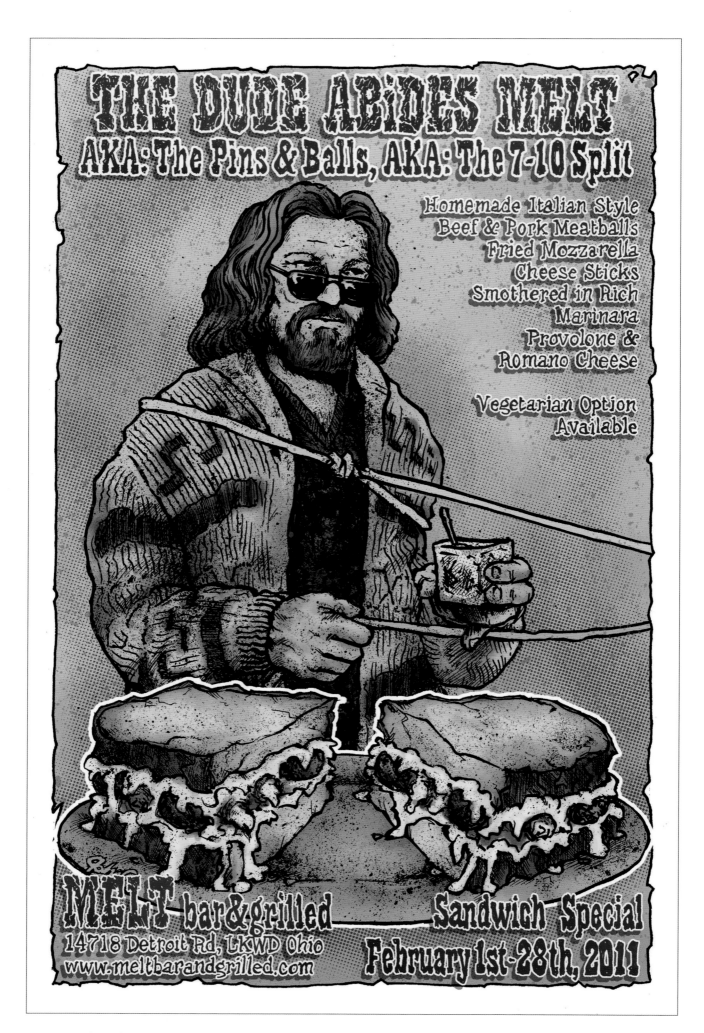

Meant to be collected and framed as a pair, this diptych features
True Grit Jeff Bridges lassoing *The Big Lebowski* Jeff Bridges.

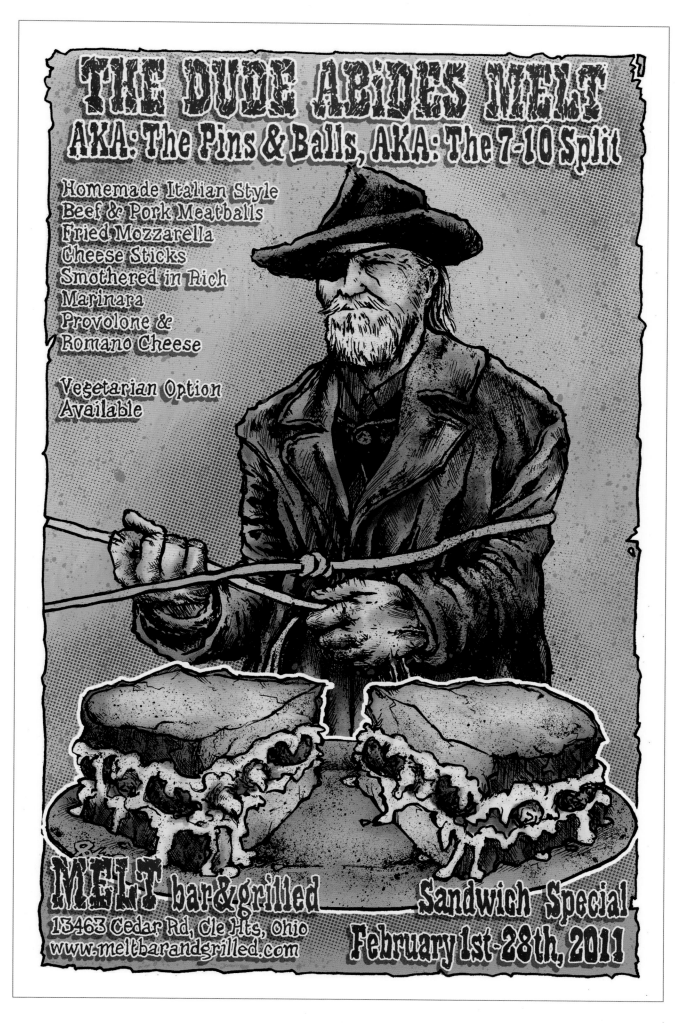

THE DUDE ABIDES MELT
AKA: The Pins & Balls, AKA: The 7-10 Split

Homemade Italian Style
Beef & Pork Meatballs
Fried Mozzarella
Cheese Sticks
Smothered in Rich
Marinara
Provolone &
Romano Cheese

Vegetarian Option
Available

MELT bar&grilled
13463 Cedar Rd, Cle Hts, Ohio
www.meltbarandgrilled.com

Sandwich Special
February 1st-28th, 2011

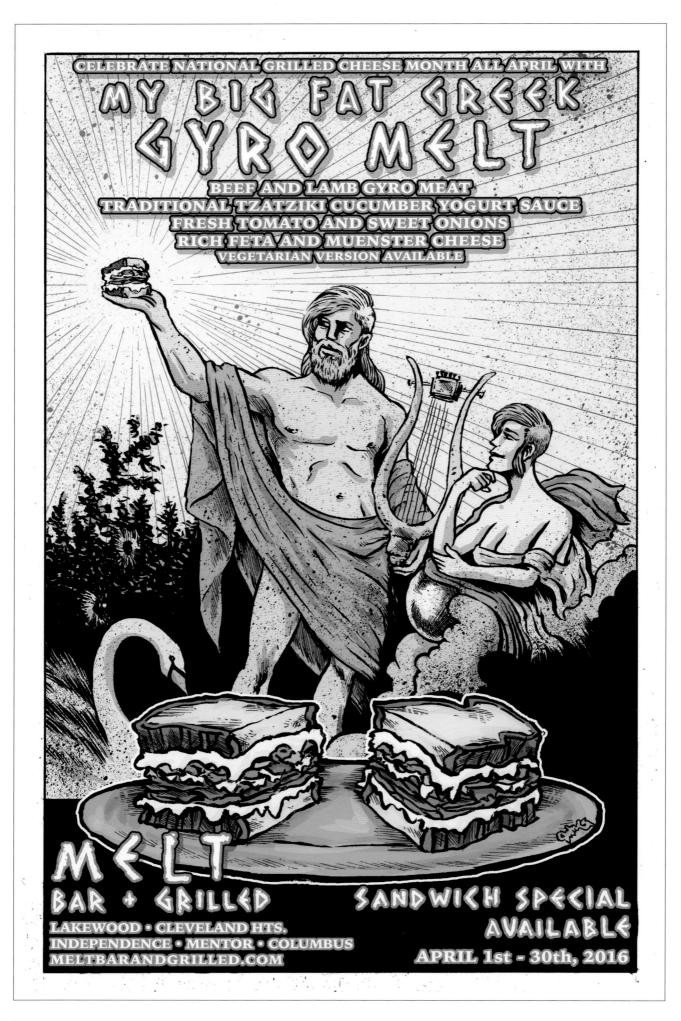

A fairly straightforward reference to Greek mythology (featuring Apollo), based on the 18th-century painting series *Apollo and the Muses* by French artist Charles Meynier that caught my attention at the Cleveland Museum of Art.

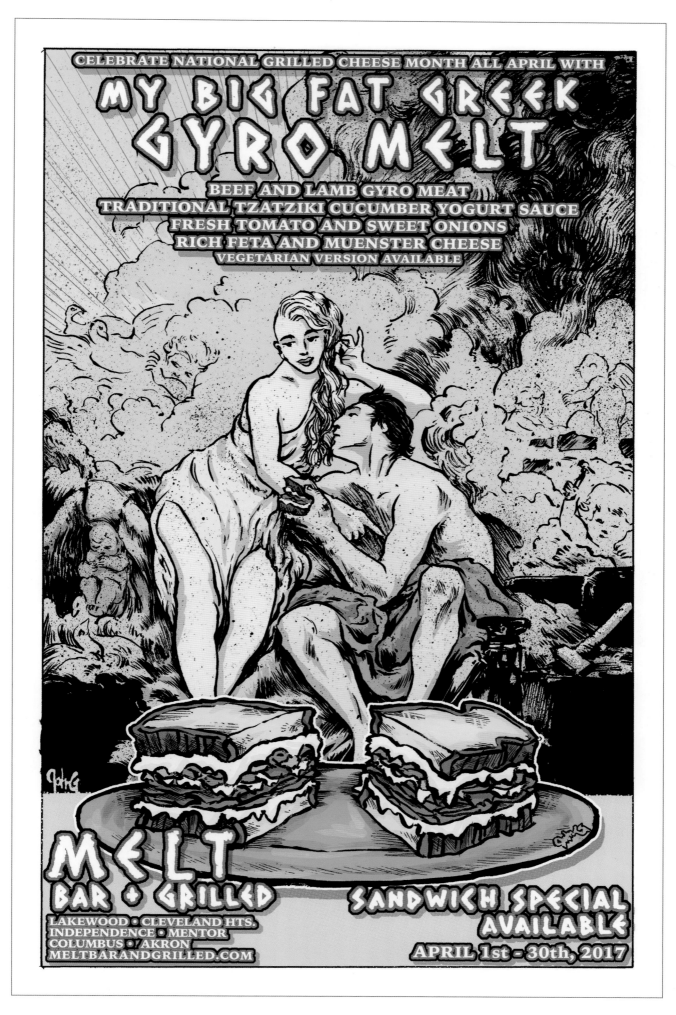

The return of the big fat gyro, one year later, and based
on *The Visit of Venus to Vulcan* (1754) by François Boucher.

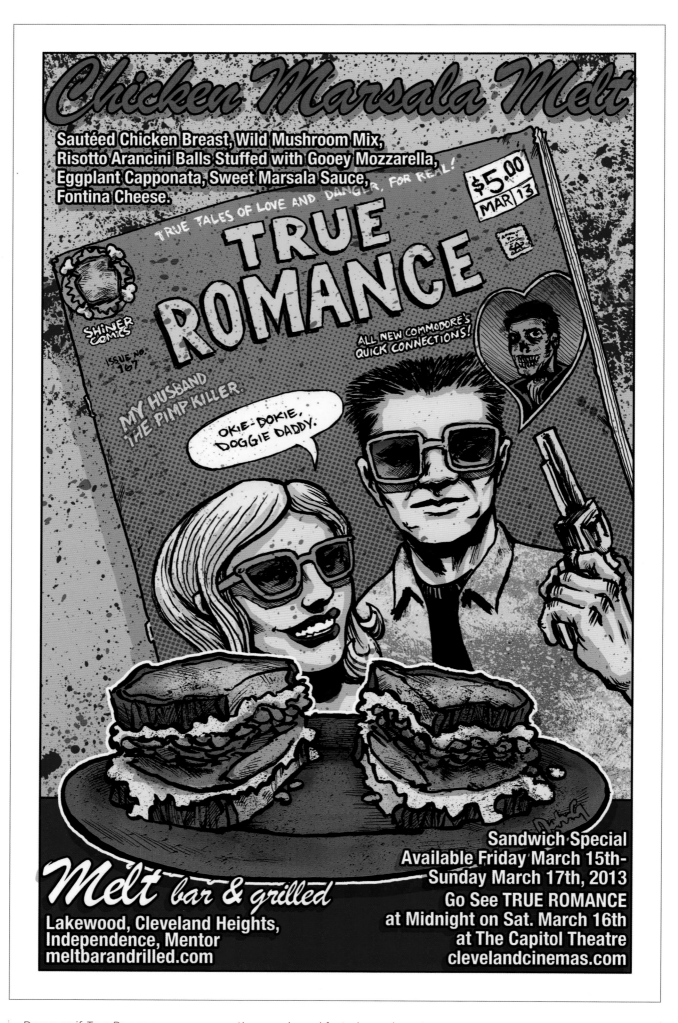

Drawn as if *True Romance* were a romantic comedy, and featuring a character
(The Commodore) from my very own comic book series called *The Lake Erie Monster*
(see him peeking in via the drawn heart).

PEE WEE'S BIG TEQUILA LIME MELT

Tortilla Crusted Chicken or Shrimp
Tequila Lime Glazed Fire Roasted Poblano Pepper
Green Tomatillo Salsa Verde · Cilantro Avocado Creme Fraiche
Pepperjack Cheese · Vegetarian Option Available

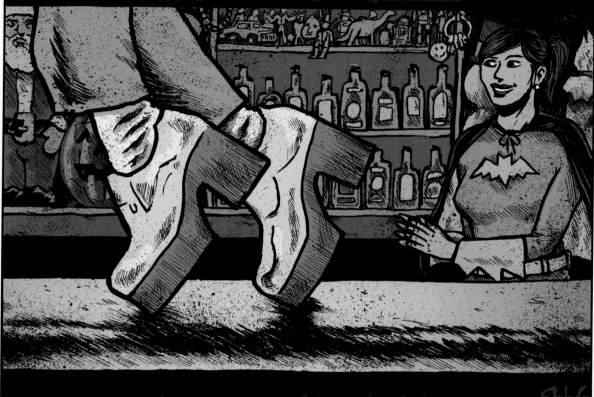

MELT
BAR & GRILLED
Lakewood · Cleveland Hts.
Independence · Mentor
meltbarandgrilled.com

Availble **JUNE 14TH**
through **16TH, 2013**
Go See **PEE WEE'S BIG ADVENTURE**
at **THE CAPITOL THEATRE**
at Midnight on Saturday, June 15th!

The iconic "Tequila" dance sequence from *Pee-Wee's Big Adventure*, along with a Batgirl costume that one of the bartenders wore for Superhero Day.

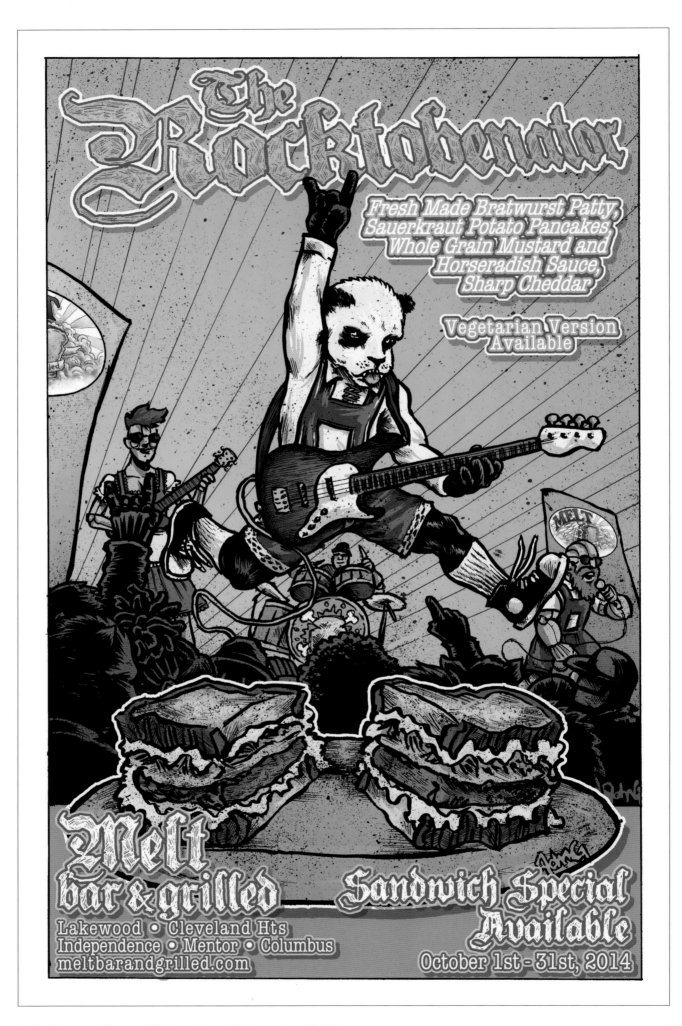

A tribute to Lakewood Melt employee Whitey, whose birthday is in October and who happens to adore pandas.

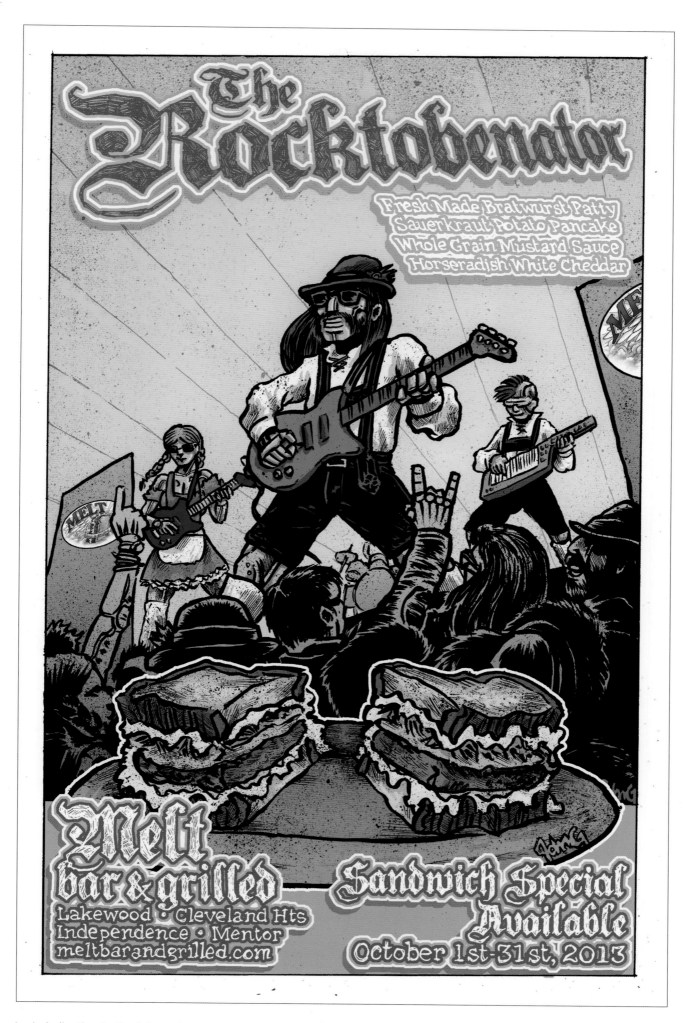

A dedication to English musician Lemmy, Ian Fraser Kilmister, who fronted Motörhead until his untimely death in 2015.

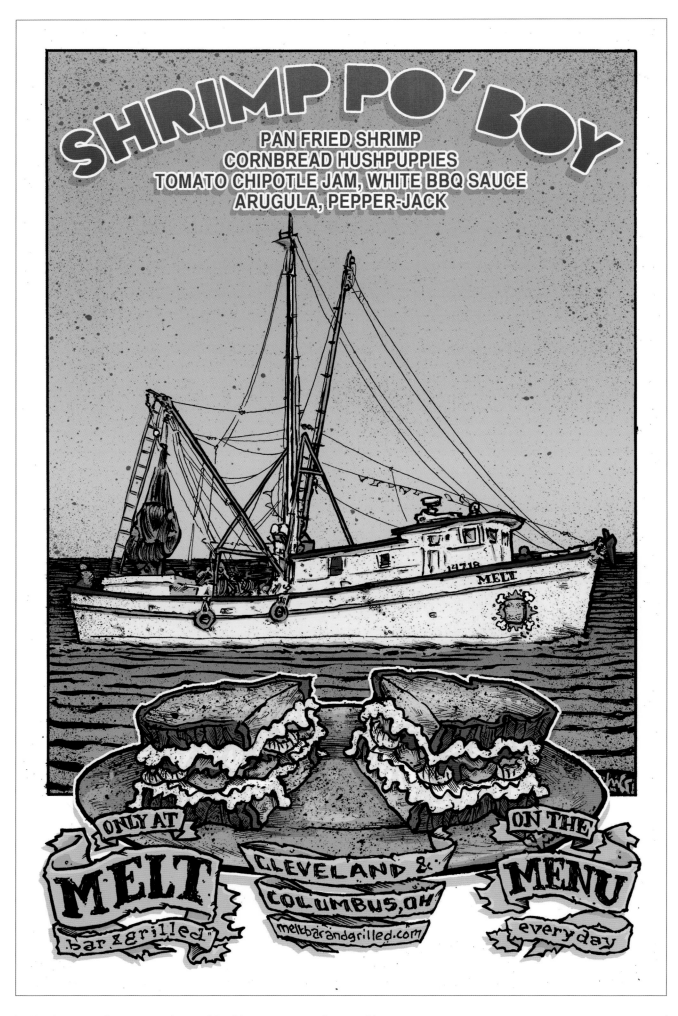

SHRIMP PO' BOY

PAN FRIED SHRIMP
CORNBREAD HUSHPUPPIES
TOMATO CHIPOTLE JAM, WHITE BBQ SAUCE
ARUGULA, PEPPER-JACK

ONLY AT MELT bar & grilled CLEVELAND & COLUMBUS, OH meltbarandgrilled.com ON THE MENU everyday

Moving away from pop culture a bit, this was an experiment with patterns and color, where a body of water was the main character. The Shrimp Po' Boy is no longer a menu item but is heavily requested.

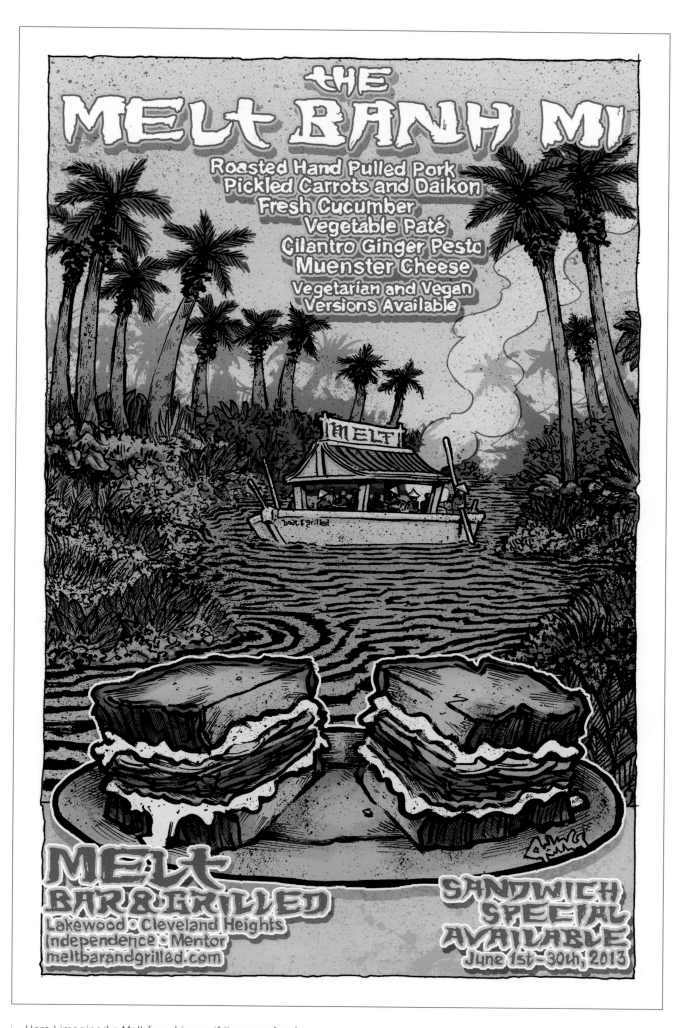

Here I imagined a Melt franchise as if it were a food boat in *Apocalypse Now* during the Vietnam War.

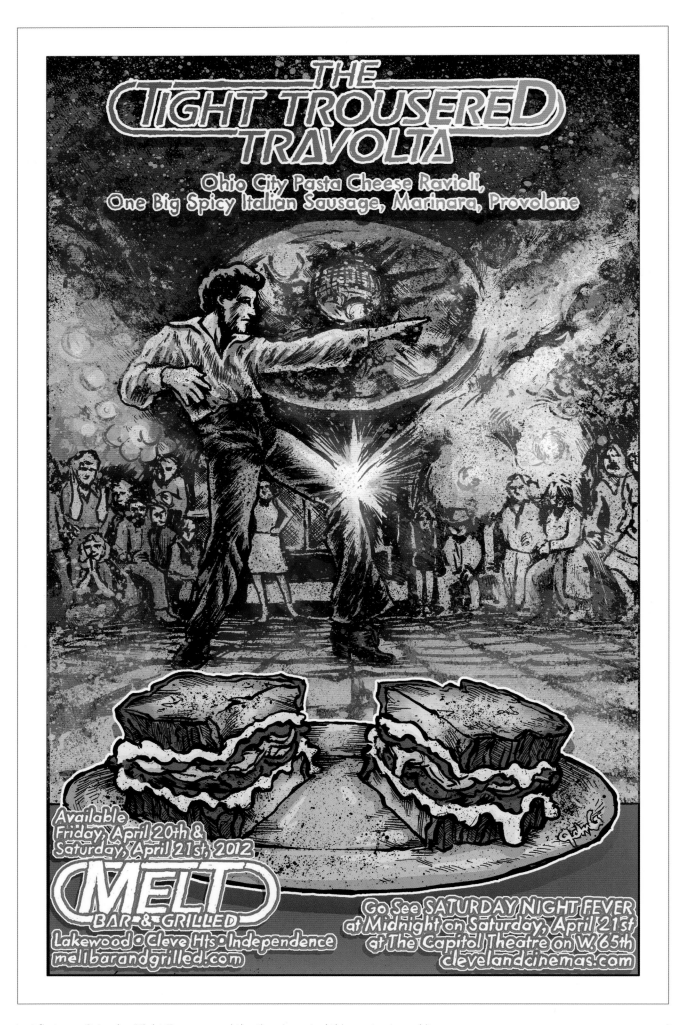

I first saw *Saturday Night Fever* around the time I created this poster. Loved it. However, I was surprised the piece was green-lit despite its phallic tag line featuring "one big spicy Italian sausage."

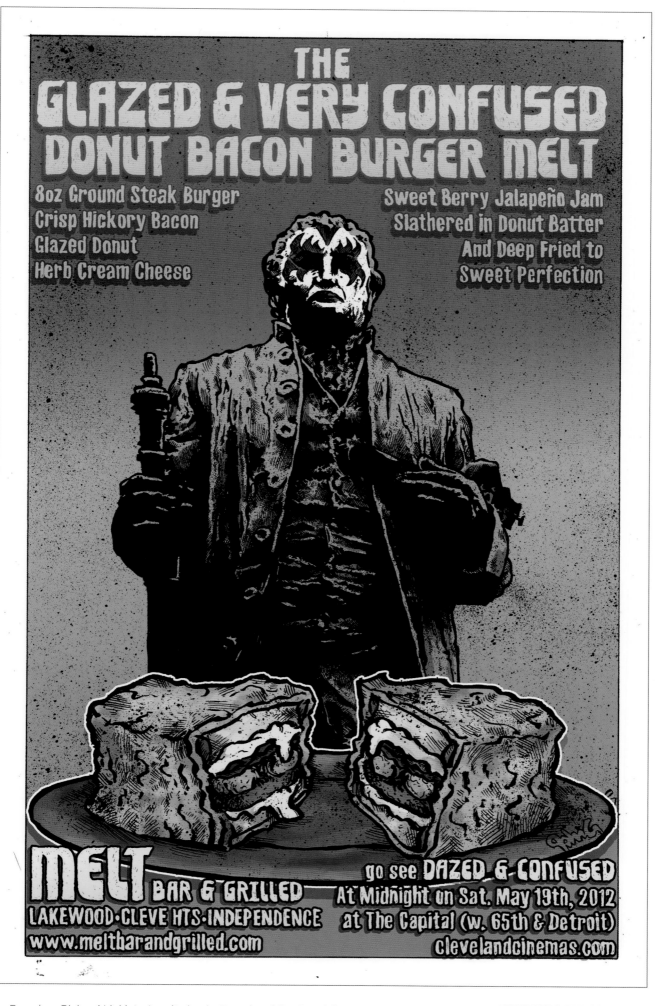

Based on Richard Linklater's cult classic *Dazed and Confused*, featuring a cameo appearance by Moses Cleveland in full KISS makeup (Matt Fish's favorite band).

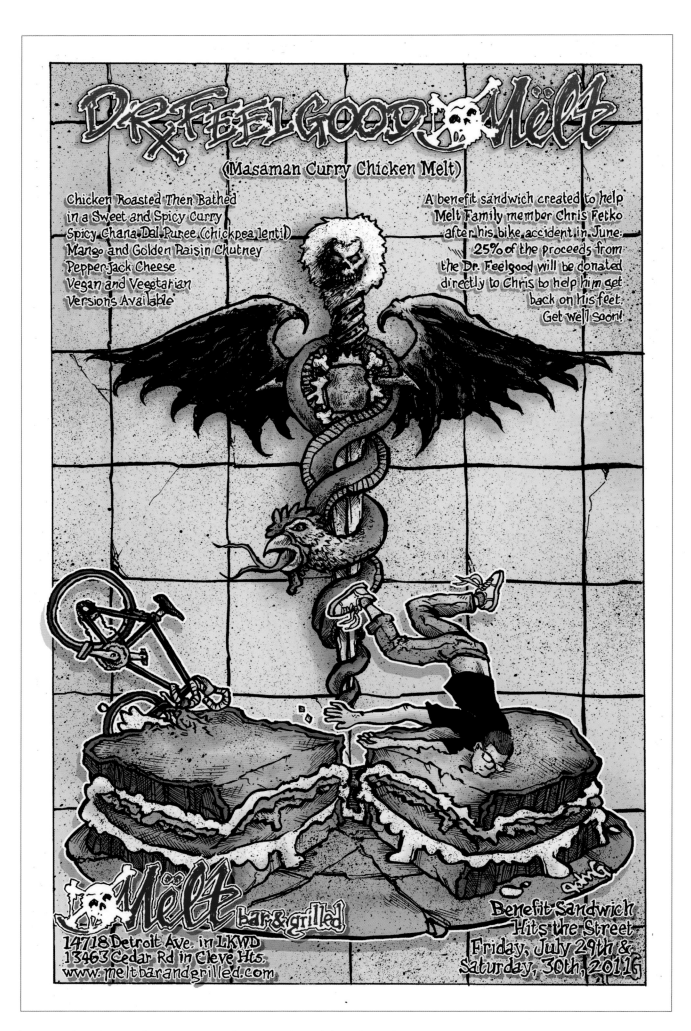

Dr. Feelgood by Mötley Crüe is one of the most formidable albums from my childhood, and this poster was created to promote a fundraiser for employee Chris, who was injured in a bike accident (see the sandwich mishap at the bottom).

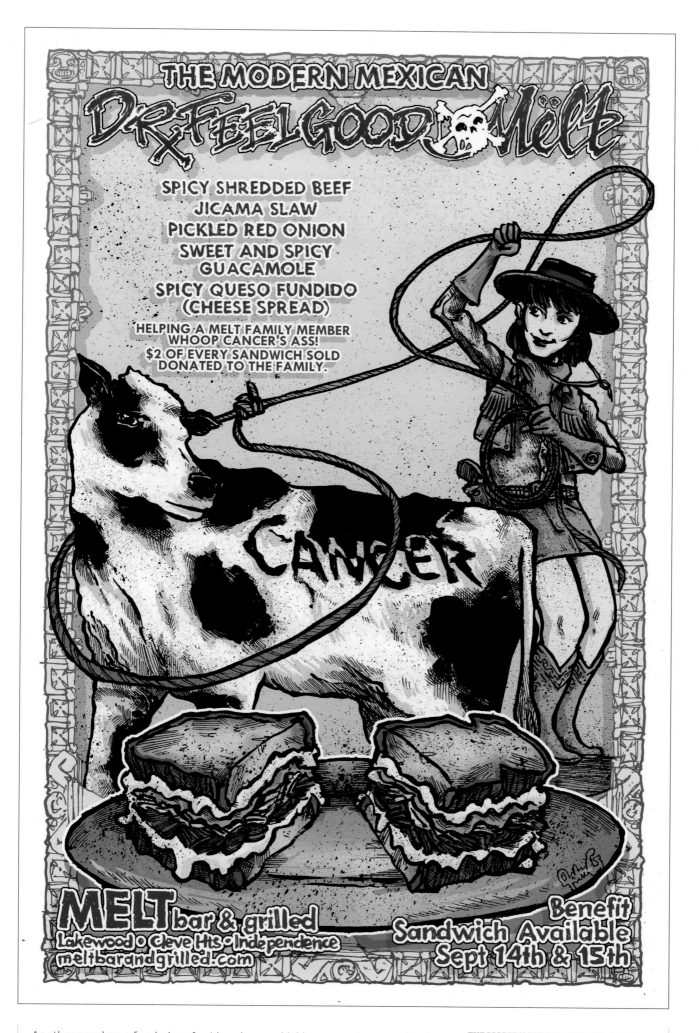

Another employee fundraiser, for Liz, who was kicking cancer's ass at the time. THE MODERN MEXICAN DR. FEELGOOD MELT

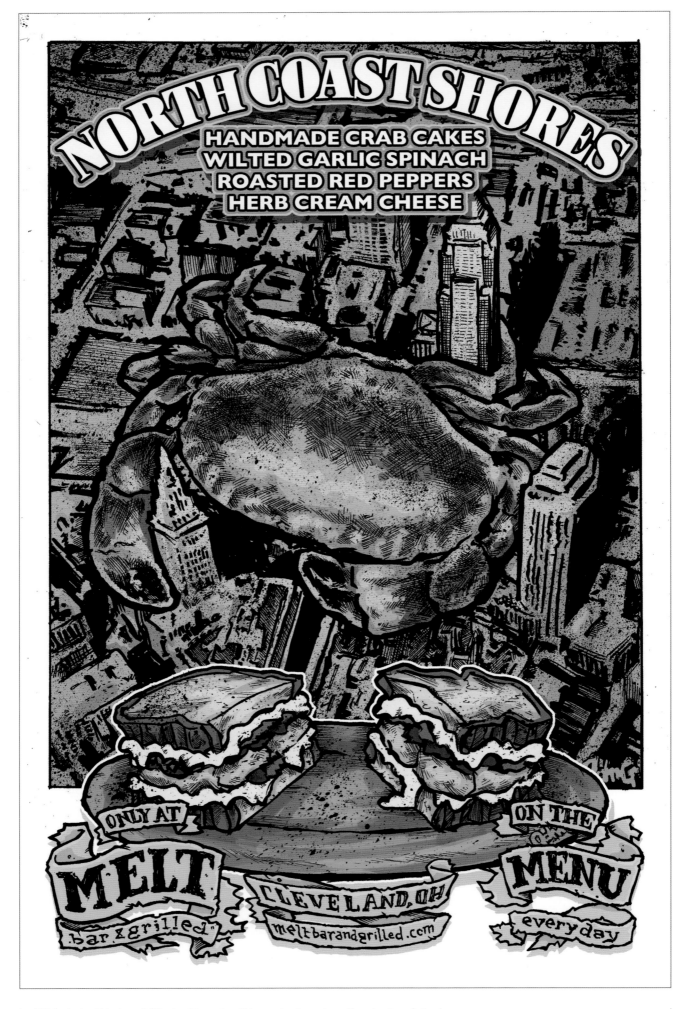

While Lake Erie is not filled with crabs, this poster imagines if a giant crab took over a Midwestern metropolis, Godzilla style. The cityscape was based on a top view of a 3D model of Cleveland.

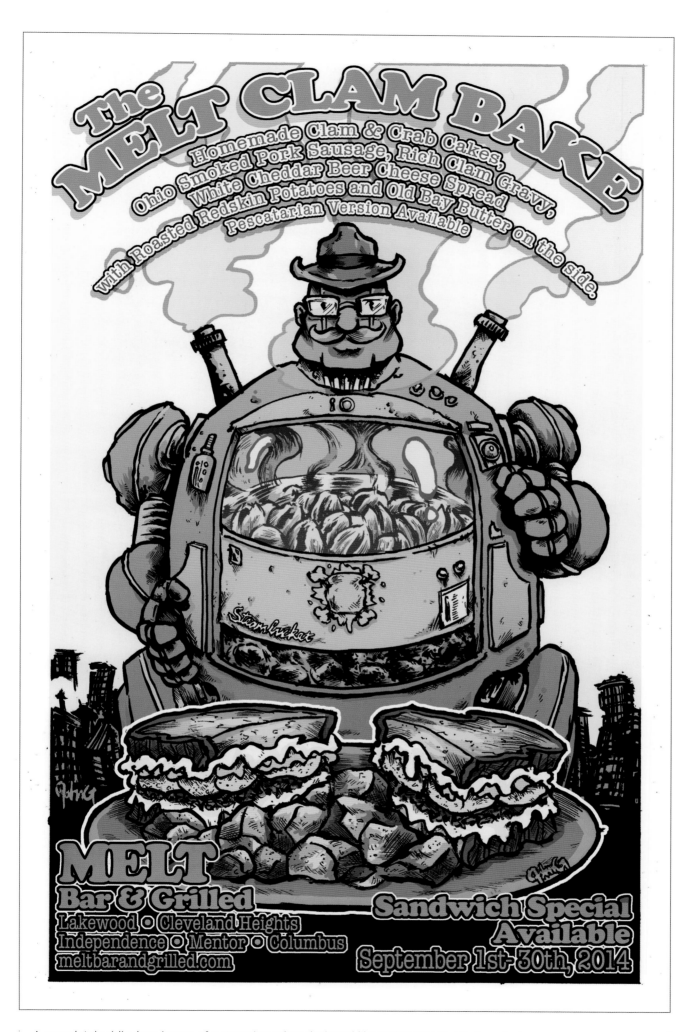

A completely ridiculous image of a steaming robot designed like Teddy Roosevelt. A perfect example of artistic freedom as well. It honestly doesn't make sense, but I loved how it looked.

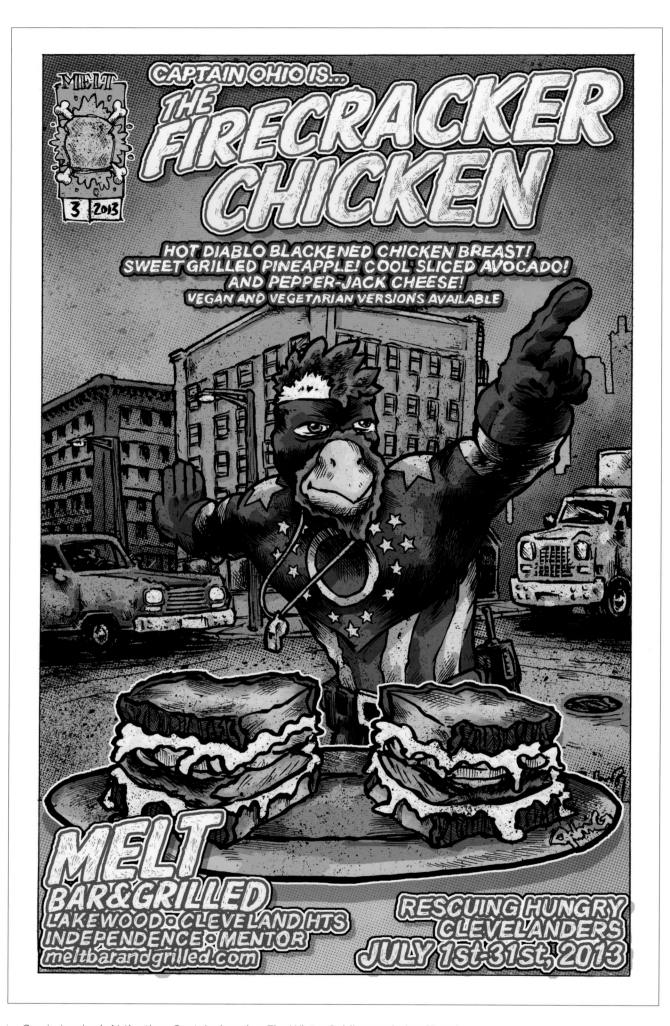

Comic-inspired. At the time *Captain America: The Winter Soldier* was being filmed in the city, and I wanted to convey how insane traffic was during the shoot.

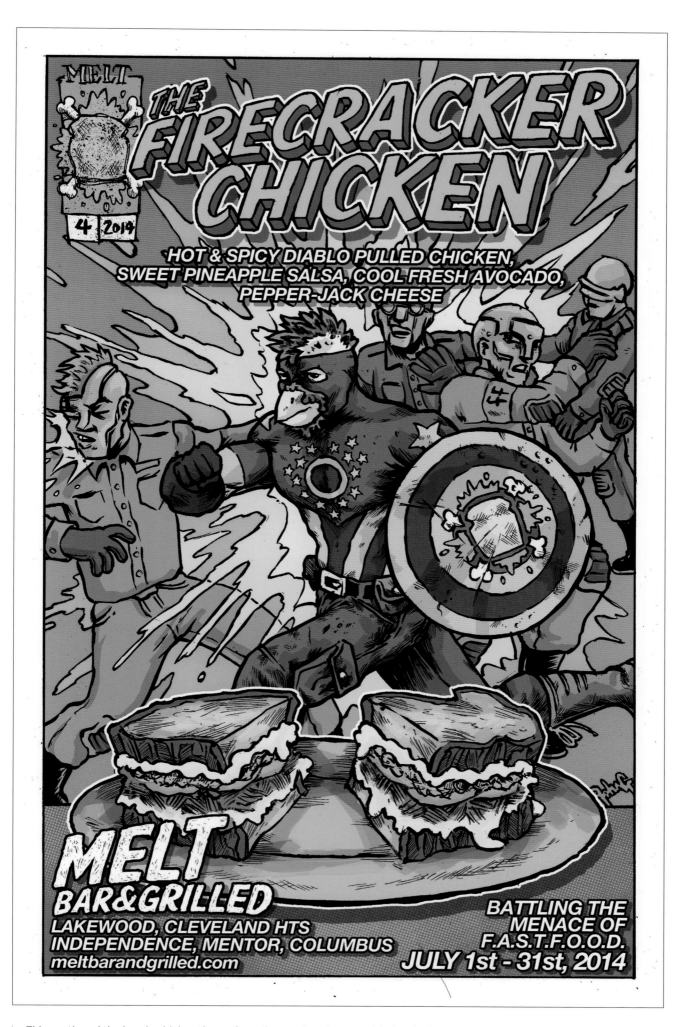

This continued the heroic chicken theme from the previous image, with the chicken taking on the fictional "menace of F.A.S.T. F.O.O.D." (notice the "FF" on one of the character's sleeve).

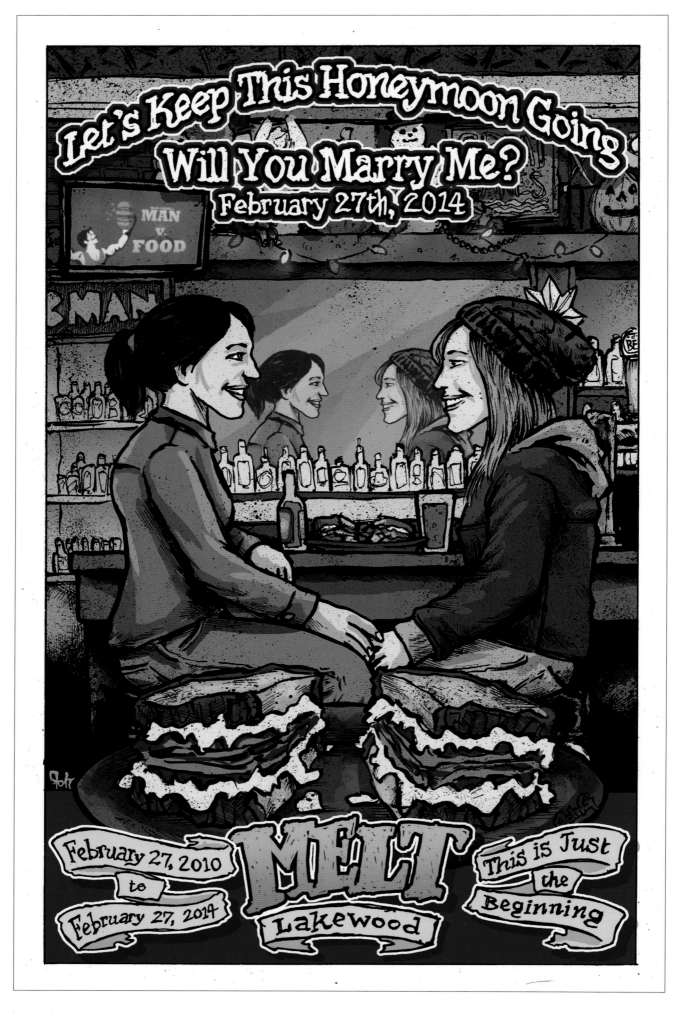

A private commission for a proposal party between two girls that were fans of Melt. Photobomb by the Travel Channel's *Man v. Food* on the television, on which Melt appeared at the time.

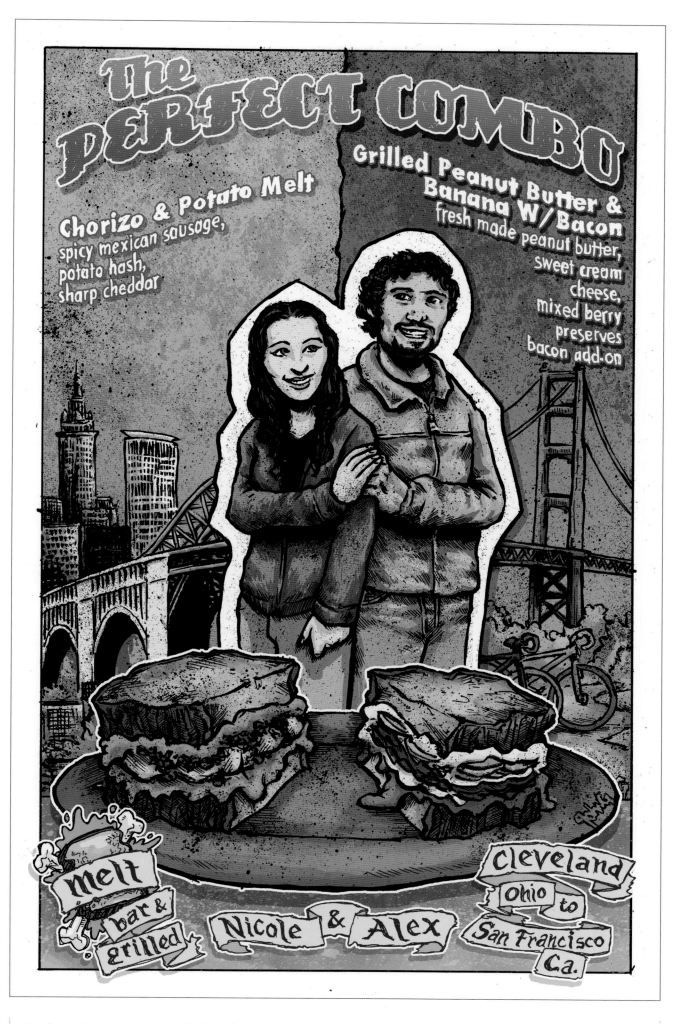

Another private party poster, this time for a couple that was moving to San Francisco.

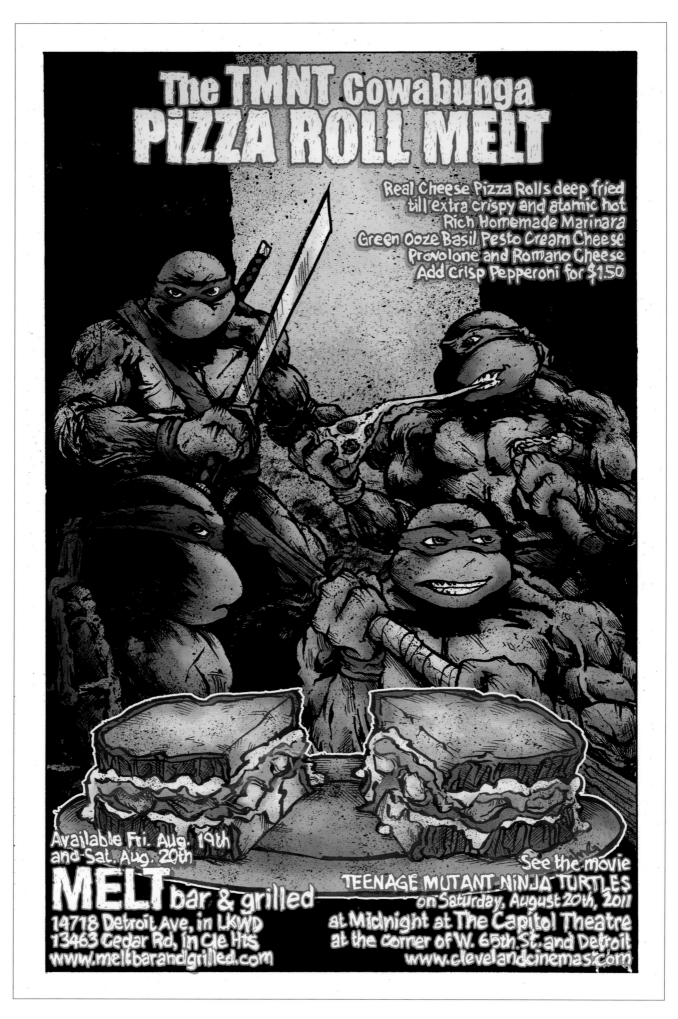

One of the few pizza sandwiches at Melt (following Ramones Pizzeria – see page 12). It's tough to draw the Ninja Turtles in your own style since they are so iconic. This special coincided with a screening of the original TMNT film that had lines out the door at the local Capitol Theatre.

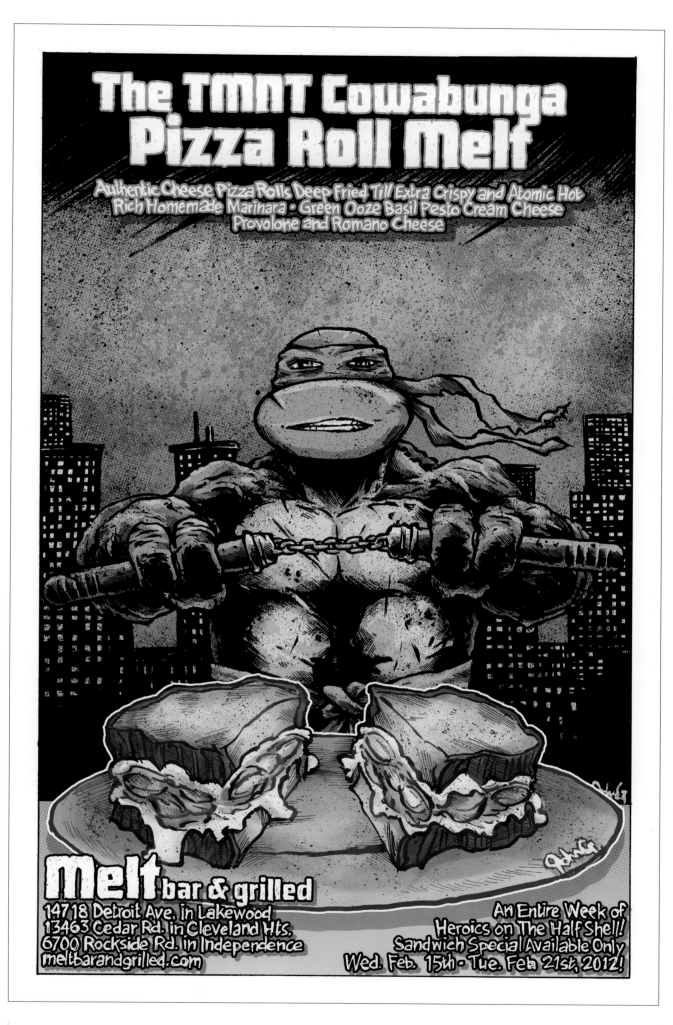

Michelangelo!

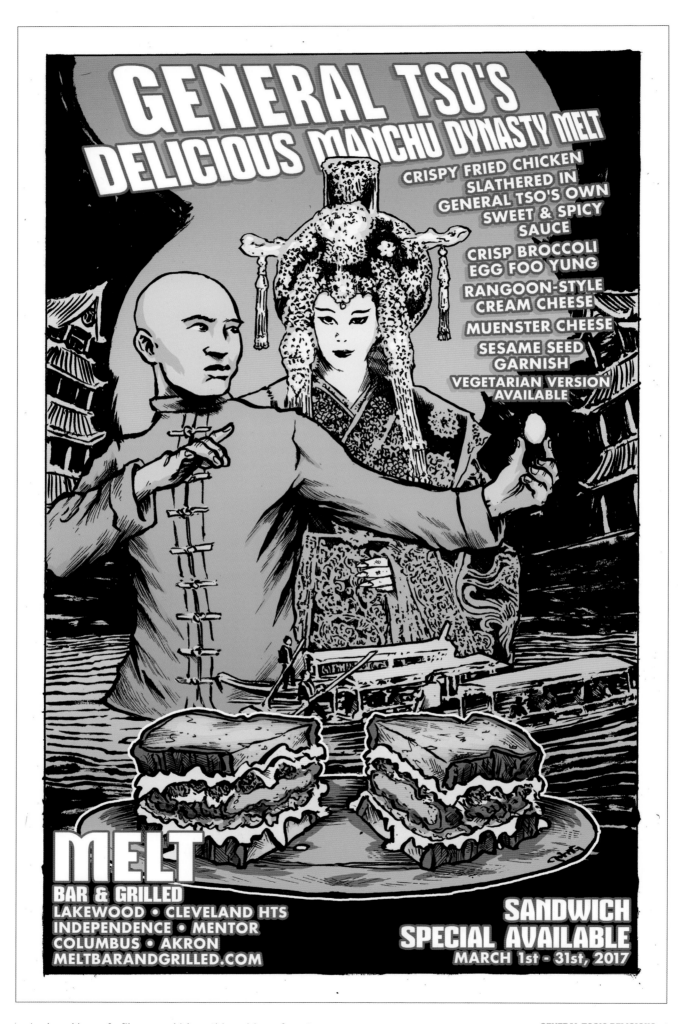

I adored kung fu films as a kid, so this pairing of posters was a treat to sketch, with details based on the Manchu dynasty.

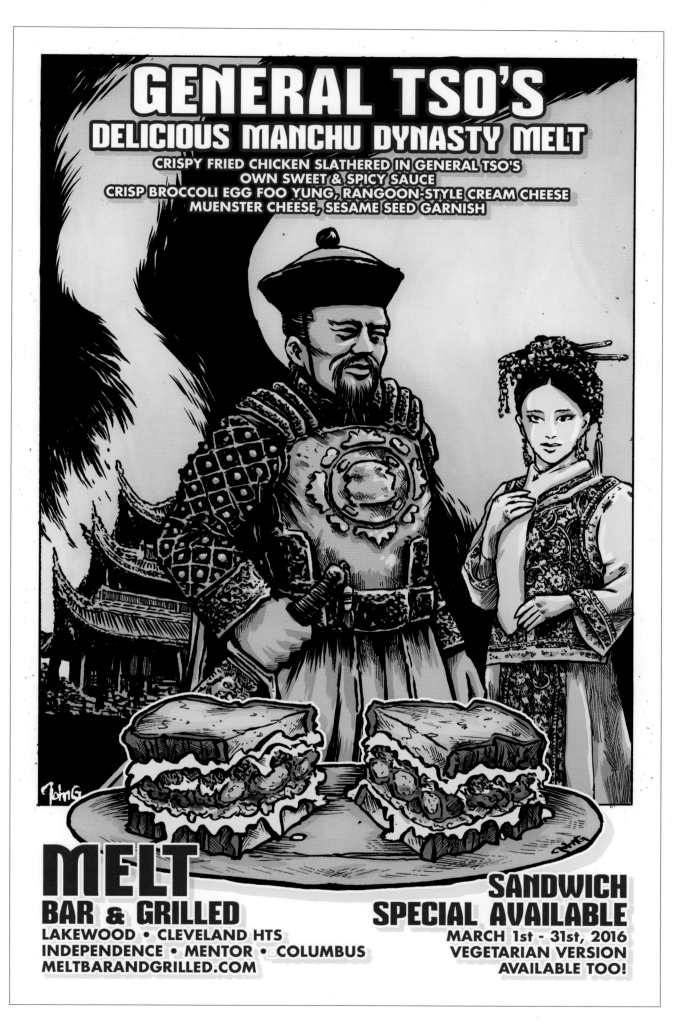

General Tso from the Qing dynasty, who also happens to be born on my birthday (November 10). Just 166 years older.

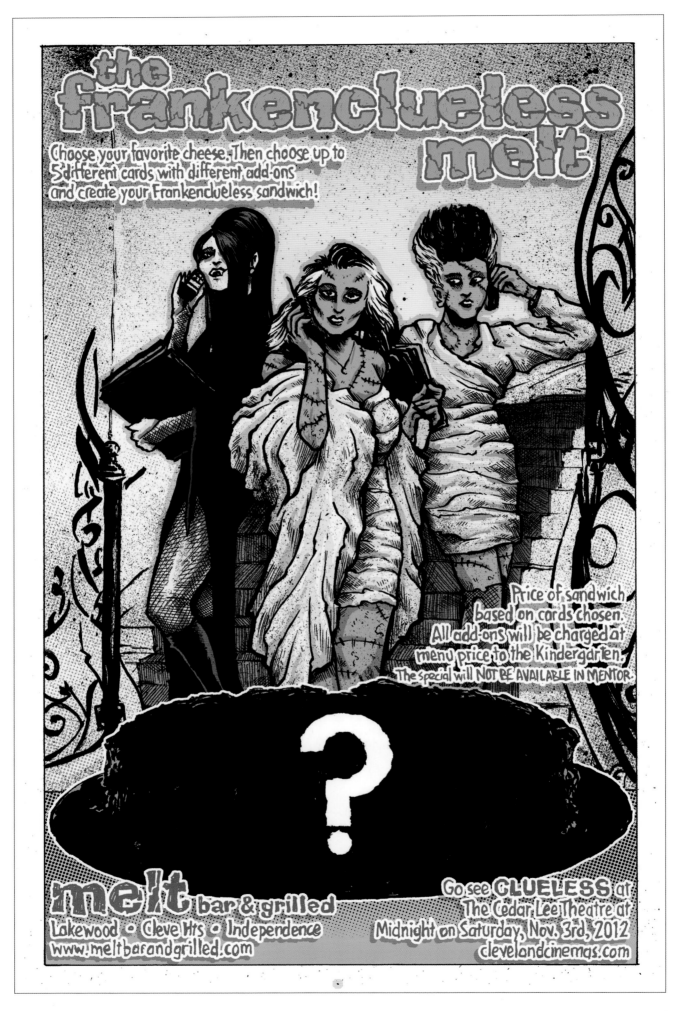

A parody poster of both *Frankenstein* and *Clueless* (with Alicia Silverstone). Patrons received a deck of cards with ingredients and built a sandwich based on random cards chosen.

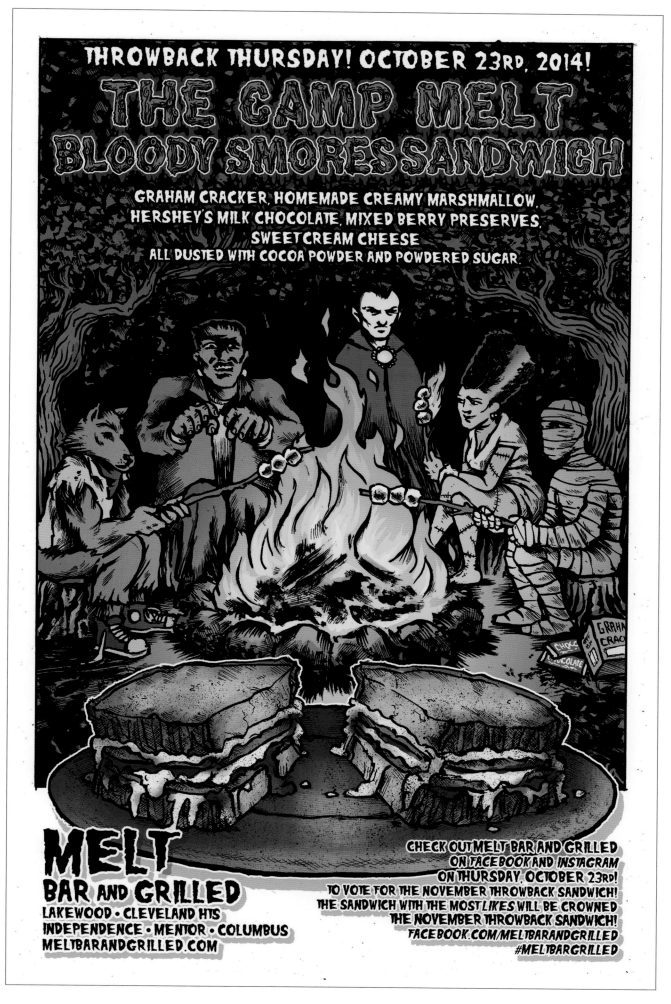

My take on Universal Monsters, replete with a *Sleepaway Camp*-esque font (see page 87). One of Melt's few sweet sandwich specials.

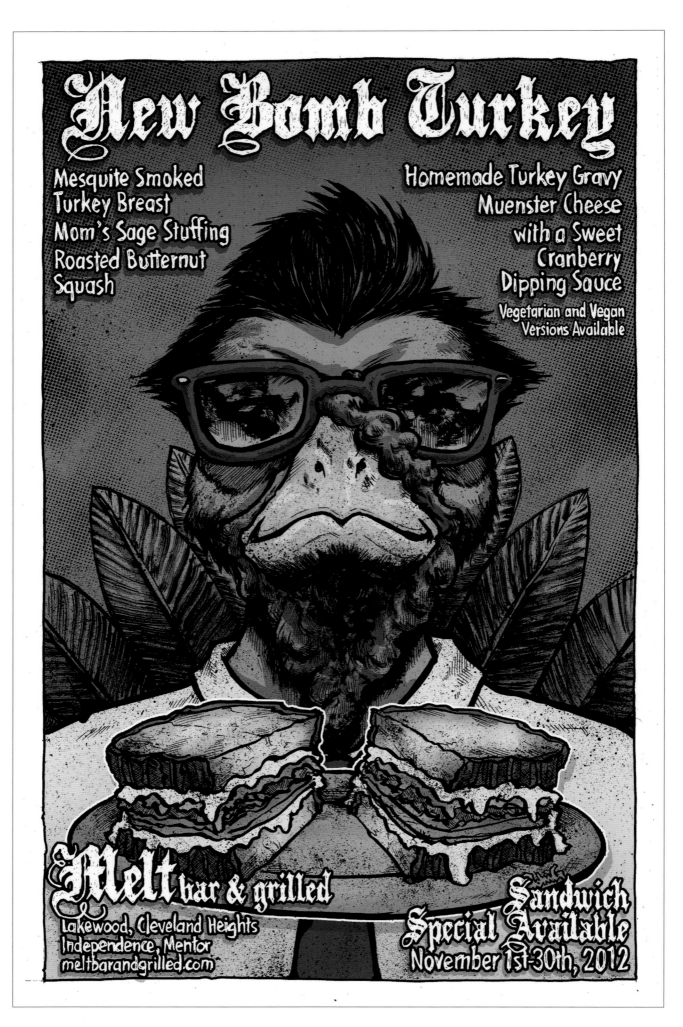

Based on lead singer Eric Davidson from one of my favorite
punk rock bands, New Bomb Turks. Check them out.

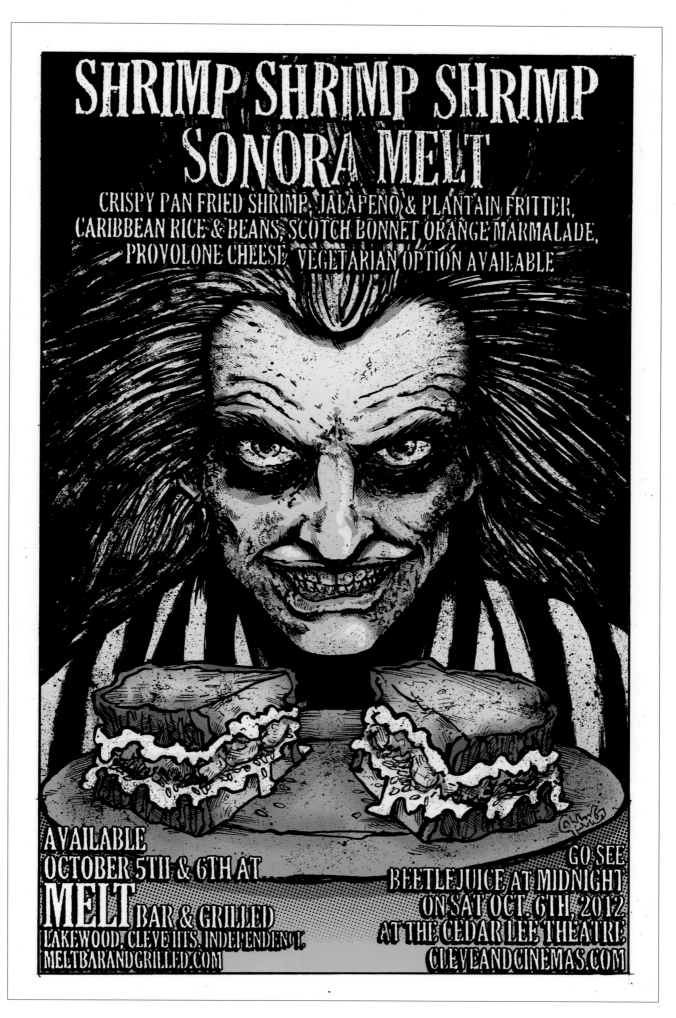

My sinister take on *Beetlejuice*, referencing the scene where giant shrimp grab the faces of the dinner guests, coupled with the film's final song "Jump in the Line (Shake, Shake, Shake Señora)." Nobody noticed this, but the lettering here was distressed using a photocopier.

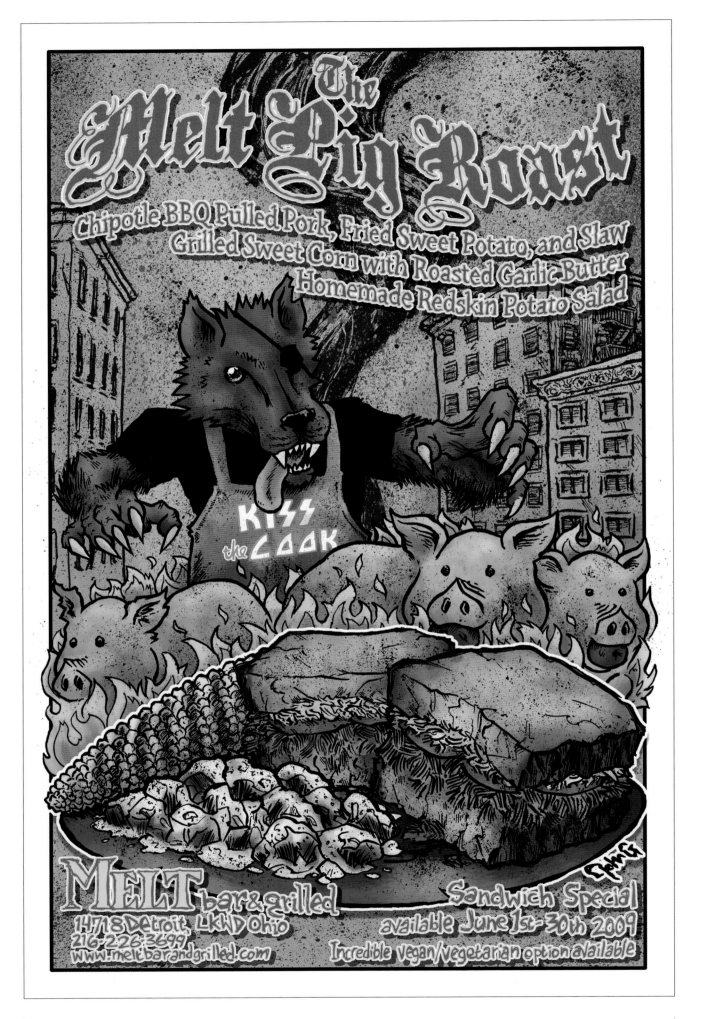

The Werewolf vs. The Three Little Pigs, and including yet another KISS reference.

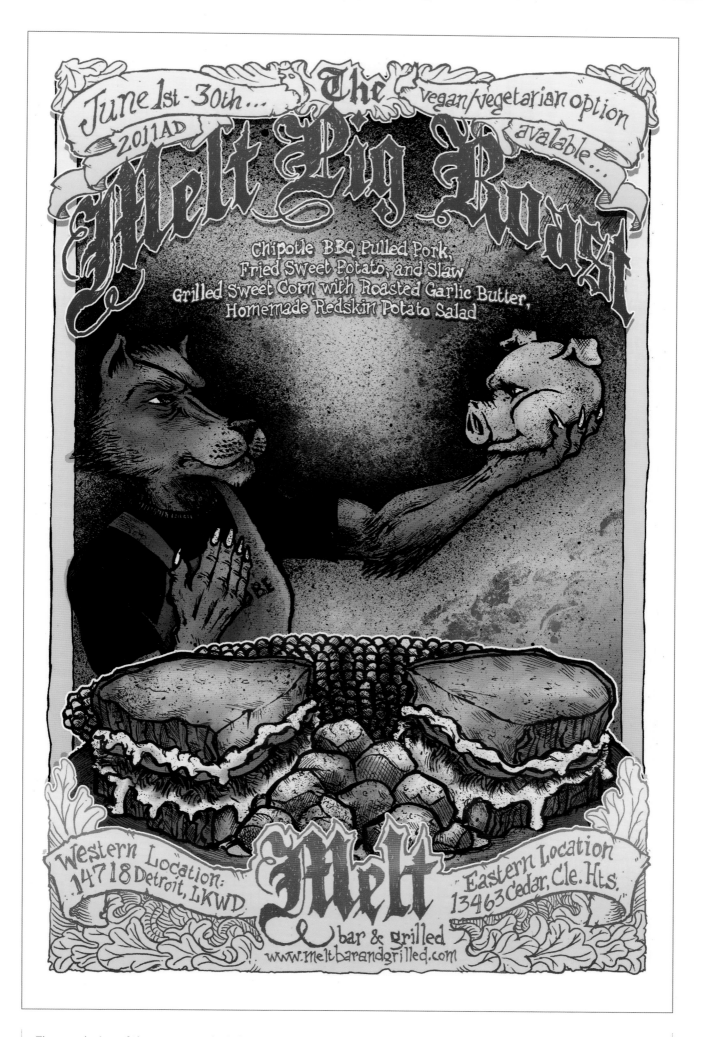

The conclusion of the poster on the left, with a highbrow reference to *Hamlet* ("ham-let").

THE MELT PIG ROAST

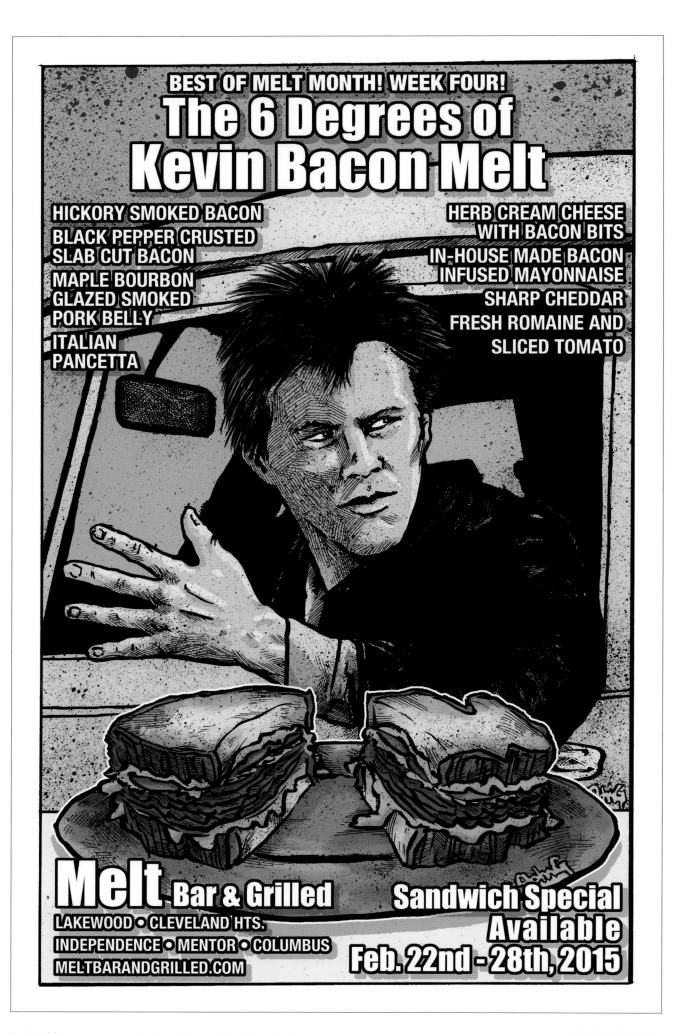

Working great as a pair, here Bacon is looking back
(a la *Footloose*) at fellow 1984 superstar Eddie Murphy.

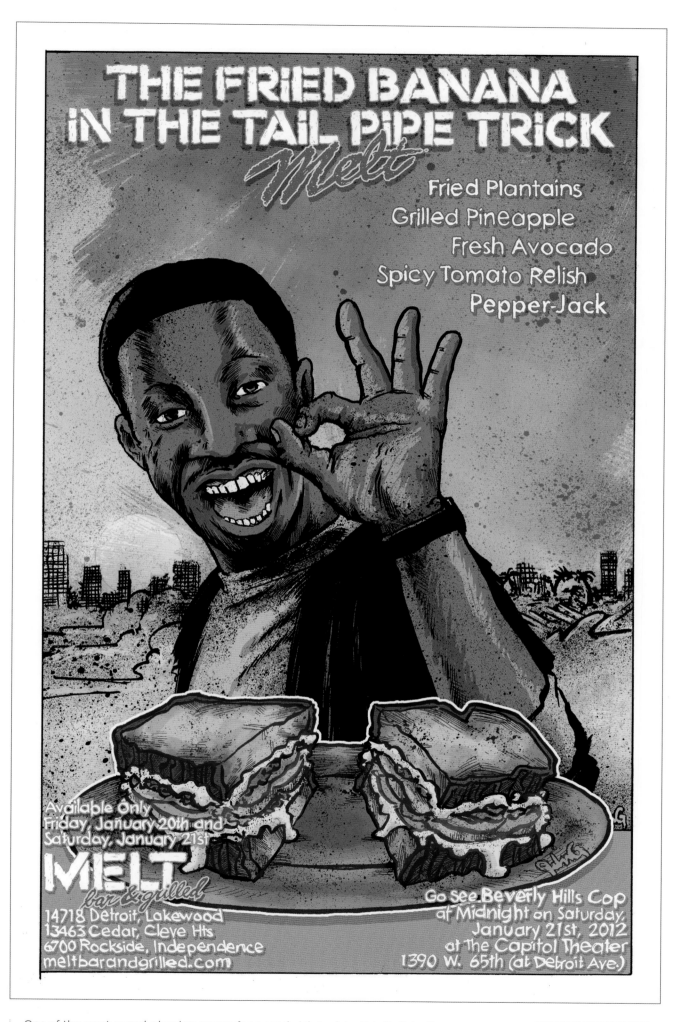

One of the most crowd-pleasing names for a sandwich to date, this "tailpipe" poster features an iconic image of Eddie Murphy from *Beverly Hills Cop*.

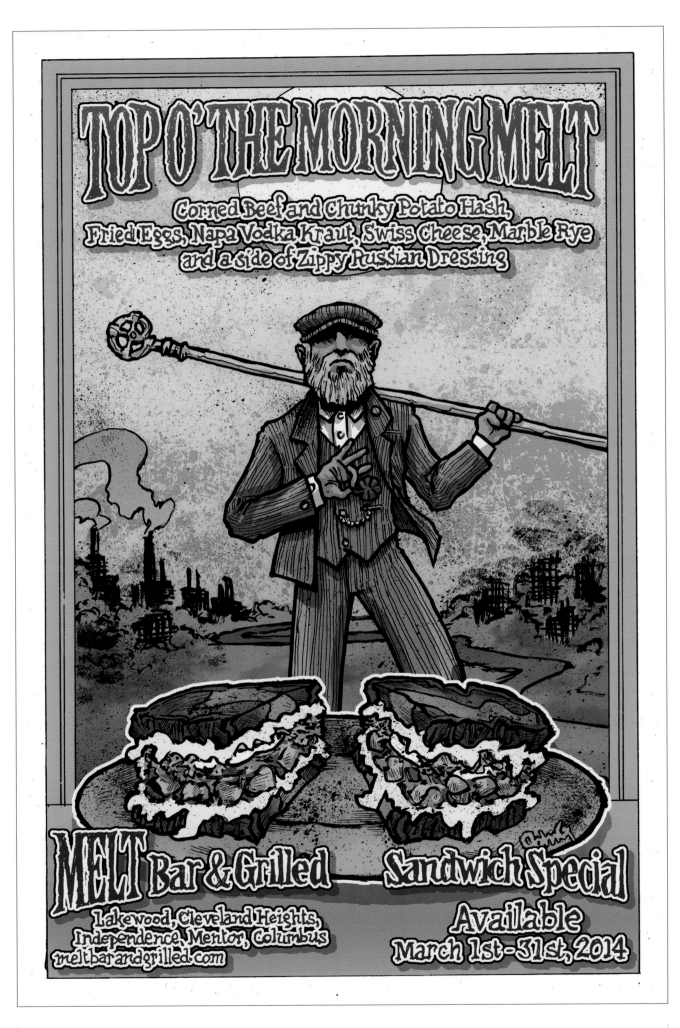

A hipster version of St Patrick holding a shamrock, with a Midwestern cityscape background.

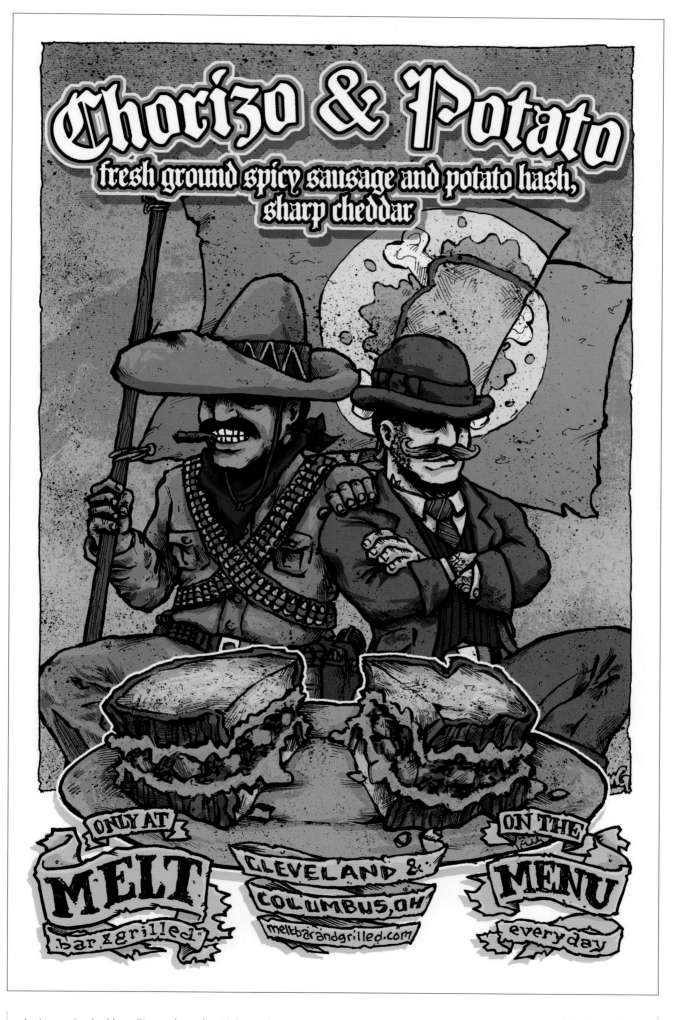

Just your typical bandito and macho Irishman hanging out.

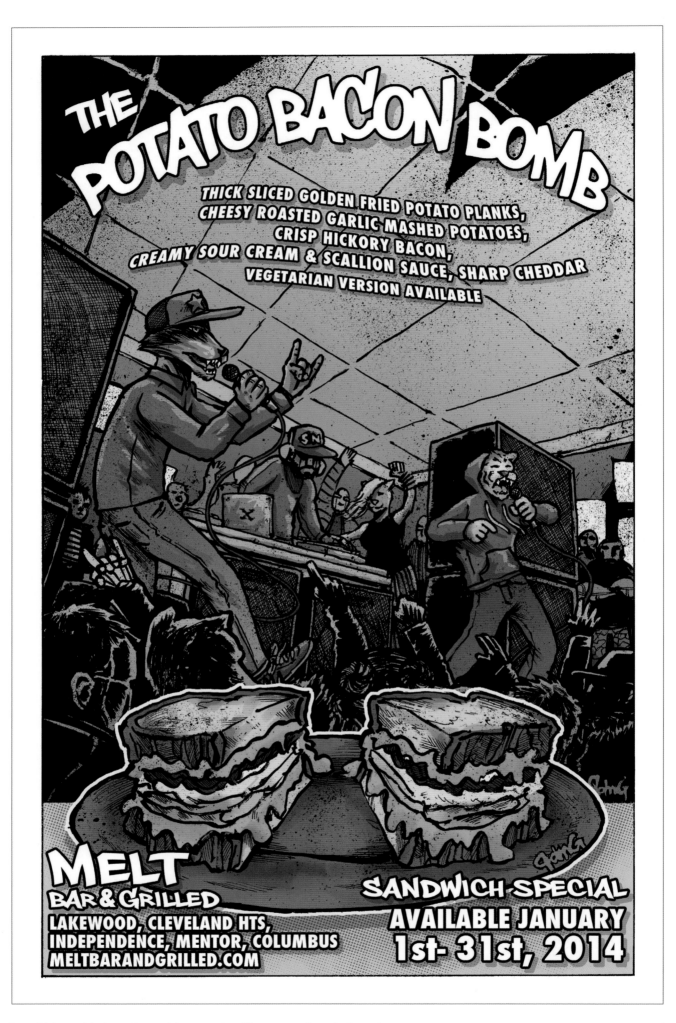

A kick-ass hip-hop show with a couple of beasts on the mic, based on the indie rap supergroup Smoke Noises (Smoke Screen + Ghost Noises).

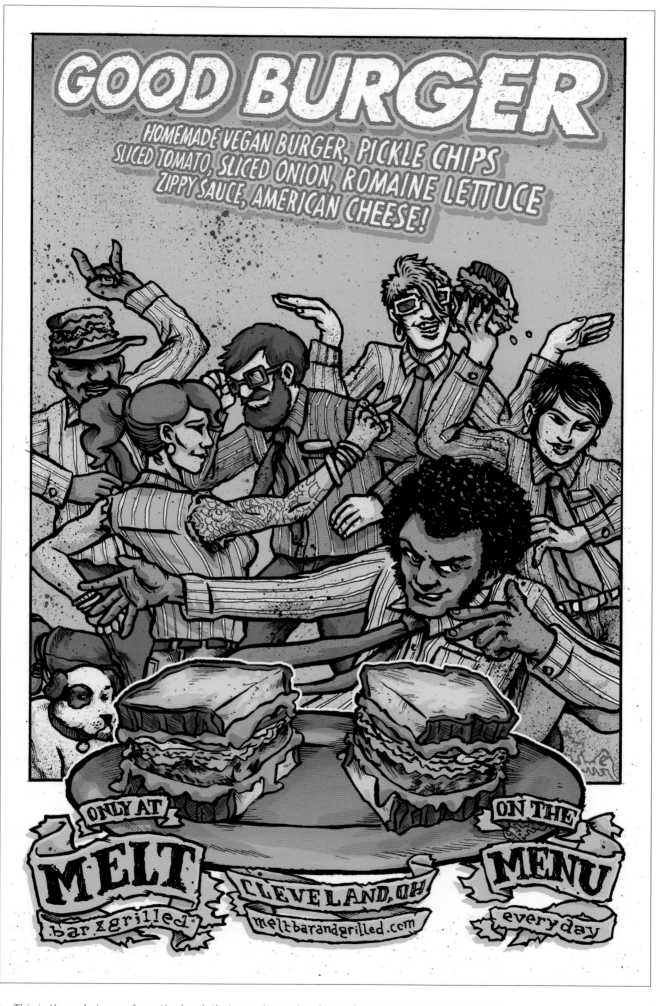

This is the only image from the book that wasn't previously used as a poster. Also a guilty pleasure of a film. I liked the base artwork so much that I wanted to finish the piece for *Sandwich Anarchy*.

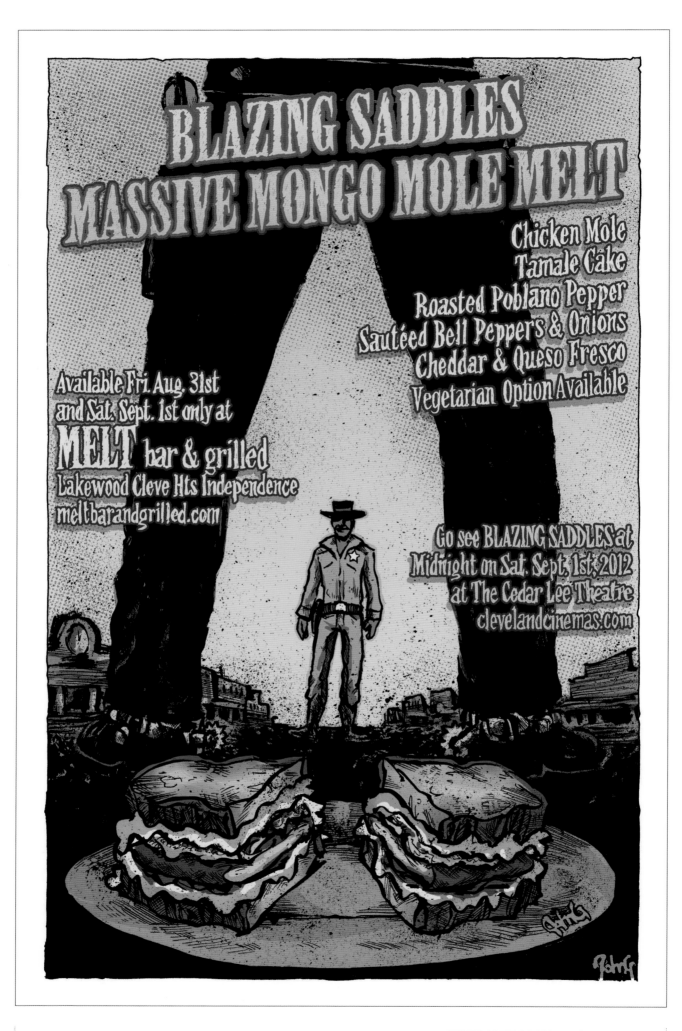

Mel Brook's *Blazing Saddles* meets Fred Zinnemann's *High Noon*.

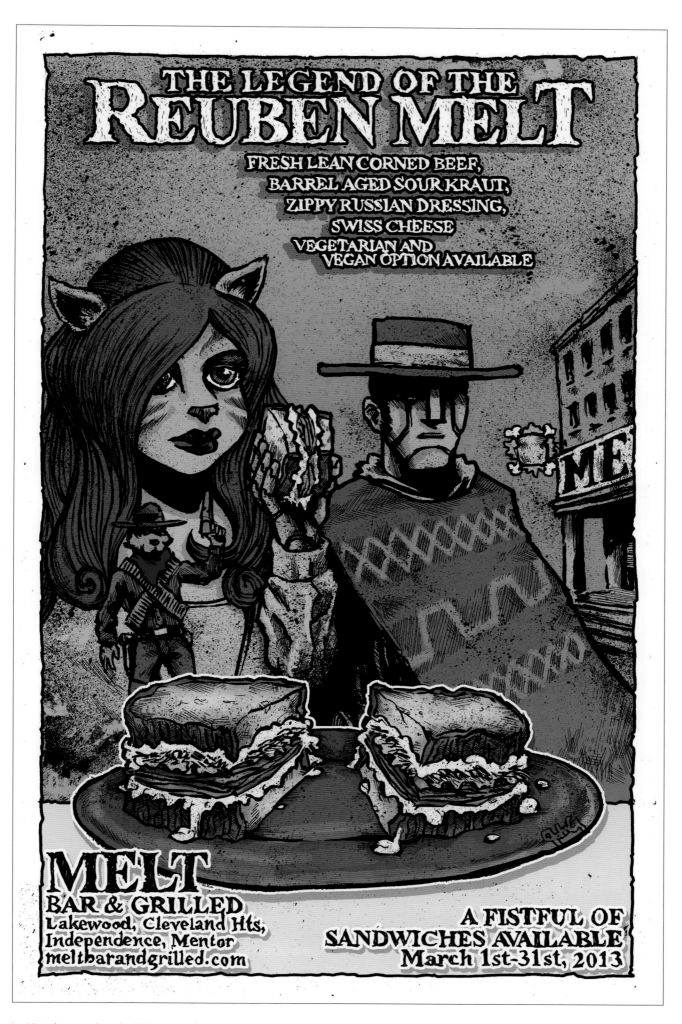

My take on a Spaghetti Western, featuring a cat girl and a robot (naturally).
The artwork has absolutely nothing to do with a Reuben Melt.

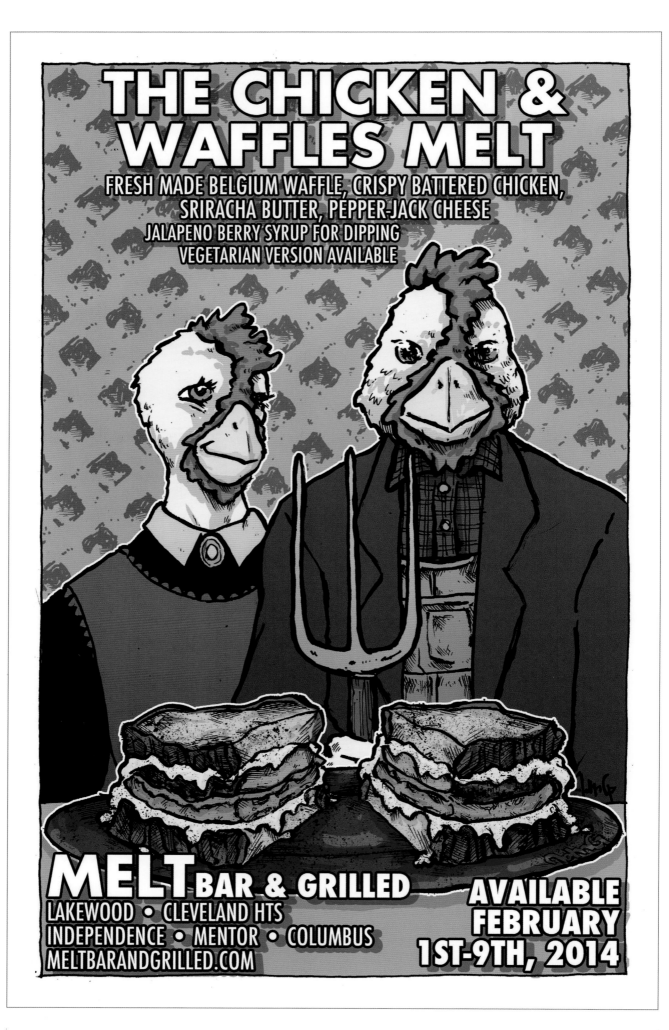

A chicken version of iconic painting *American Gothic* by Grant Wood (1930).

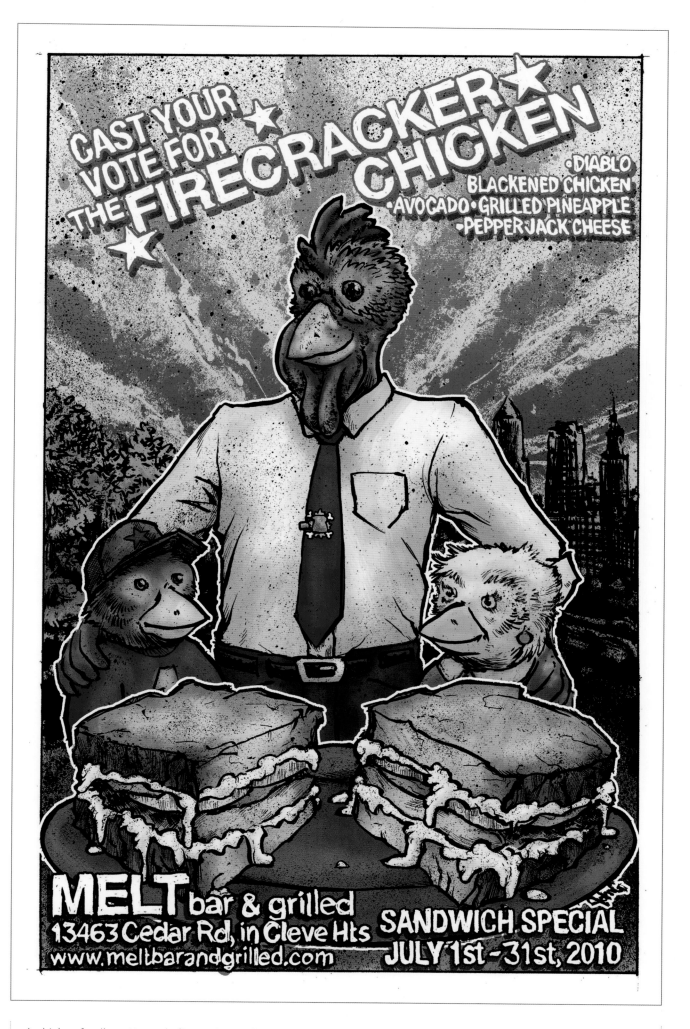

A chicken family patterned after a photo of President Barack Obama.

THE FIRECRACKER CHICKEN

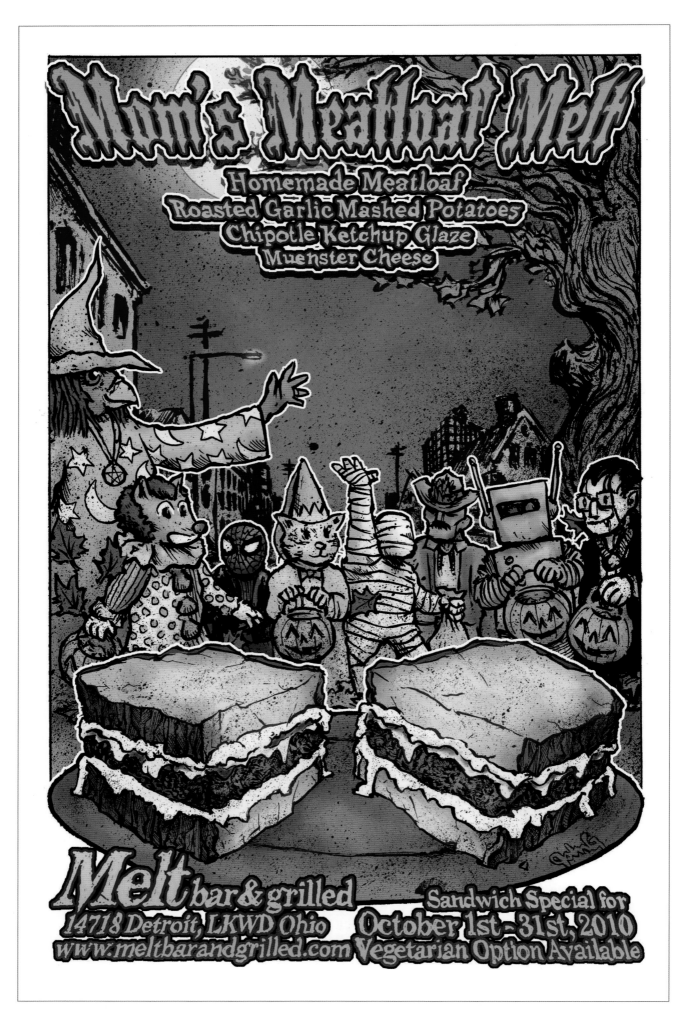

This two-part poster series also features "kid versions" of characters from other posters, including Parmageddon (page 18) and East Side Invasion (page 106).

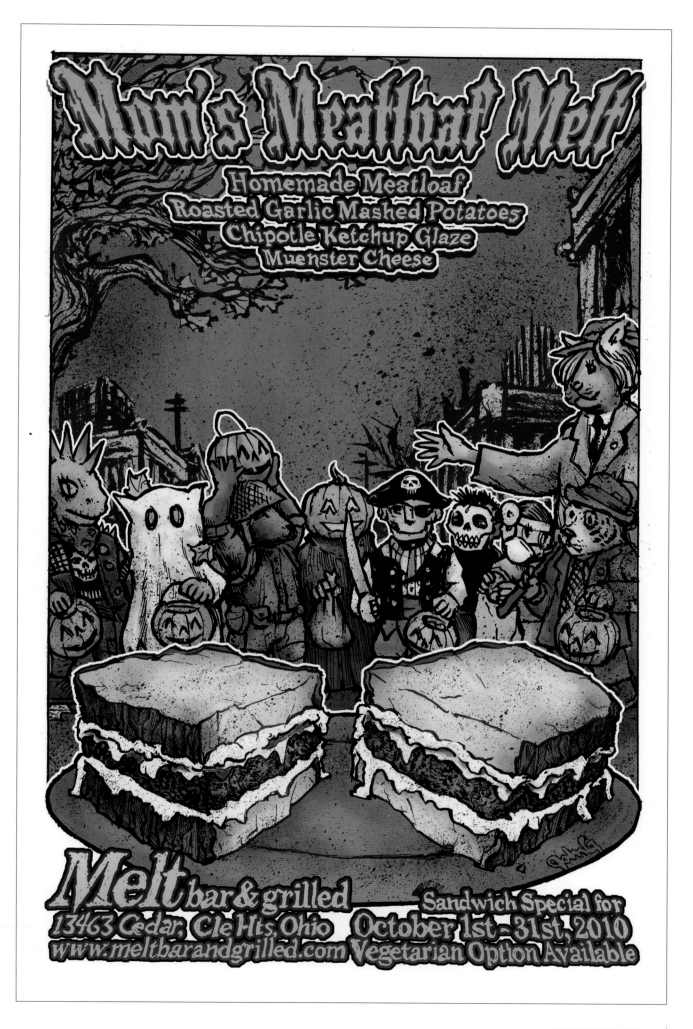

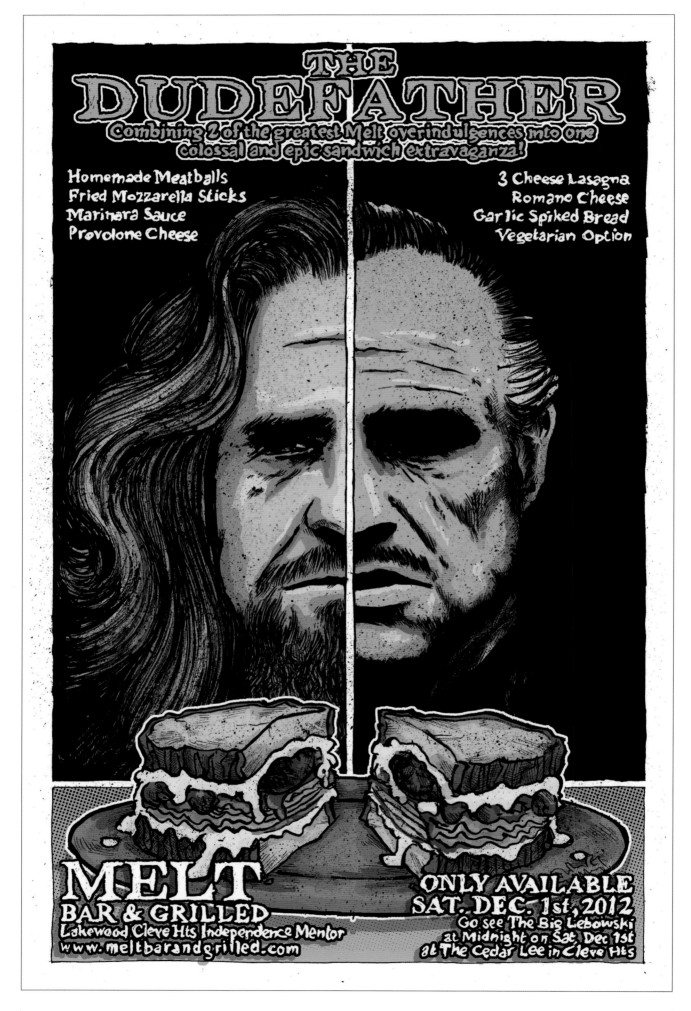

Two sandwiches in one, with a poster to match. ½ The Dude Abides + ½ The Godfather.

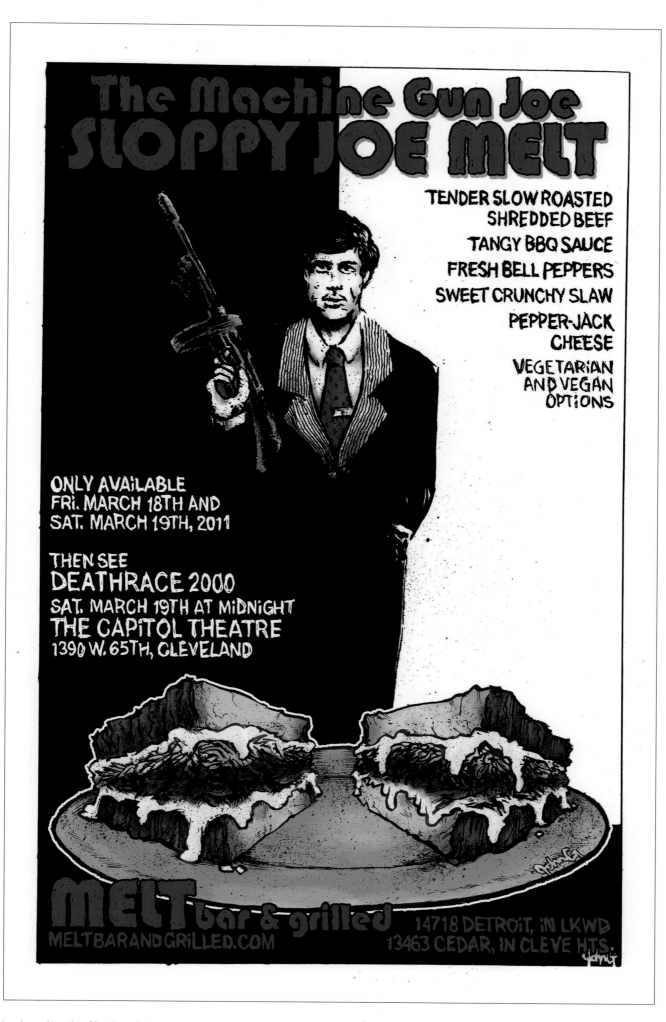

A nod to the film *Death Race 2000* (the '75 Roger Corman classic with Sylvester Stallone) mashed with the black/white poster style of *Scarface*.

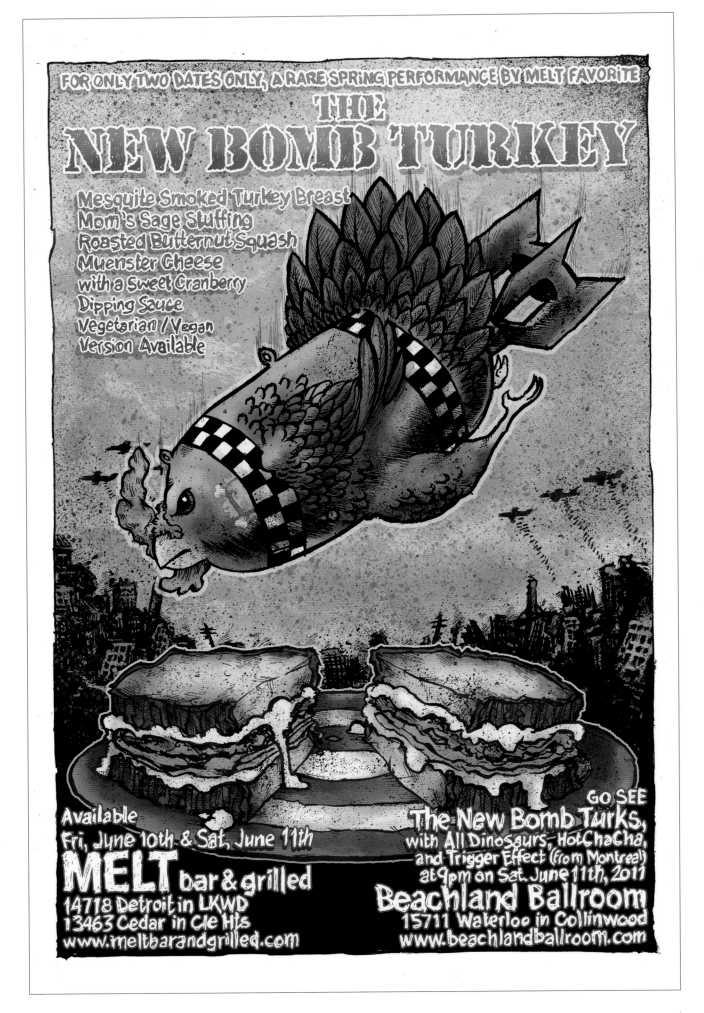

It's back again! This time designed as a World War II-era bomb.

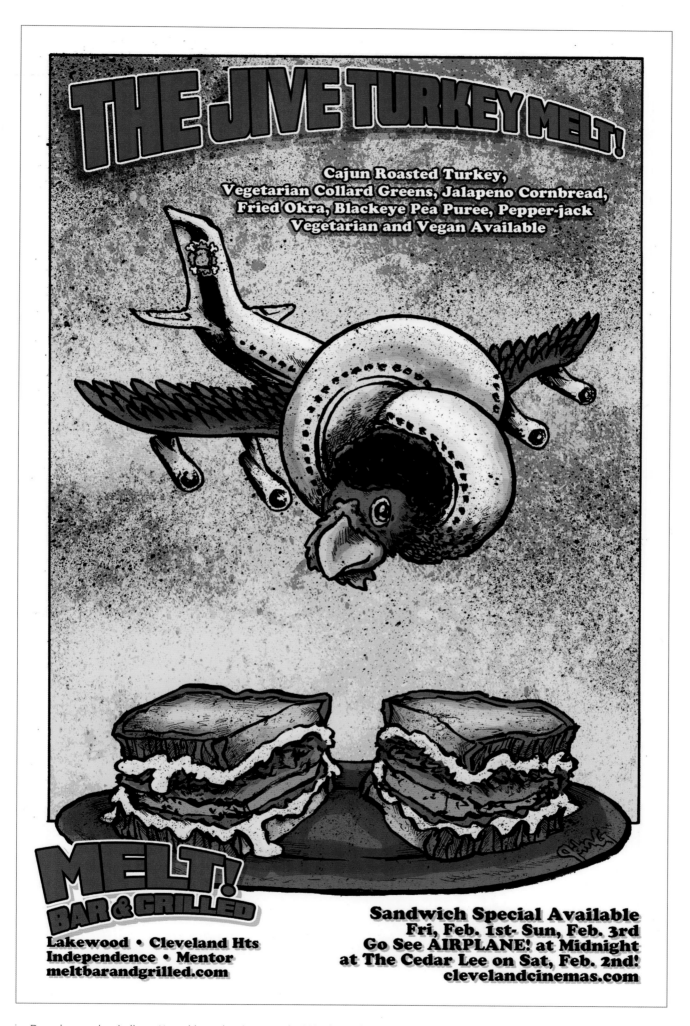

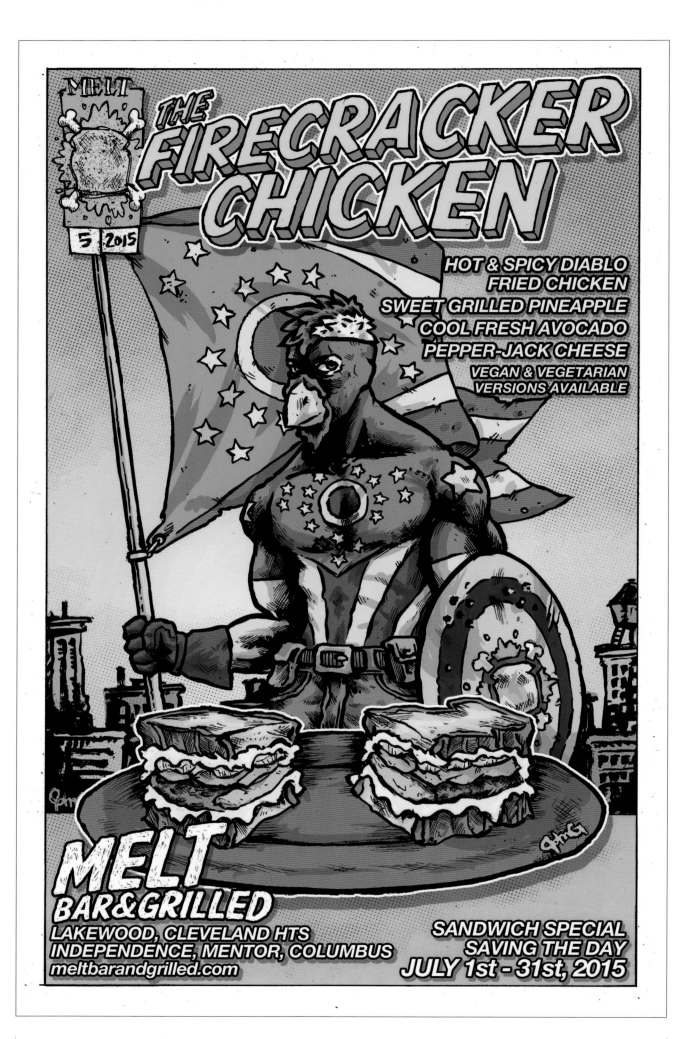

The Firecracker Chicken character reborn as Captain Ohio (sporting an Ohio flag).

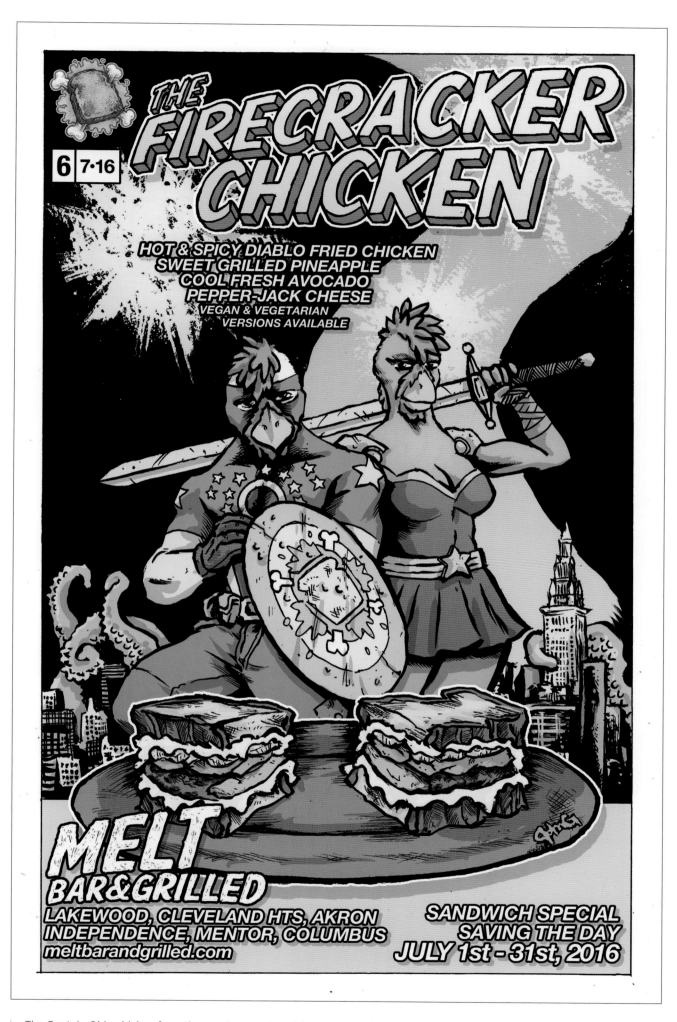

The Captain Ohio chicken from the previous poster with a new Wonder Woman-inspired sidekick. Note the octopus attacking the cityscape.

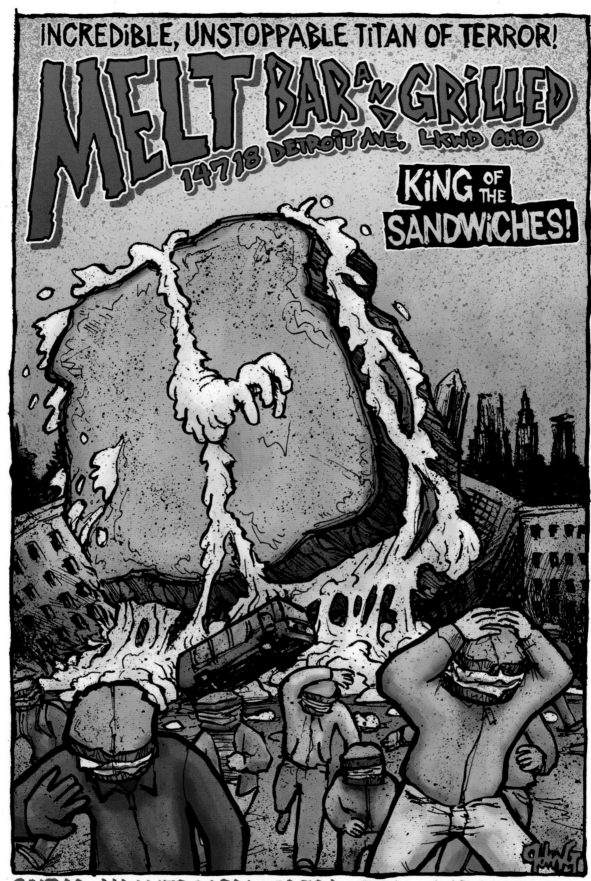

A Godzilla-themed poster, where fleeing patrons have cheese sandwich heads.

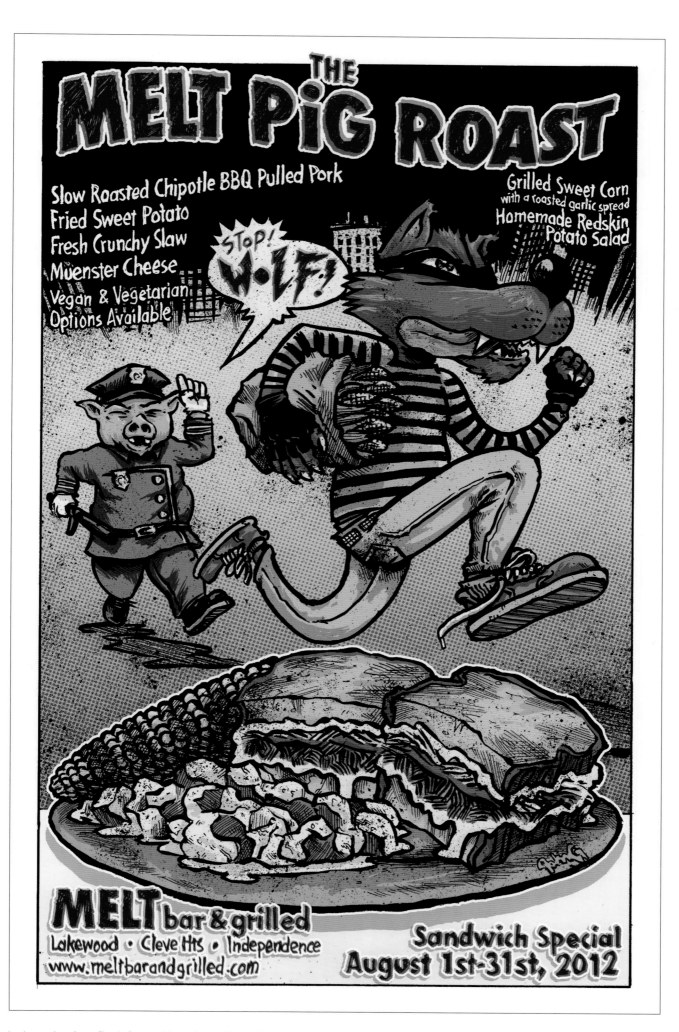

I received no flack for making the police officer in this poster a pig, which surprised me. This was my attempt at a *Looney Tunes*-style poster.

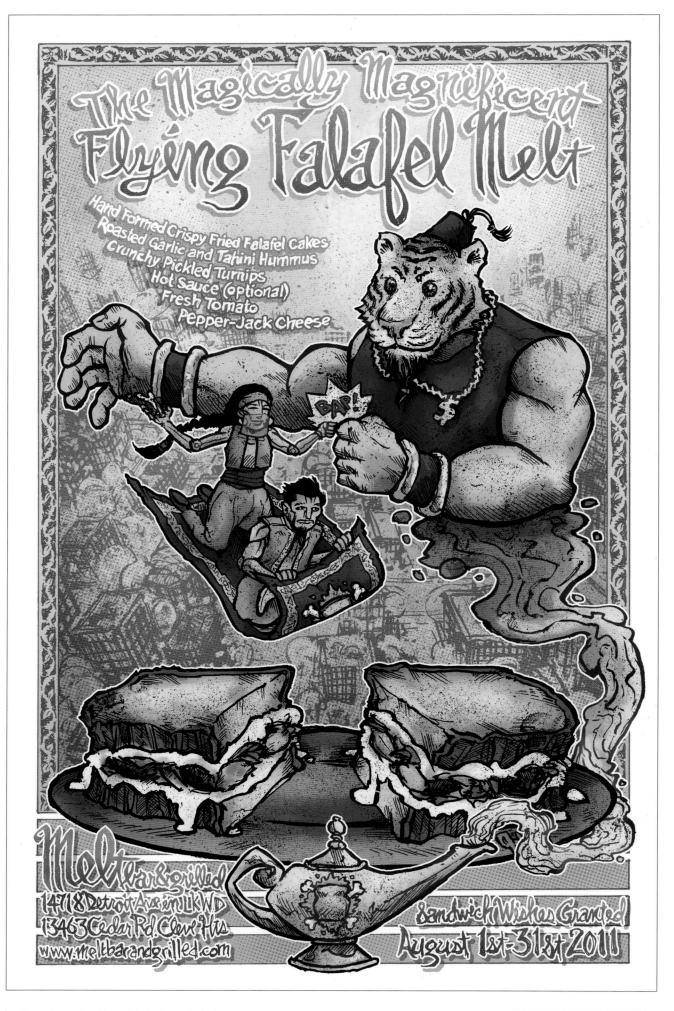

Based on the film *Thief of Baghdad* – the '40s film,
not the made-for-TV 1978 version with Roddy McDowell.

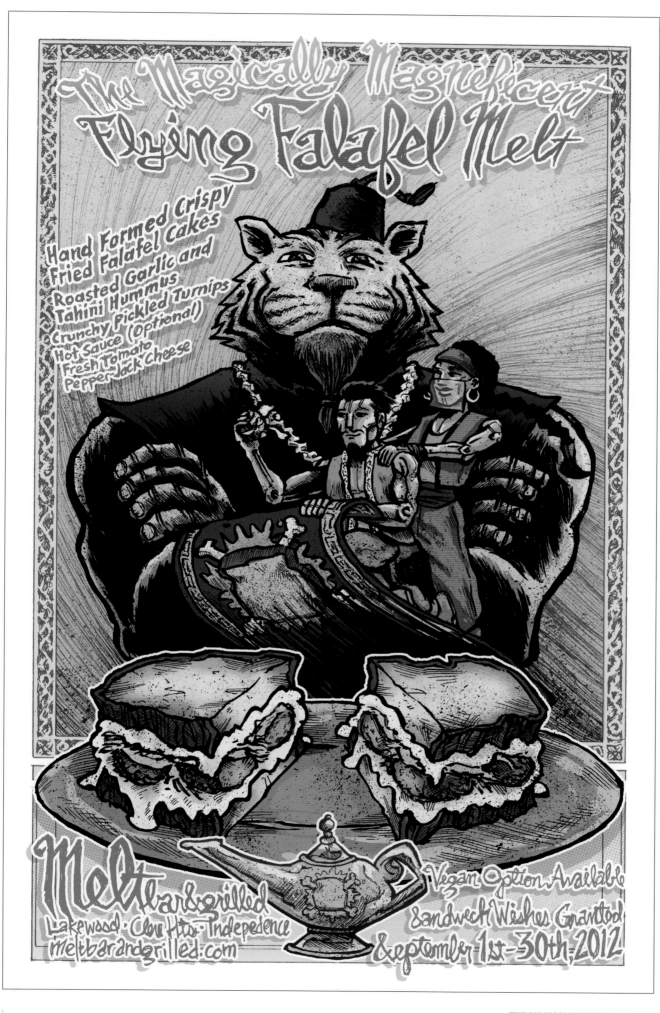

The giant blue tiger genie returns!

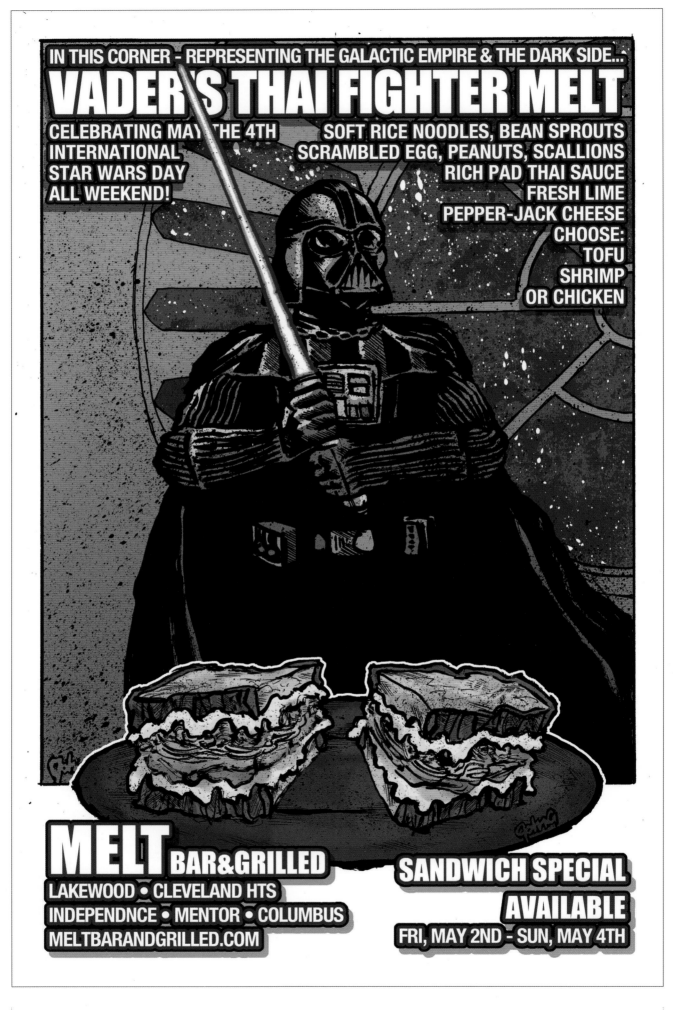

A *Star Wars* diptych that, when framed together, reveals the Death Star window.

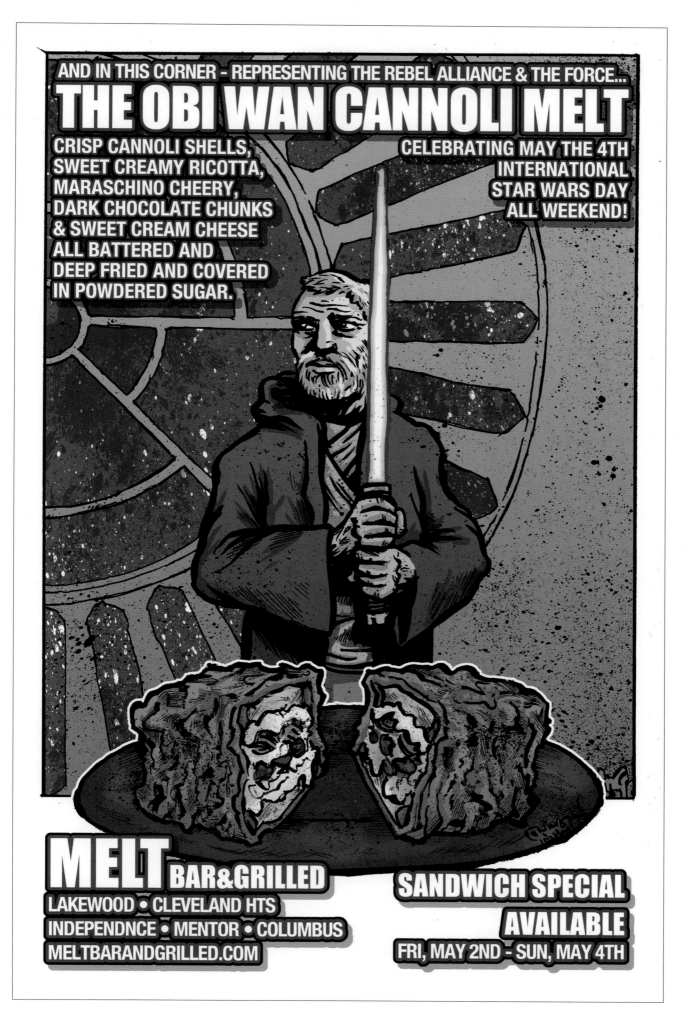

Both posters were also featured on "May the 4th" (Be With You). Arguably one of Melt's most clever sandwich titles as well (although..."The Tight Trousered Travolta").

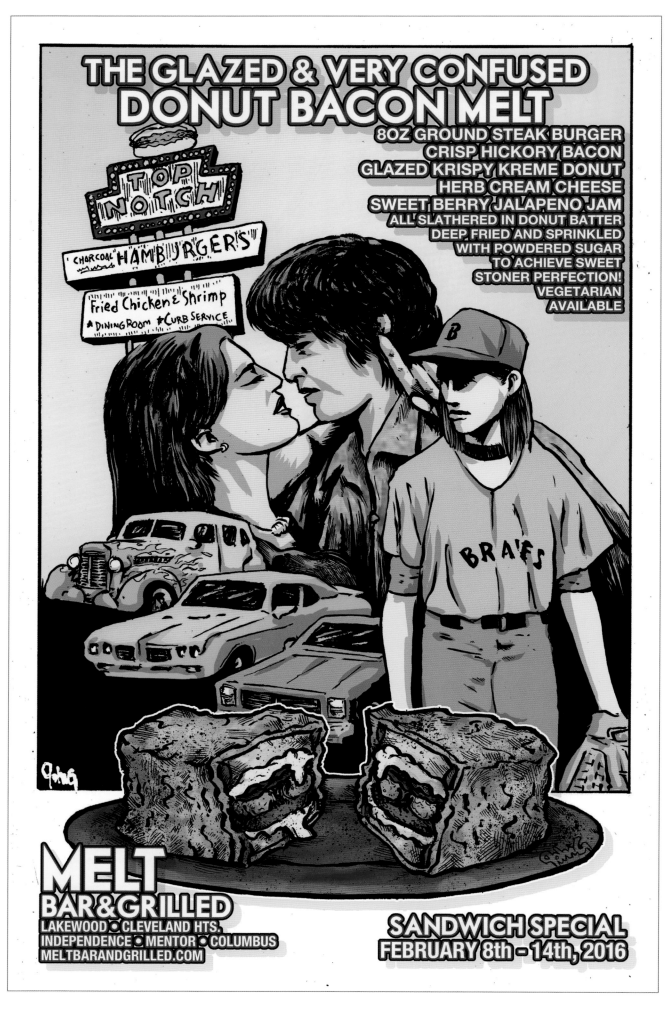

This *Dazed & Confused* print was wink at the *Empire Strikes Back* movie poster (which was a wink at the *Gone with the Wind* poster). A turducken of winks.

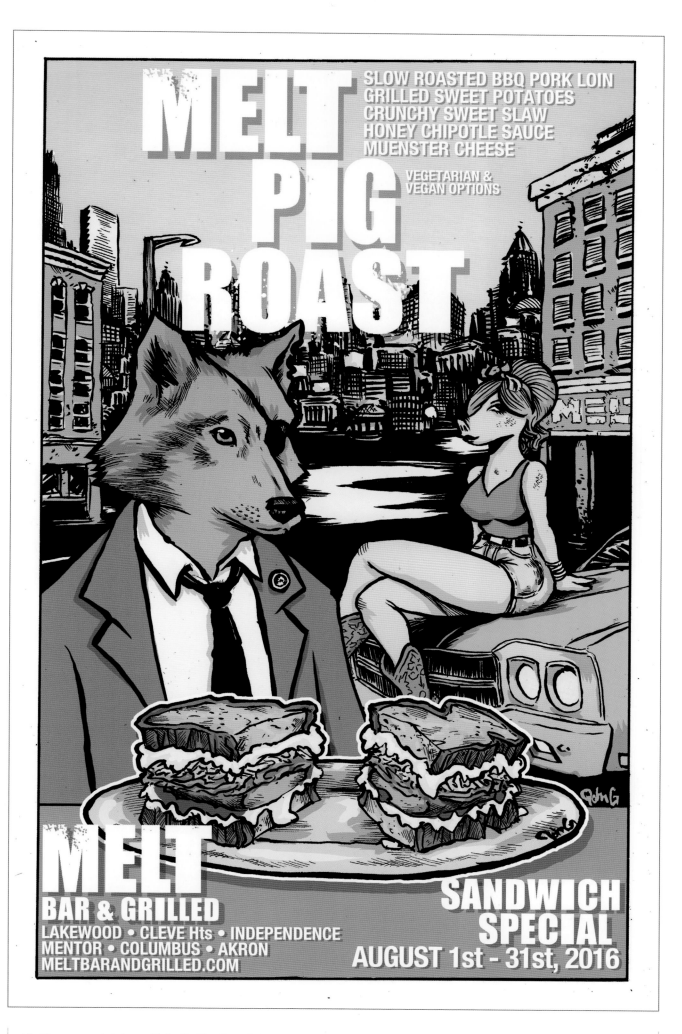

My film neo-noir take, with both *The French Connection* and *Mean Streets* in my cranium at the time. **MELT PIG ROAST**

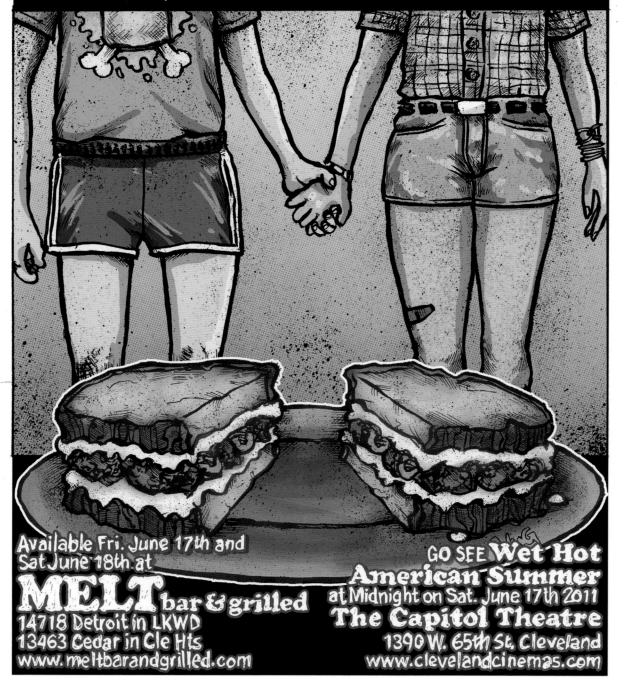

A tribute to the cult classic camp flick *Wet Hot American Summer*, directed by Clevelander David Wain and co-starring Clevelander Molly Shannon. "It's nice to go into town, even if it's only for an hour."

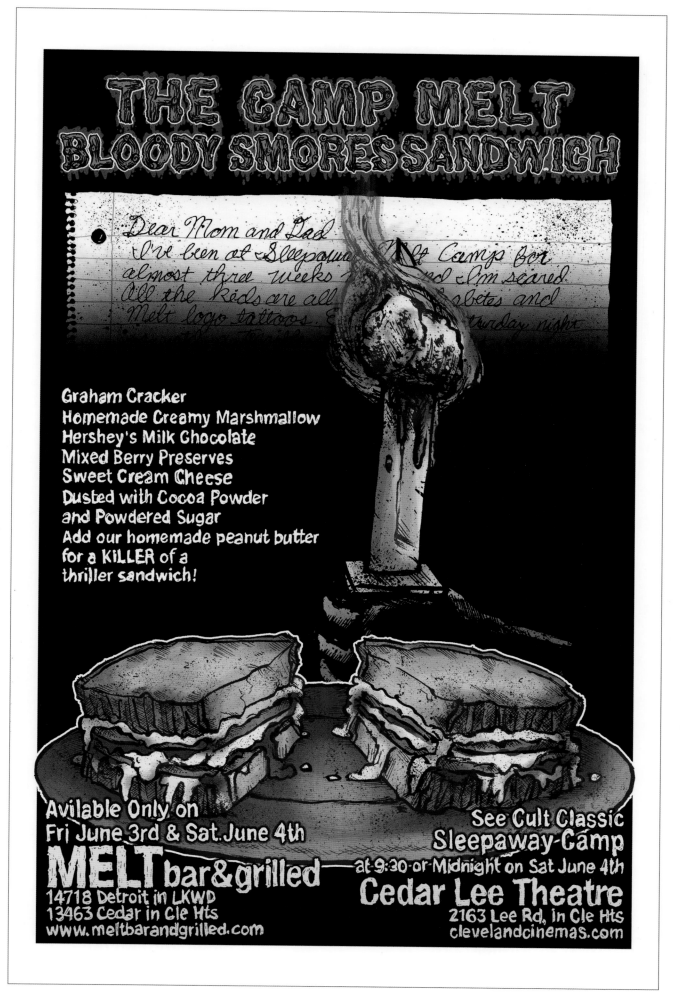

Gender-bending horror flick *Sleepaway Camp* is a favorite of Cleveland Cinemas' Marketing Director (and Late Shift film programmer) David Huffman. The note in the background starts talking about Melt four lines in.

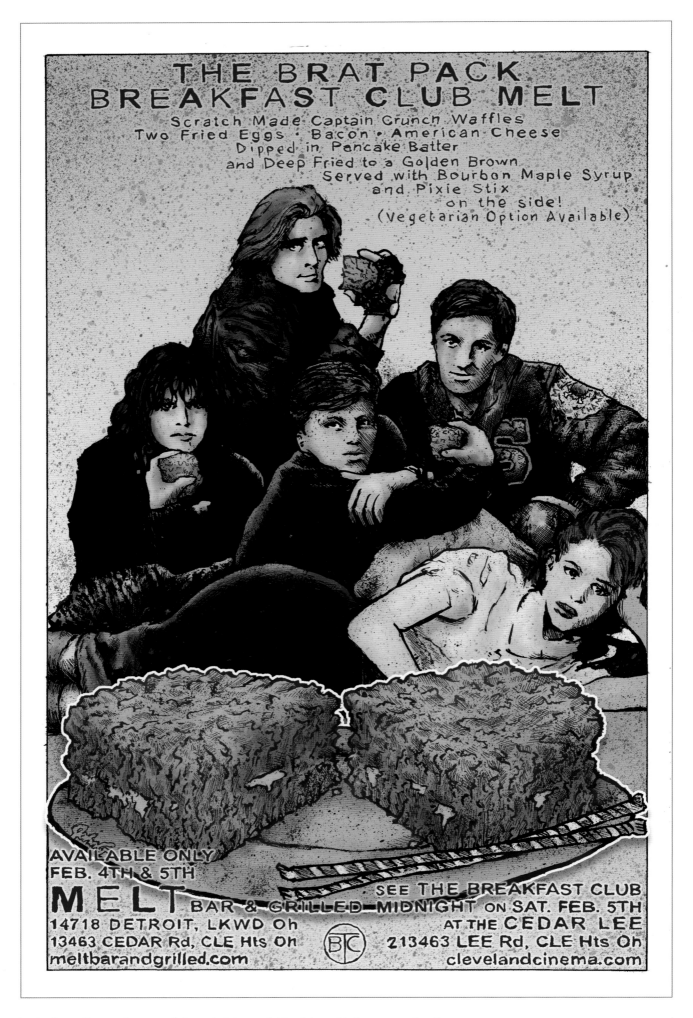

Perhaps the most successful sandwich special to date, with lines wrapping the block (in winter!). Patrons received Pixy Stix to create the Ally Sheedy crunch effect. Also note the Melt logo on Emilio Estevez's sleeve.

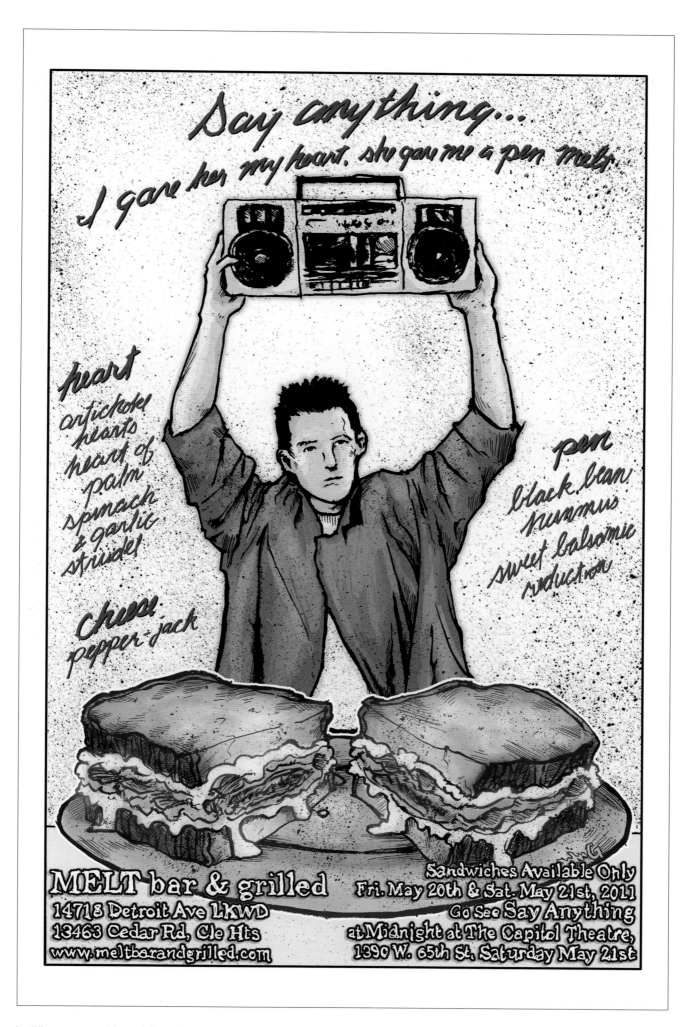

Filmgoers could participate in a challenge to "hold a boom box the longest" above their head to win a prize.

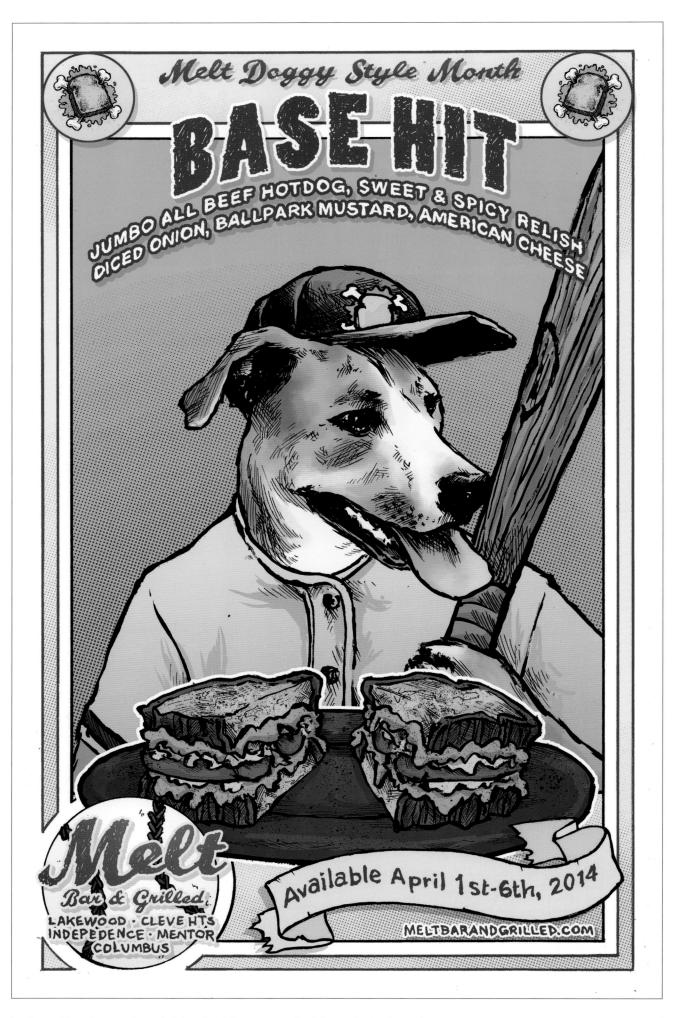

One of four featured sandwiches in Melt's "Doggy Style" month. Each week's poster was an homage to retro baseball cards, and all of them featured dogs I personally knew. This was Lulu.

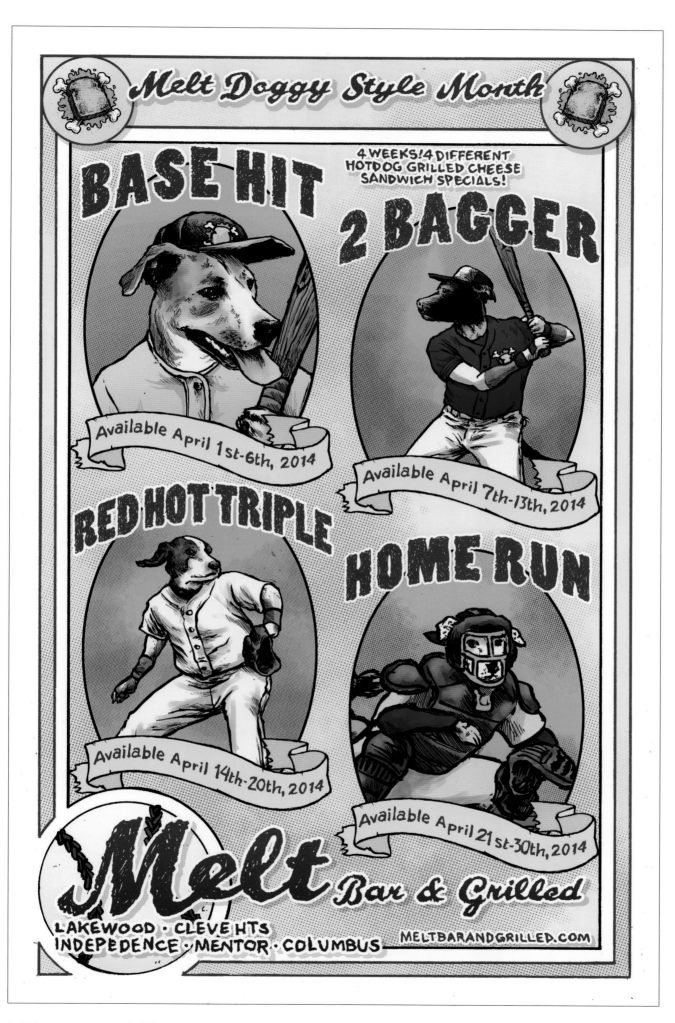

This poster captured all four "Doggy Style" images as a single image.
I thought that the "Doggy Style" connotation might have been too much,
but Matt was perfectly OK with the idea.

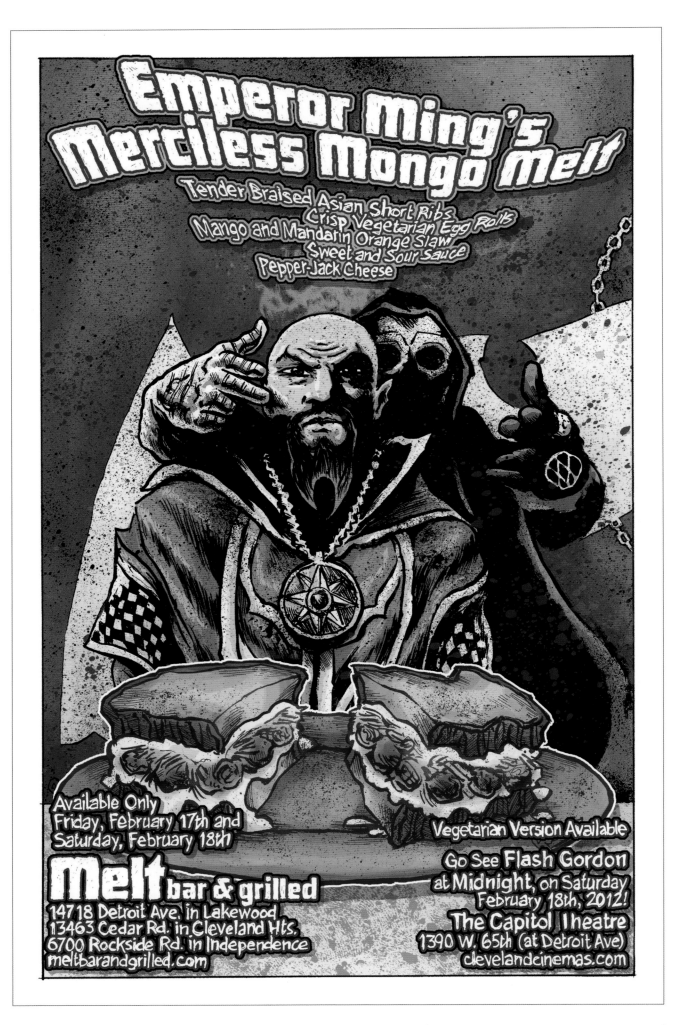

The *Flash Gordon* film (with Ming the Merciless) meets Raekwon's *Only Built 4 Cuban Linx...* LP cover. When the Lakewood Melt location first opened *Flash Gordon* played on a loop day and night.

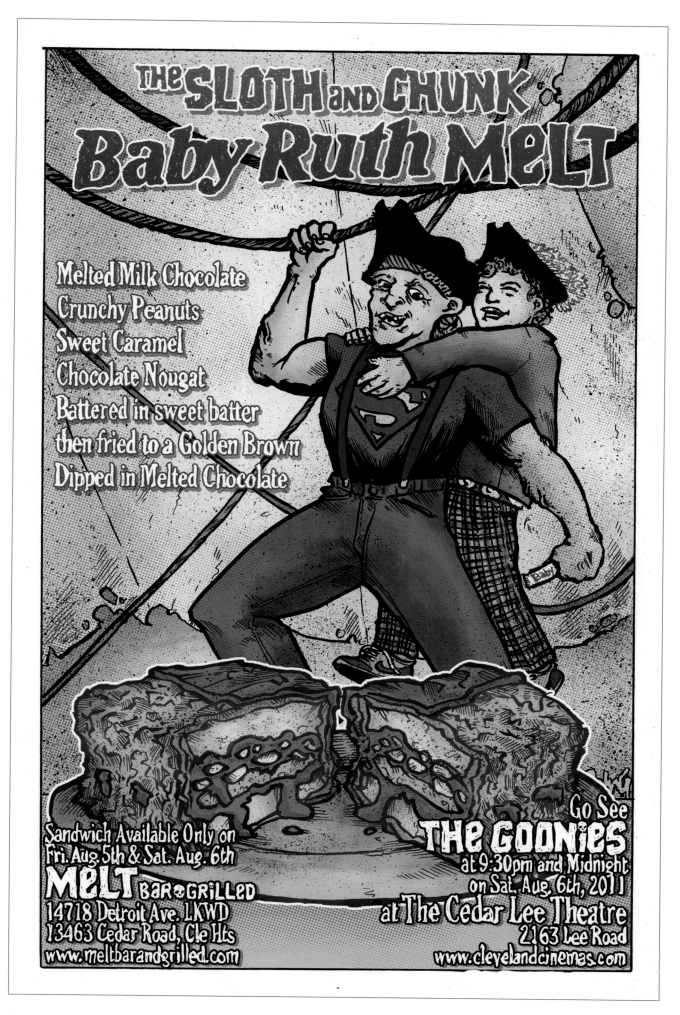

Sloth and Chunk... together again! Featured a "Truffle Shuffle" contest at the theatre where patrons could show off the goods.

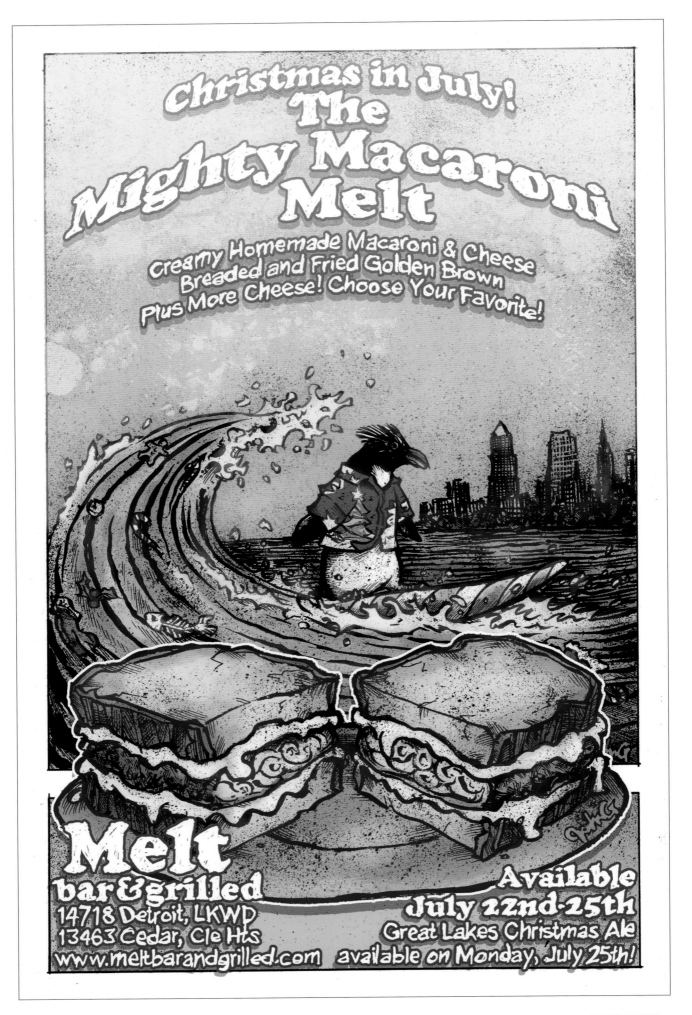

A penguin surfing Lake Erie, with holiday adornments and assorted objects as floaters in the wave.

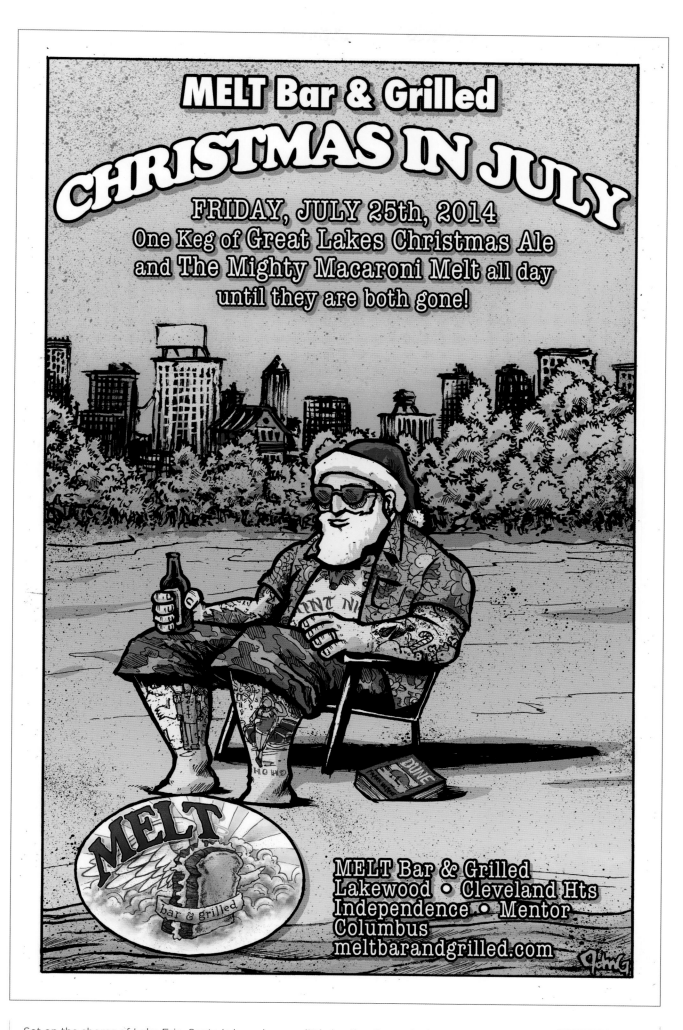

Set on the shores of Lake Erie. Santa is based on my little brother Dan, who has similar tattoos. **CHRISTMAS IN JULY!**

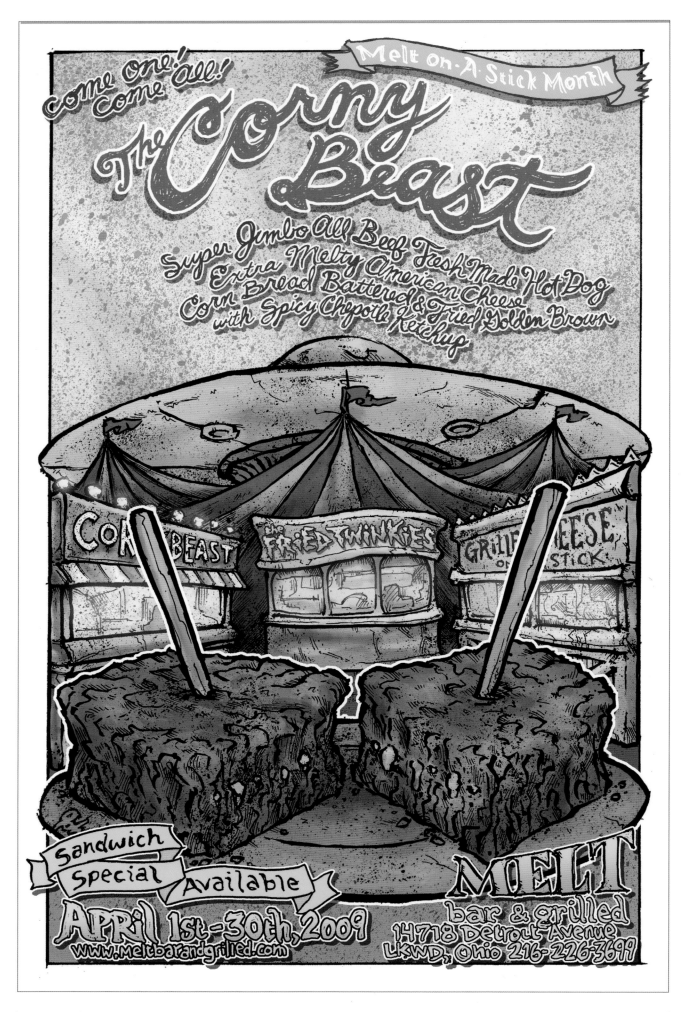

Melt's take on carnival eats ...everything on a stick!

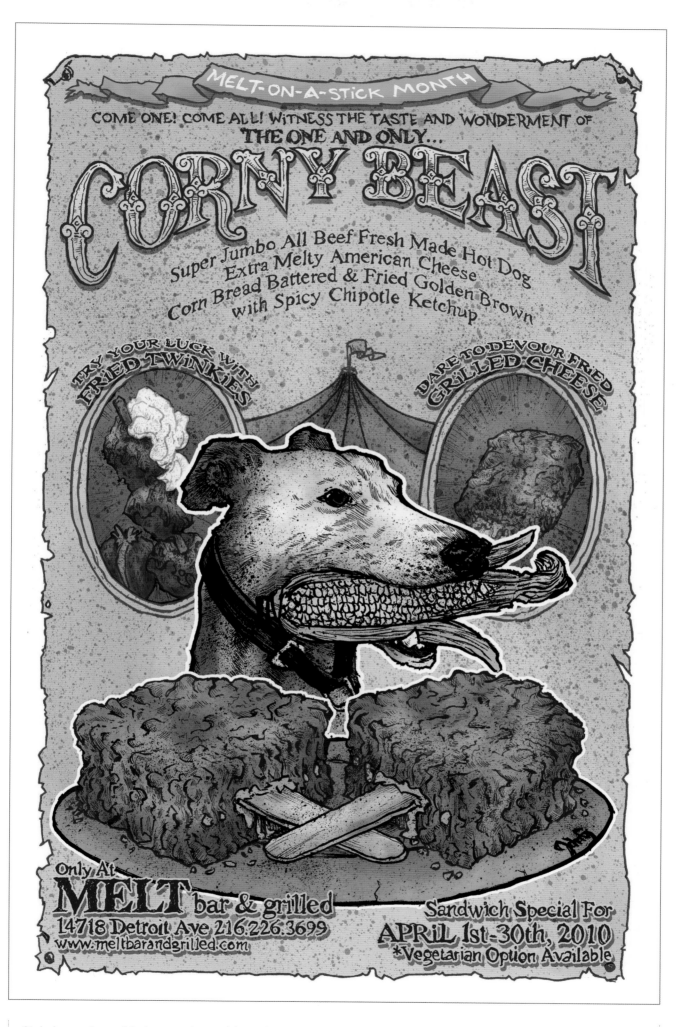

Styled as a circus sideshow poster, and featuring a pup mirrored after my friend Oscar.

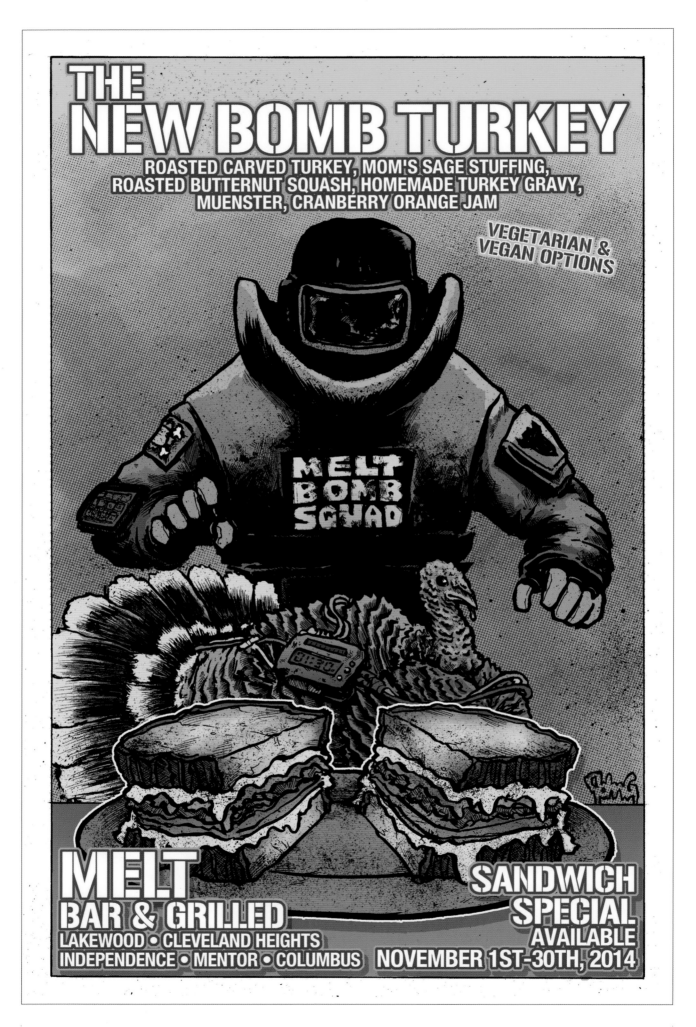

Here I envisioned a loaded turkey as a bomb facing a potential diffusion.

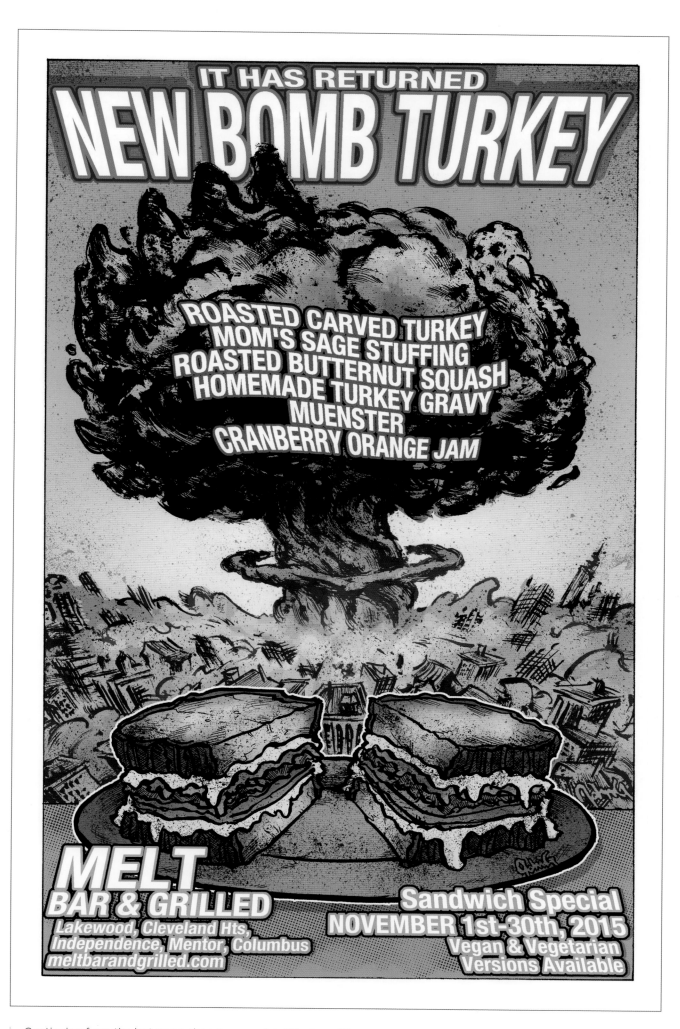

Continuing from the last page, the unsuccessful diffusion of the New Bomb Turks lead to a turkey-shaped mushroom cloud.

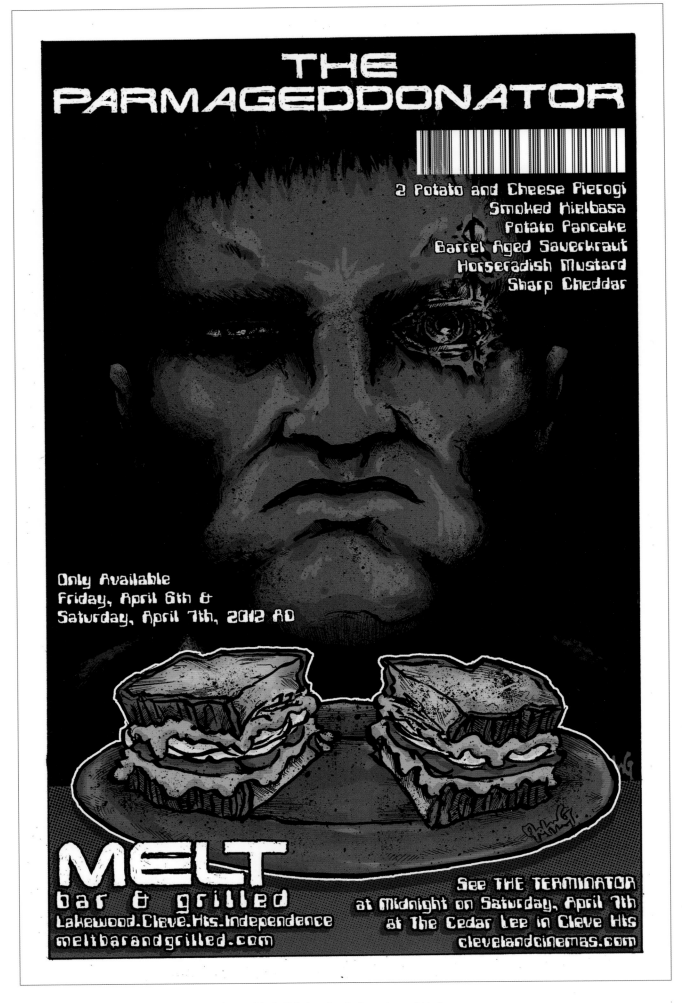

Parma, Ohio (page 18) returns! Replete with Polish-inspired pierogis and kielbasa.
Above I showcased the classic scene from *The Terminator* where he cuts his eye out.

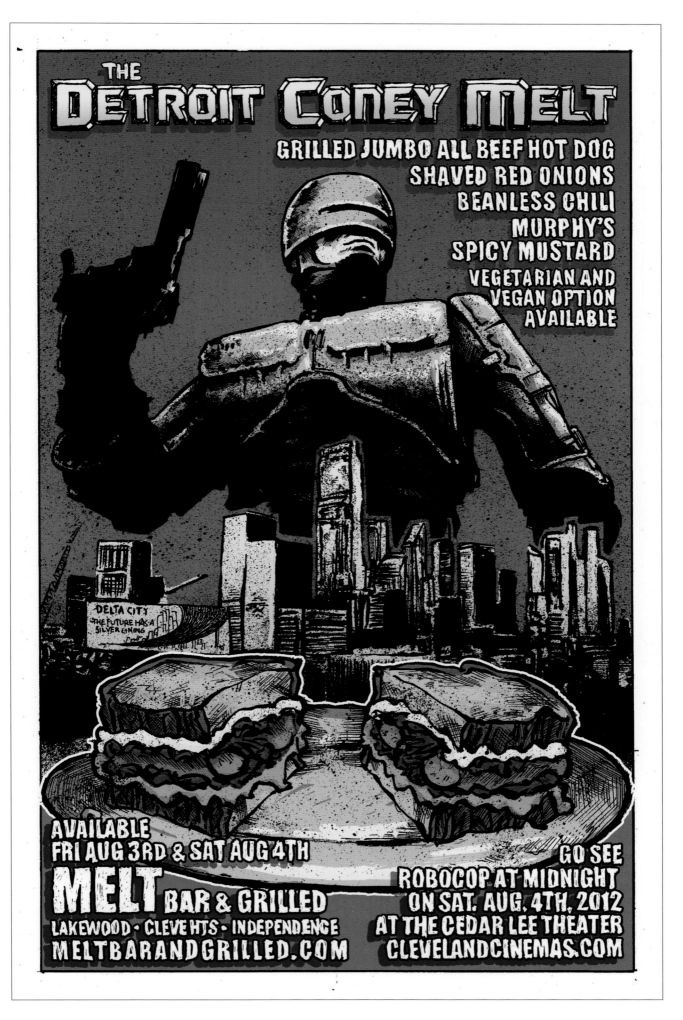

A play on *Robocop* and the film's concept that a large company (Omni Consumer Products) is planning to erect a corporate-backed "New Detroit," dubbed "Delta City," to replace the crime-ridden ruins of "Old Detroit."

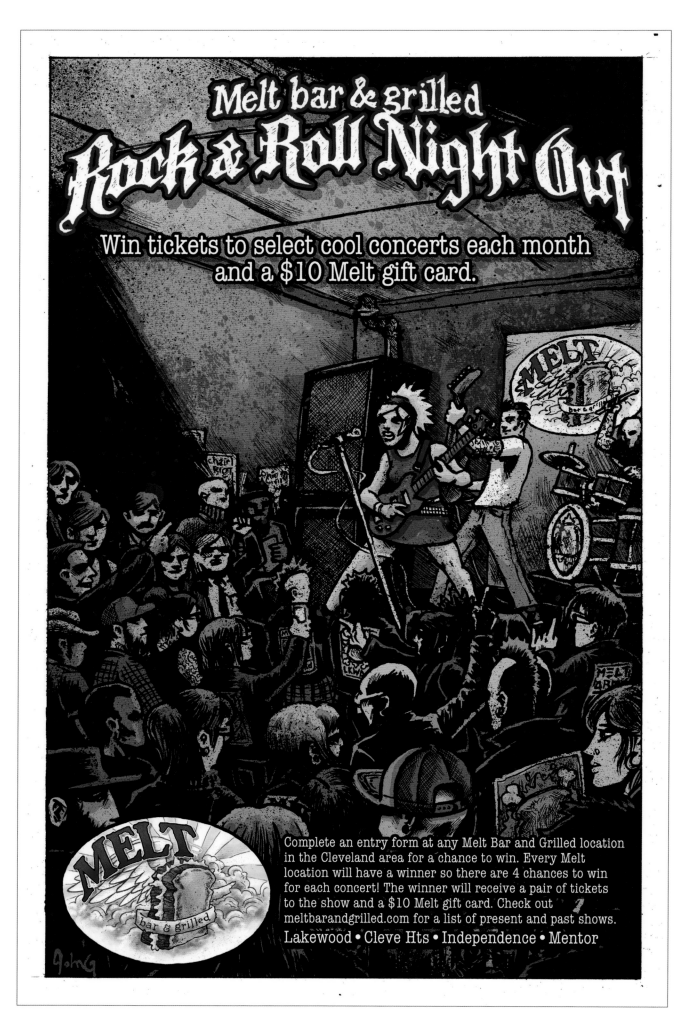

Always supportive of Ohio's best music venues (The Grog Shop, The Beachland Ballroom, Cleveland Agora, Now That's Class), this poster cross-promoted the indie music scene.

ROCK & ROLL NIGHT OUT

102

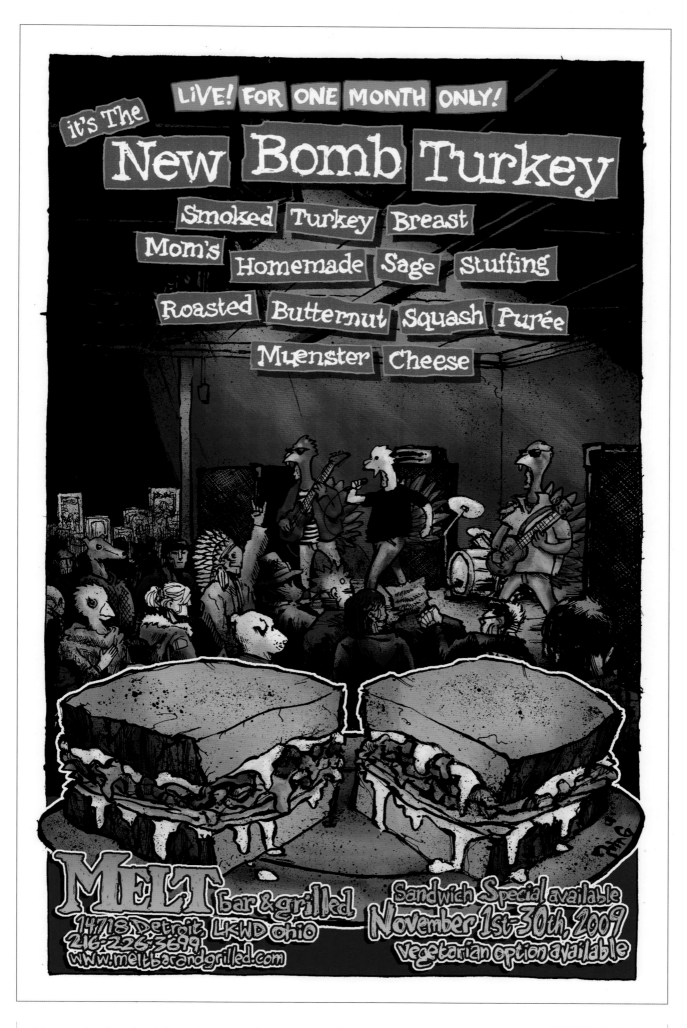

A burgeoning favorite at the restaurant, and yet another tribute to punk outfit New Bomb Turks. THE NEW BOMB TURKEY

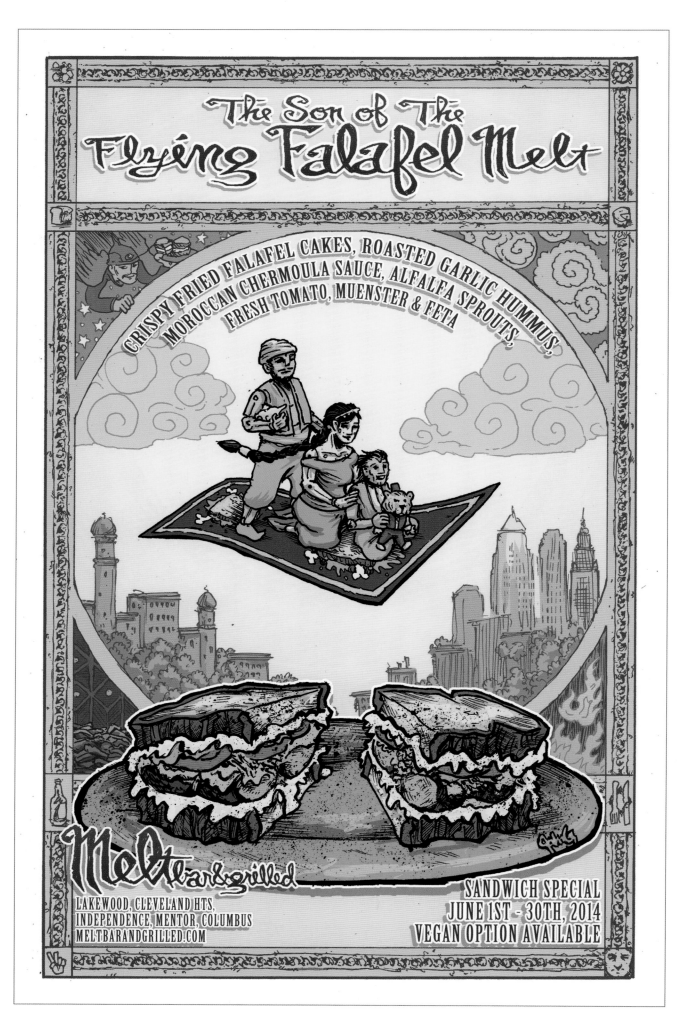

This print features eight (!) different Easter eggs, each squared off throughout the border, including chickpeas (top left), a peace sign (bottom left), and even my face (bottom right).

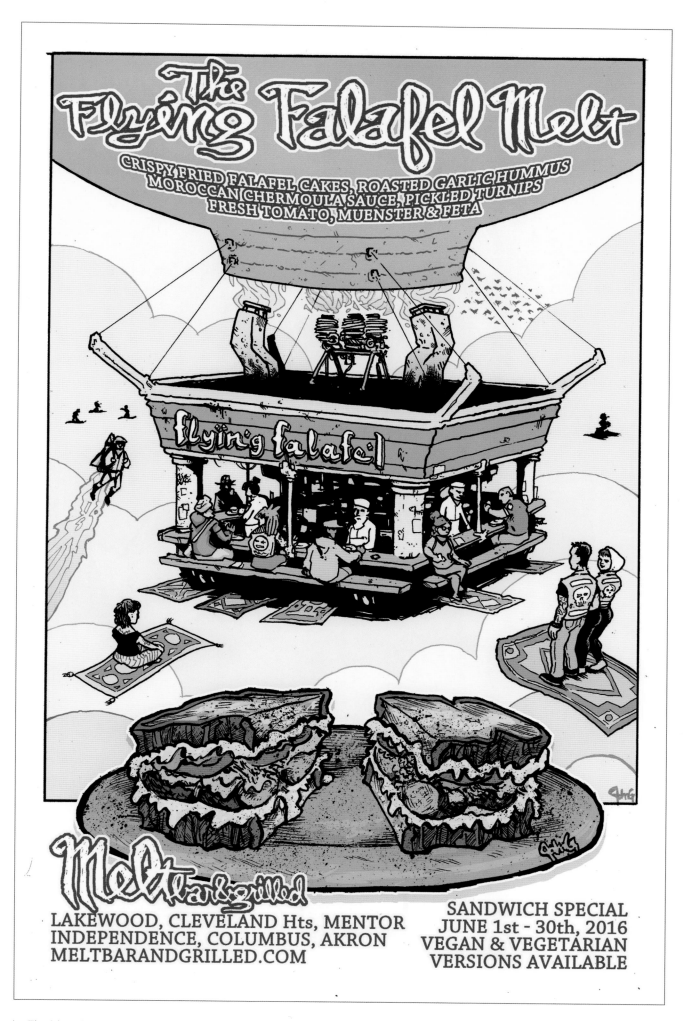

The idea above was a flying "food truck," where patrons would need flying carpets to place orders. The color scheme was exactly lifted from the Chicken Pot Pie Melt stand from page 28.

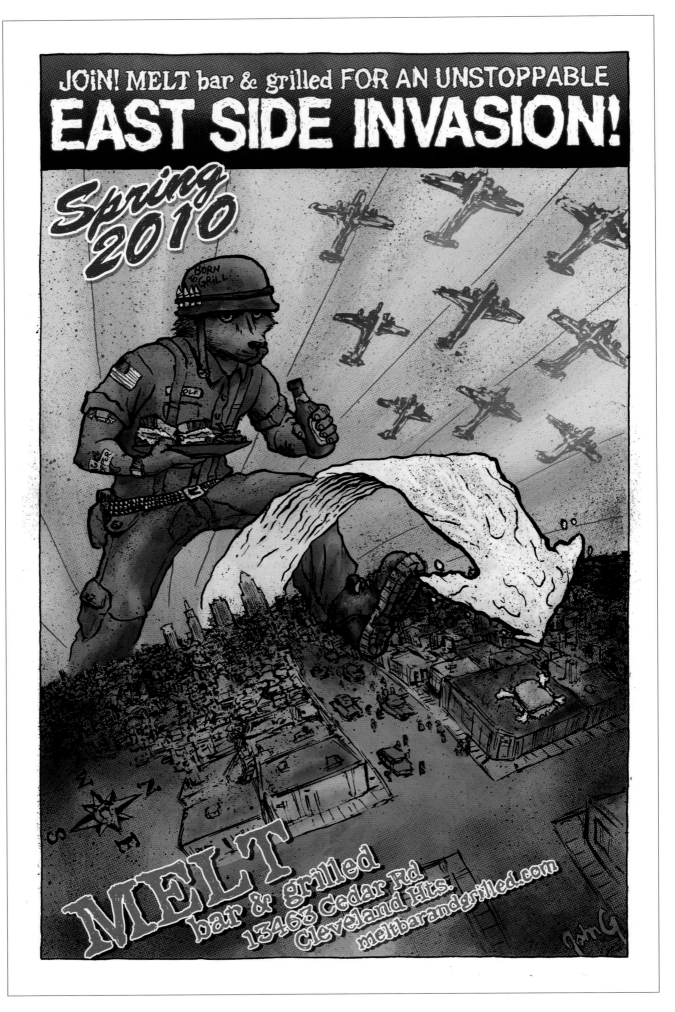

A propaganda-style poster for a new East Side location.
The poster now hangs as a huge oversized print in the restaurant.

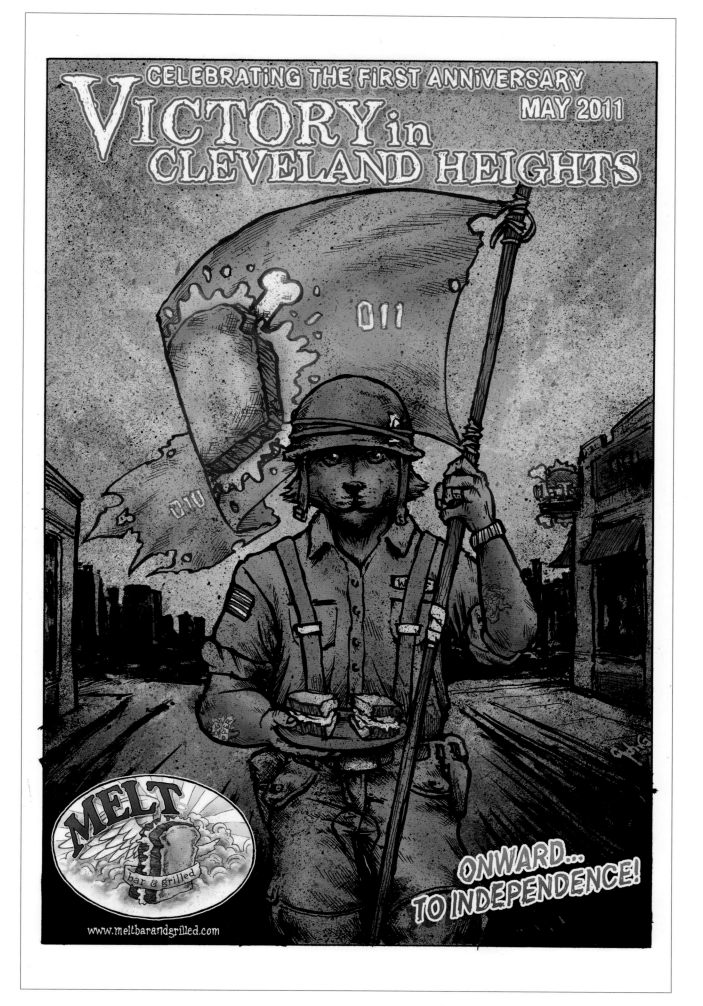

The one-year anniversary of the East Side location introduced at left, along with an announcement of a new location in Independence (yes, that's the actual city name).

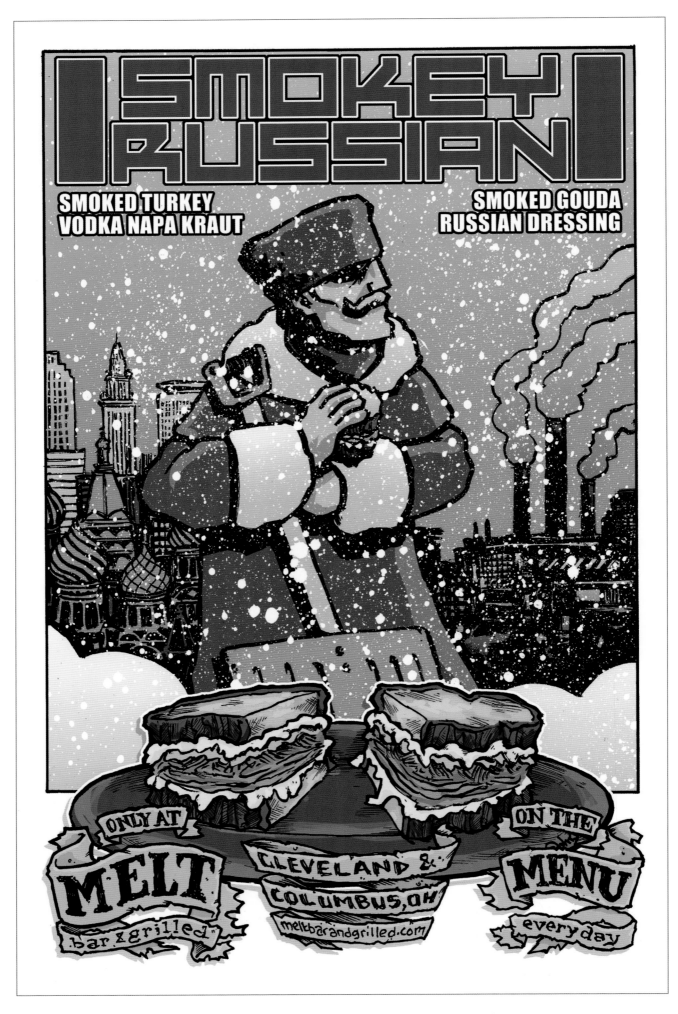

It's long been rumored that "Russians love Cleveland" due to its cold weather and buildings reminiscent of Russian structures. Or perhaps that's just propaganda.

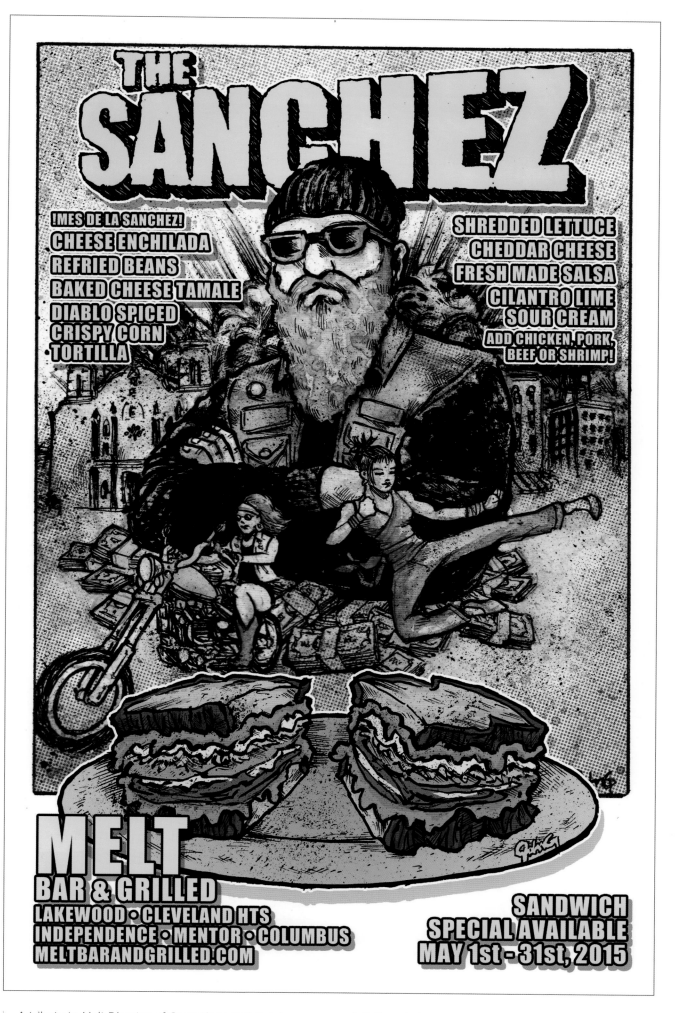

A tribute to Melt Director of Operations Neil Sanchez as an exploitation-style poster, naturally featuring a custom chopper motorcycle and a girl tossing a ninja kick.

THE SANCHEZ

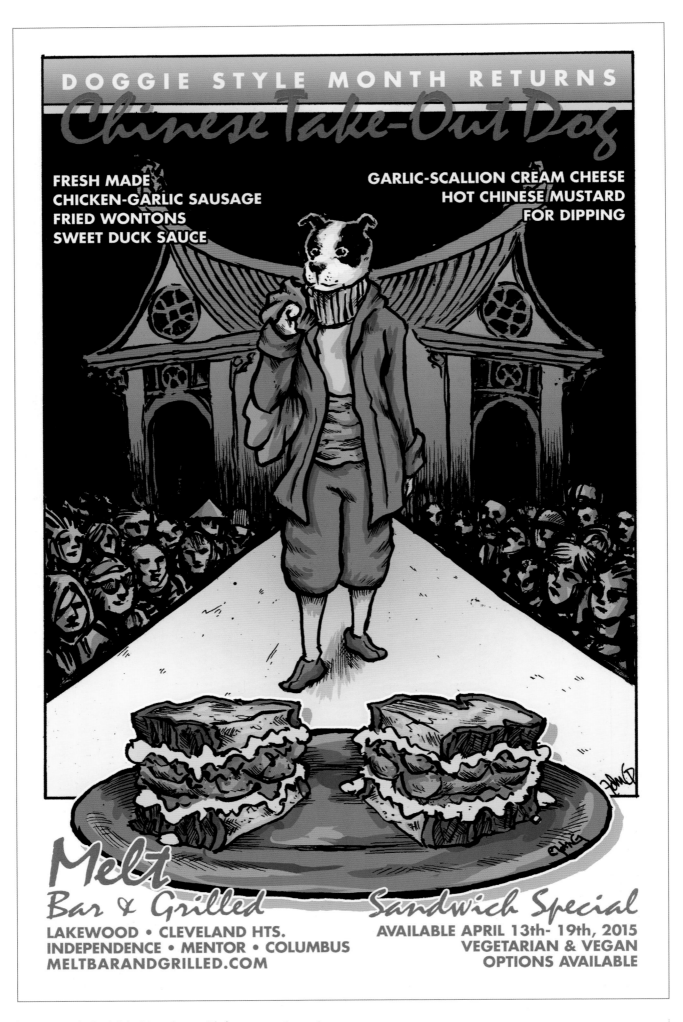

A "Doggie Style" fashion show with four separate posters.
All posters were based on real street fashions at the time.

War Dog was based on a friend's dog named Gayle. Fun fact: she also owned Chicken Tender on page 189.

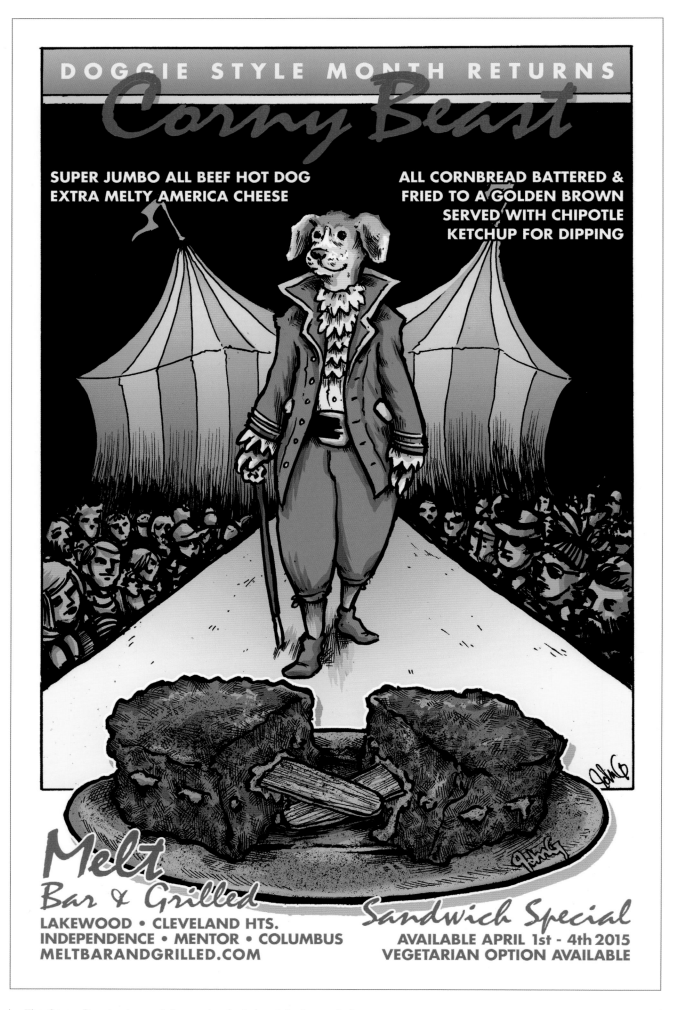

The Corny Beast returns. A "super jumbo" dog + "extra melty" cheese... on a stick. Nod to the *Seinfeld* "puffy shirt."

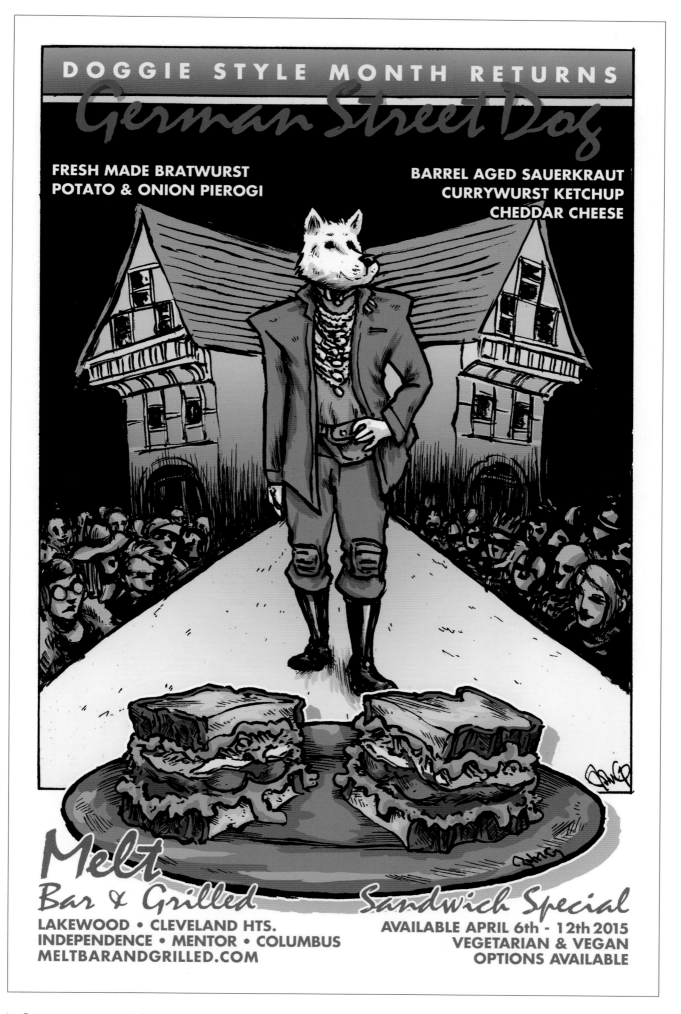

Germans represent! A brat-based sandwich. This pup was patterned
after my friend Valerie Mayen's dog Salt (Valerie was on *Project Runway*).

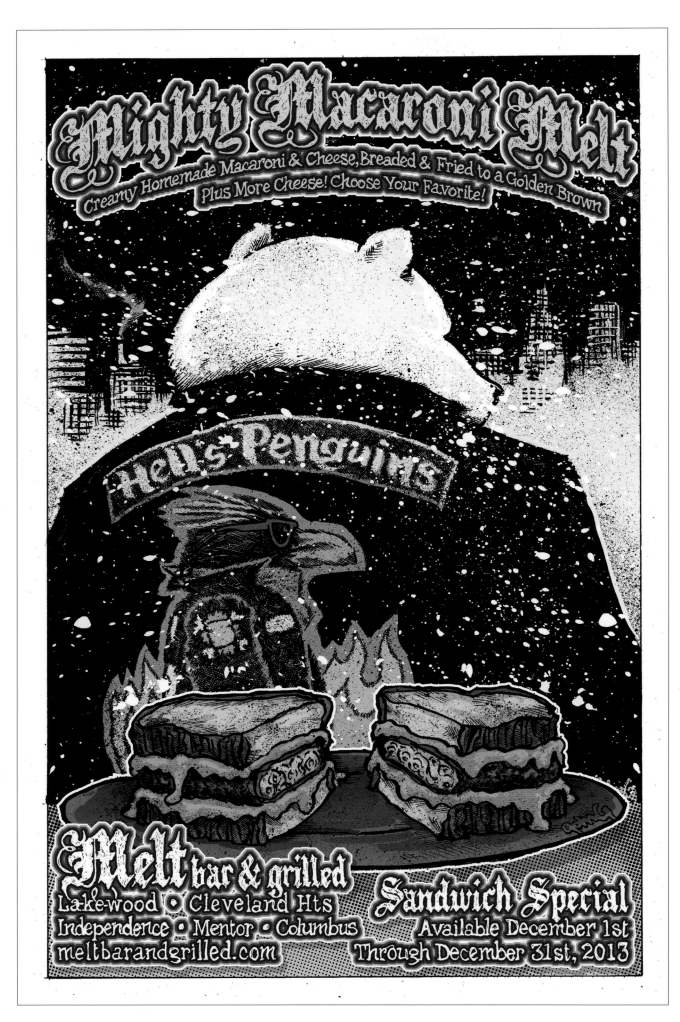

A polar bear wearing a Hell's Angel-esque leather jacket.
The idea of Hell's Penguins cracked me up.

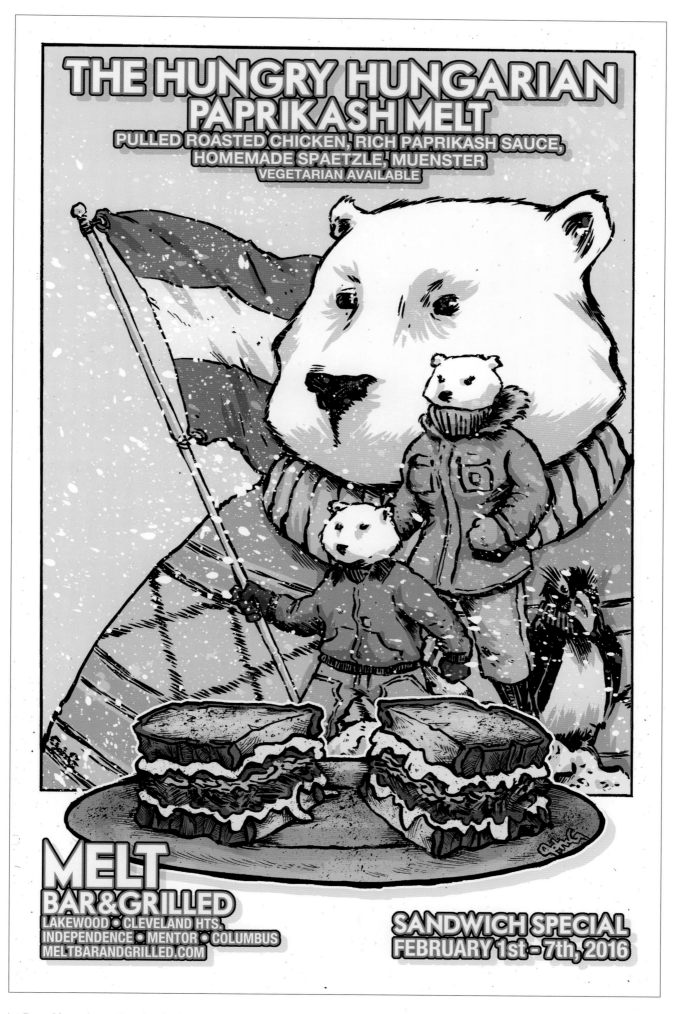

Based loosely on the classic *Star Wars: A New Hope* film poster layout and featuring a Hungarian flag.

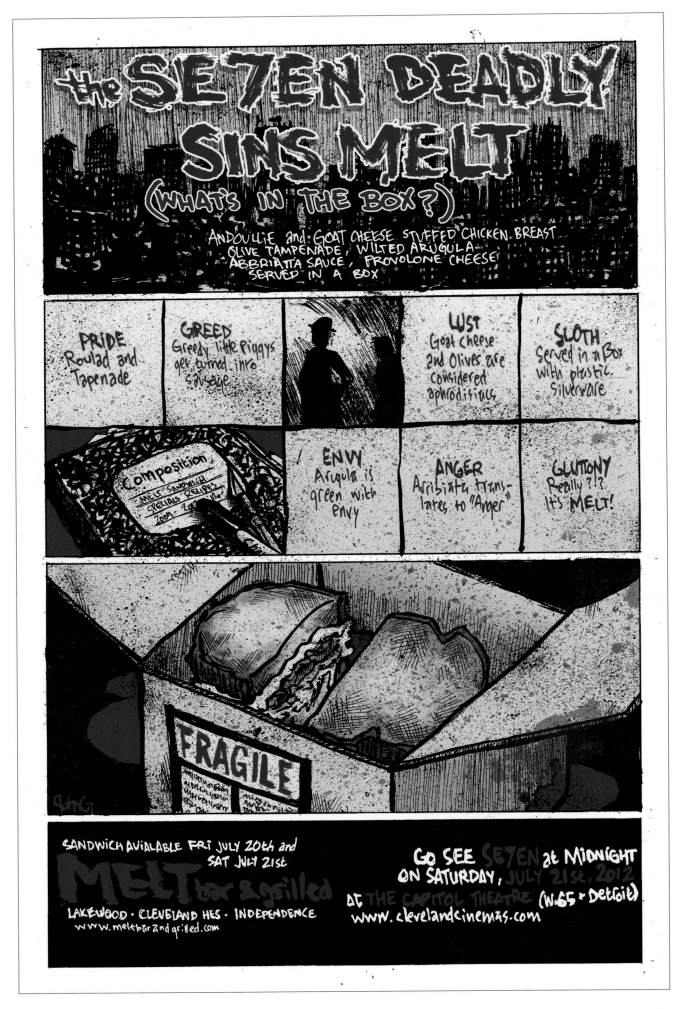

A recreation of the classic end (spoiler alert!) of *Se7en*, this time
featuring a sandwich inside a box instead of Gwyn**h Paltr**'s h**d.

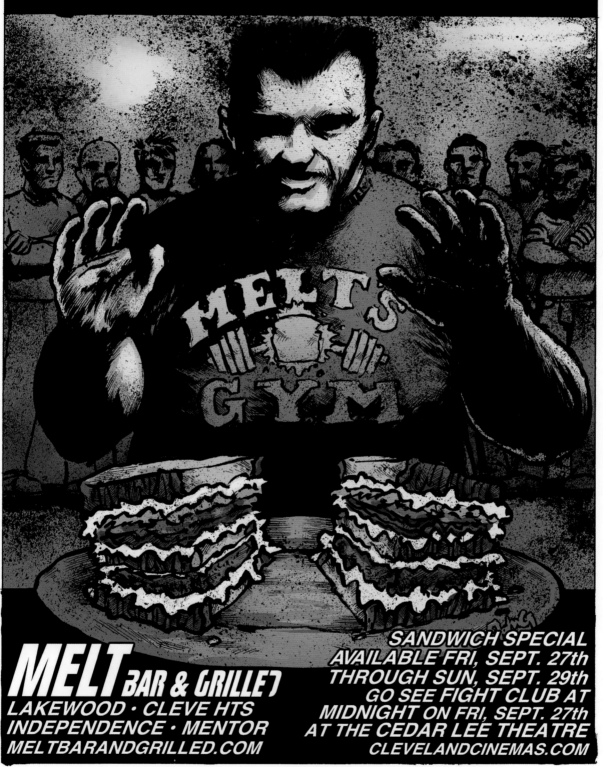

Meatloaf, the unsung hero from *Fight Club*. "His name was
Robert Paulson." Pending merch: "Melt's Gym" t-shirts.

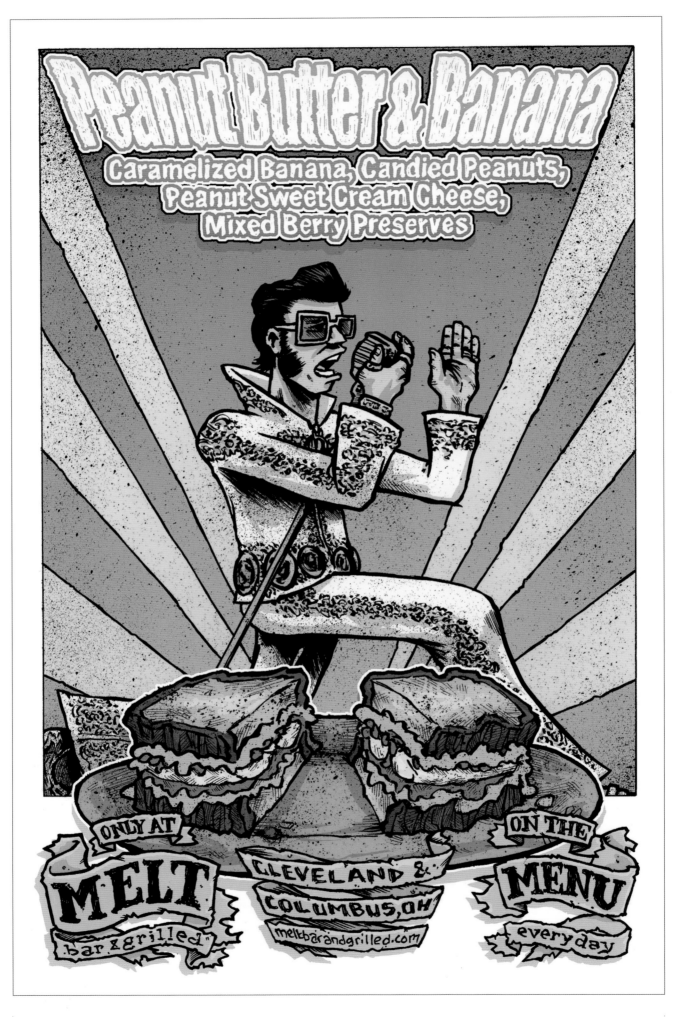

Elvis' favorite sandwich comes to Melt. Well, the '70s-era Elvis.

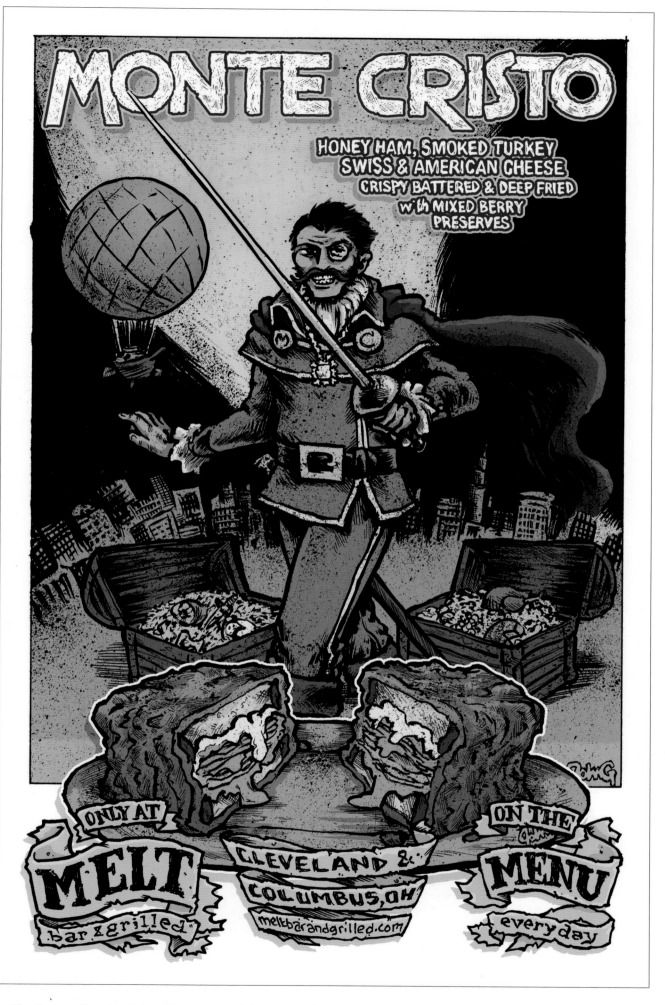

The Count of Monte Cristo selling the world-famous sandwich, essentially a fried ham and cheese, which is a variation of the French croque monsieur.

I went into this poster thinking it was so different from my typical work that the Melt crowd might not appreciate it. Totally wrong. I traced my 37-year-old hand for this image (who didn't do this as a kid?), which was hugely nostalgic for patrons.

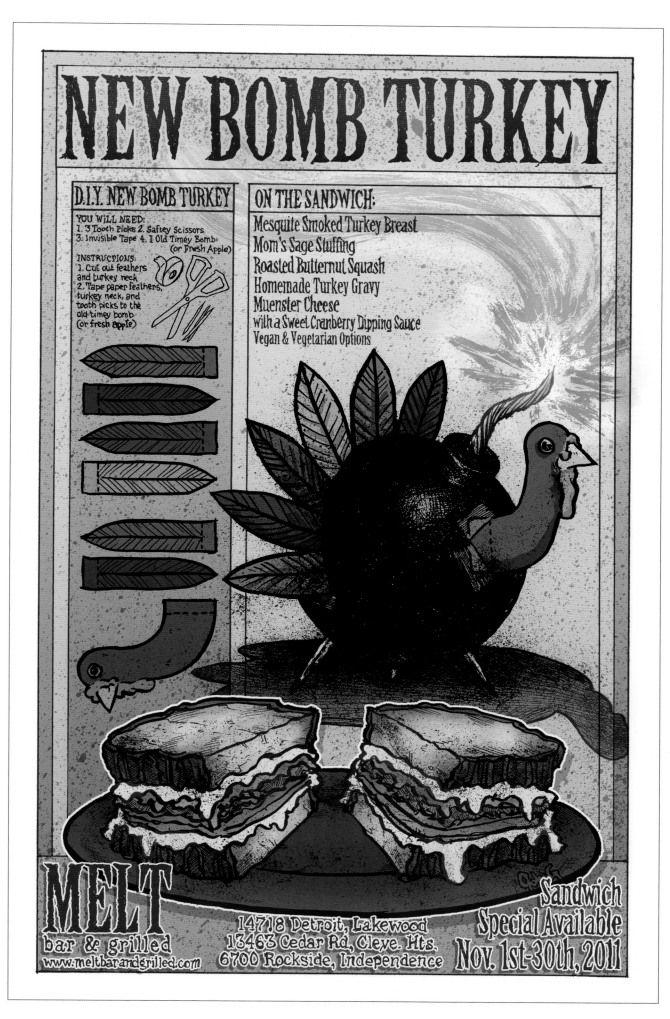

Bringing back a successful sandwich is great for business, but not necessarily for creating fresh artwork. So above I envisioned the sandwich as a cut-and-paste activity page. Bomb creation details not supplied.

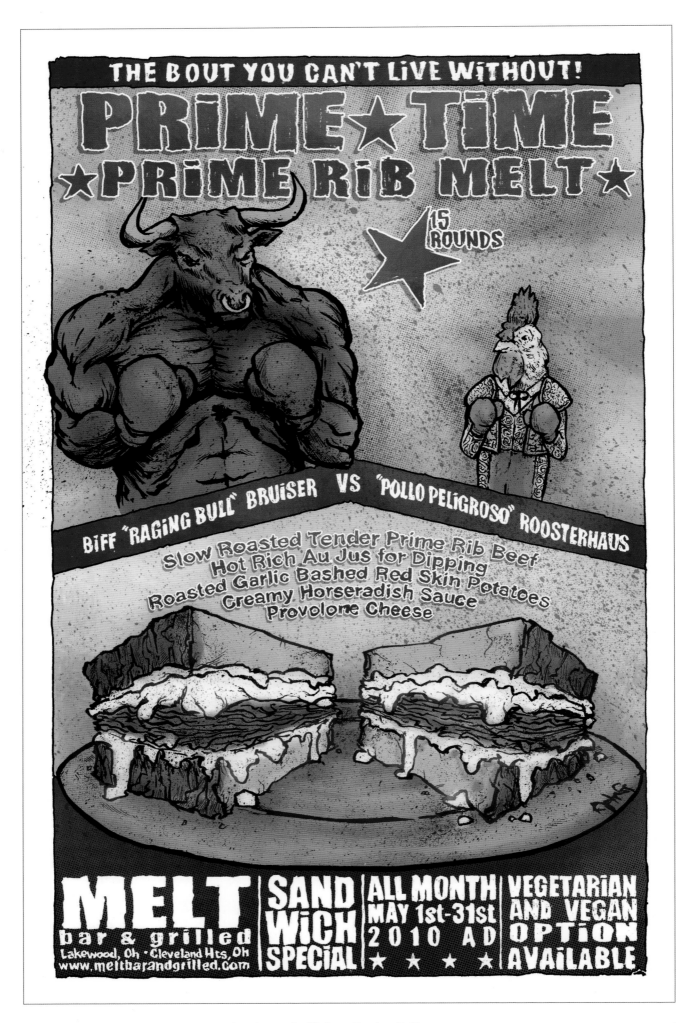

A fight poster, David and Goliath-style, where a bullfighter (Raging Bull) and a cockfighter (Pollo Peligroso) go glove-to-glove.

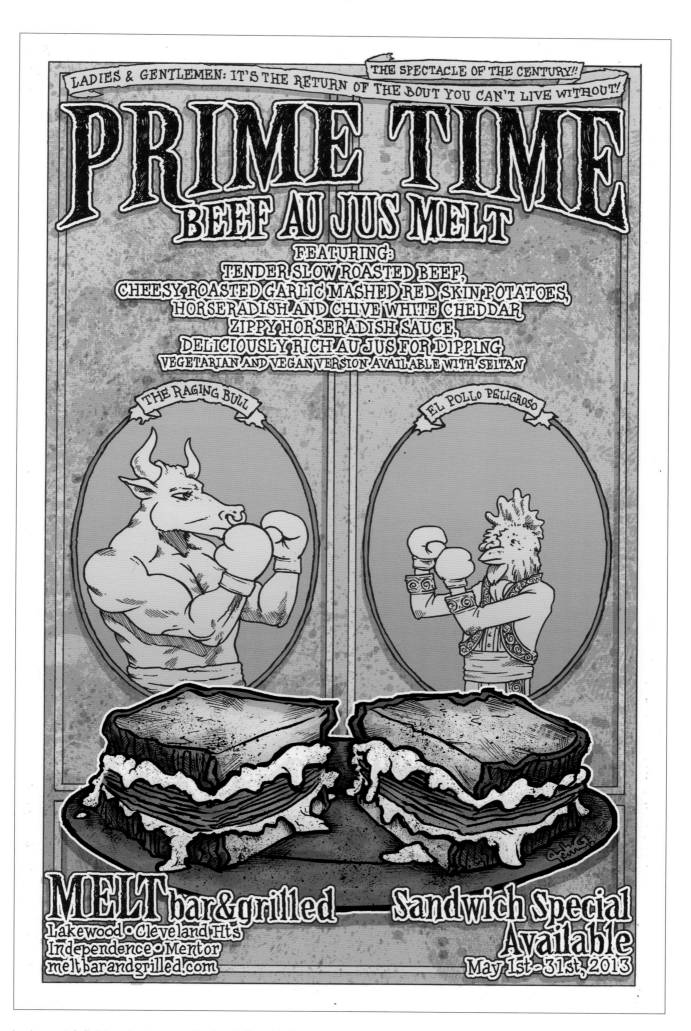

A rematch fight poster between Raging Bull and Pollo Peligroso, this time from the Victorian or Edwardian era.

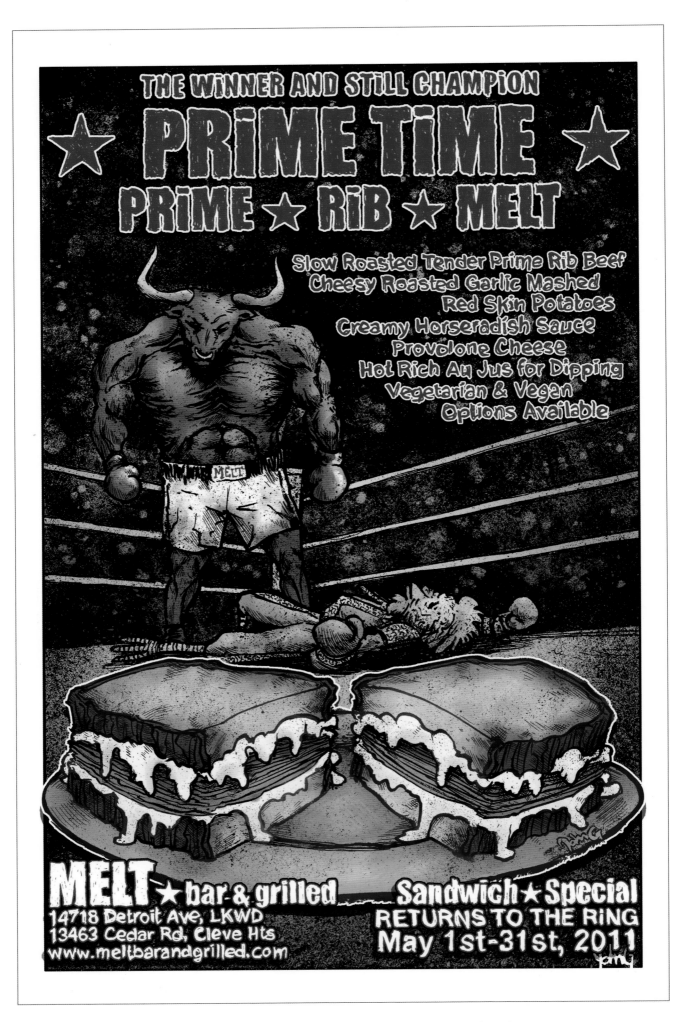

Based on the iconic 1965 photo of Muhammad Ali taking on Sonny Liston. The bout lasted one minute. This was also my only image that contained a black-and-white variant.

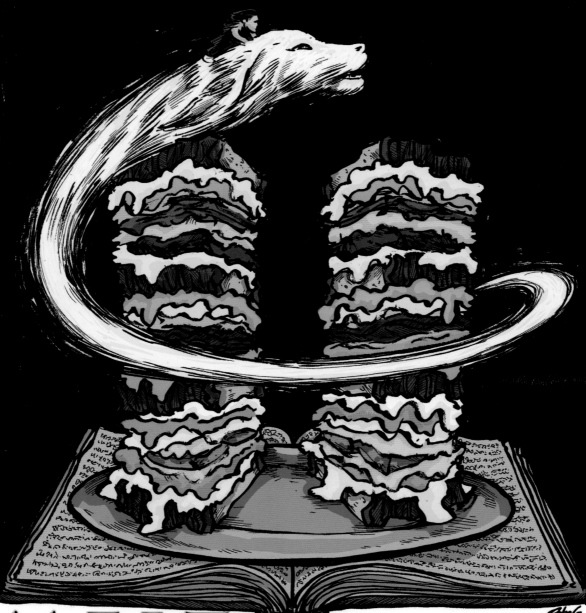

THE NEVER ENDING MELT SANDWICH

The Mini Melt Challenge bigger than Rockbiter and tougher than G'mork
4 Slices of Grilled Bread, 3 Different Cheeses Stacked higher than Falkor can fly!
Choose different add-ons to make this sandwich even more endless!

MELT
BAR & GRILLED
LAKEWOOD · CLEVE HTS
INDEPENDENCE · MENTOR
MELTBARANDGRILLED.COM

SANDWICH SPECIAL AVAILABLE
FRI JAN 18 - SUN JAN 20, 2013
SEE THE NEVER ENDING STORY
AT MIDNIGHT ON JANUARY 19TH
AT THE CAPITOL THEATRE
CLEVELANDCINEMAS.COM

A towering sandwich that would easily feed Falkor (or at least a few Limahls). Eight inches of sandwich deliciousness.

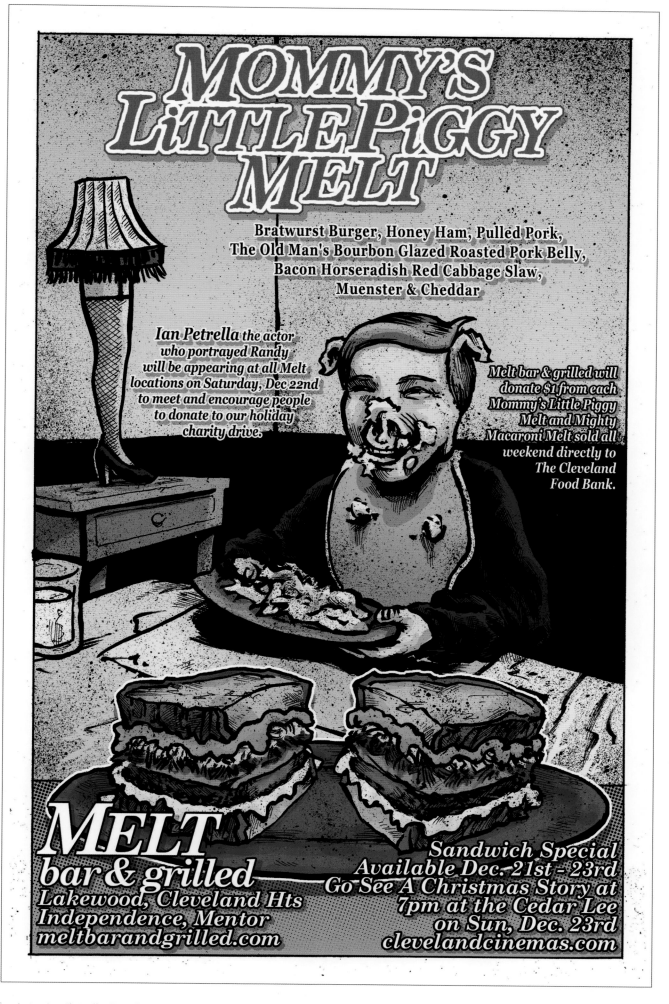

Actor Ian Petrella (Randy in *A Christmas Story*) is frequently seen around town in Cleveland, as the city is host to the *Christmas Story* house and museum. Ian occasionally pops into Melt for a bite.

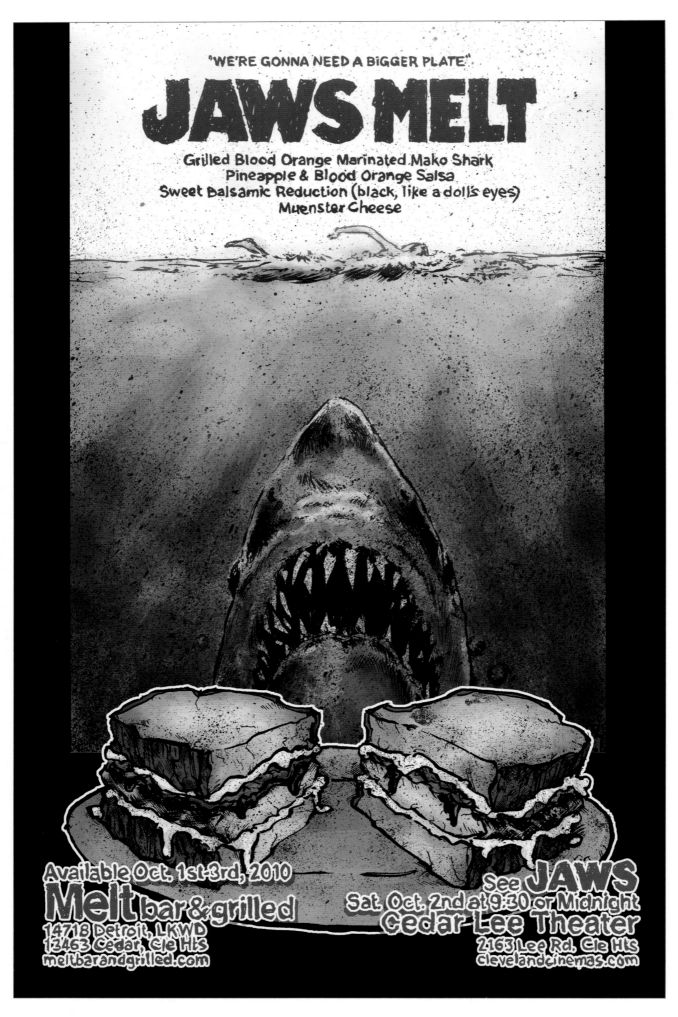

A tribute to the classic Spielberg film. When I first saw *Jaws* I wouldn't even take a bath for weeks. "We're Gonna Need a Bigger Plate" is an obvious riff on the iconic line from the movie.

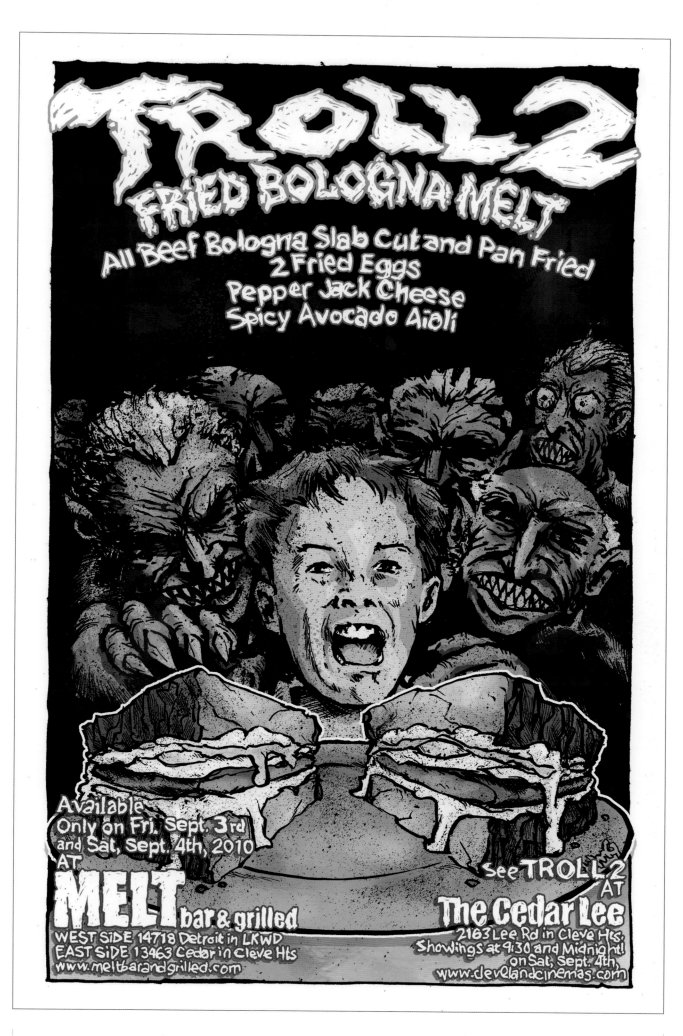

Worst movie ever made. Eat the sandwich instead.

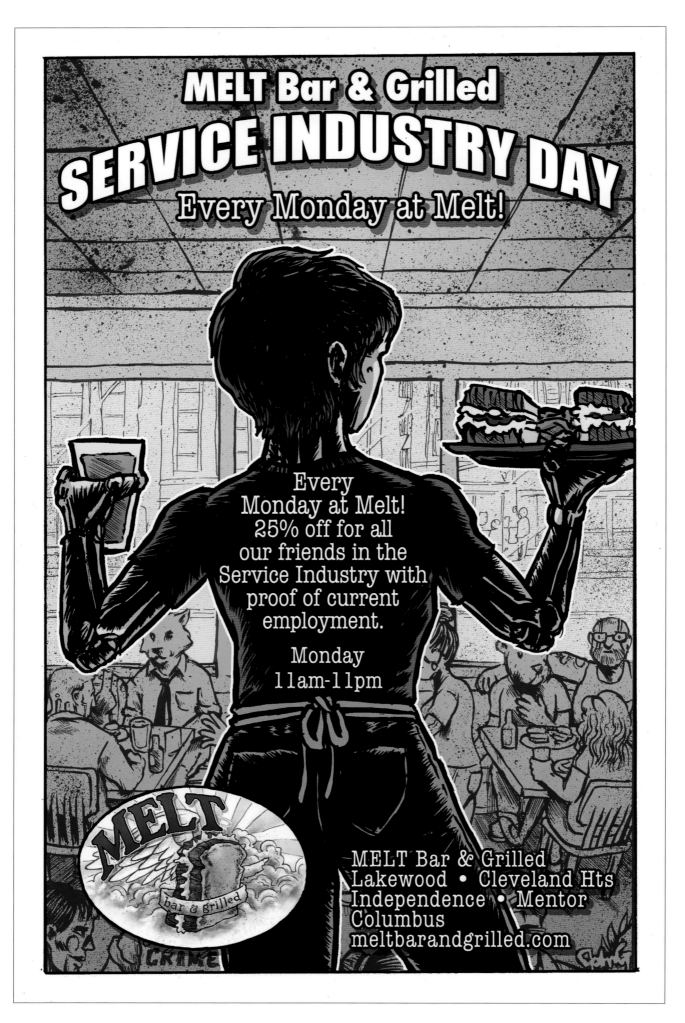

Melt's loyalty to its employees cuts deep, and every Monday all service employees (from any restaurant) get 25% off their orders.

SERVICE INDUSTRY DAY

130

MELT Bar & Grilled
BLACKOUT PARTY

THURSDAY, AUGUST 14th, 2014
11th Anniversary of the Great Midwest Blackout.
Great Lakes Blackout Stout on tap all day.
Bring a candle or a flashlight and
receive a $1 off your bill.
No lights, No TV's.

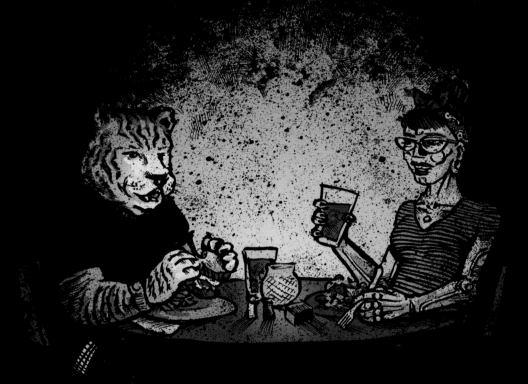

MELT Bar & Grilled
Lakewood • Cleveland Hts
Independence • Mentor
Columbus
meltbarandgrilled.com

A nod to the Northeast blackout of 2003. The Blackout Party featured local brewery
Great Lakes on tap (their Blackout Stout draft, of course). Plus 10% off if you brought
a candle. No lights, no television, no music.

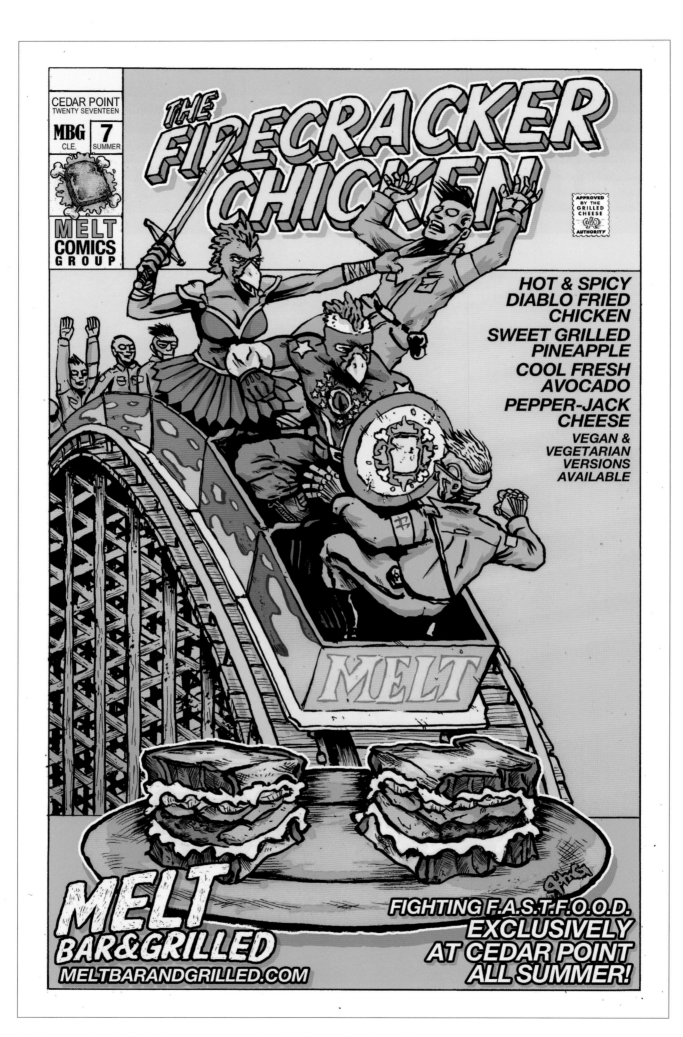

Melt opened at Cedar Point amusement park in 2017. The park's oldest roller coaster, the Blue Streak (1964), was in mind when drawing this piece.

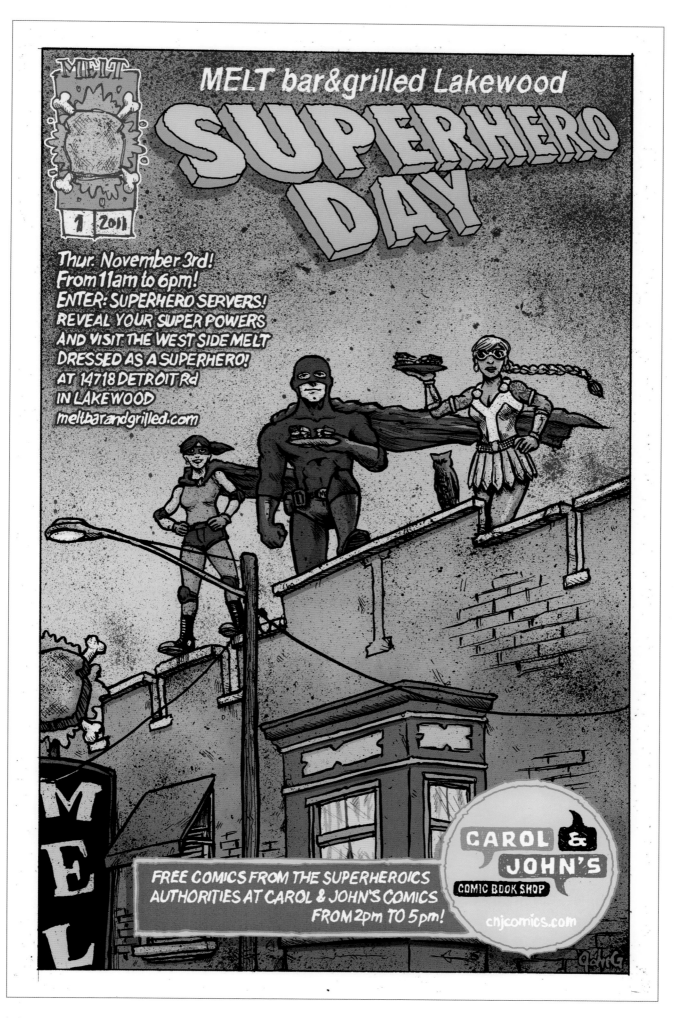

Cosplay and comics are embraced at Melt, and on Superhero Day employees are encouraged to dress as their favorite superhero. This was also a cross-promotion with one of the best comic book shops on the planet, Carol & John's.

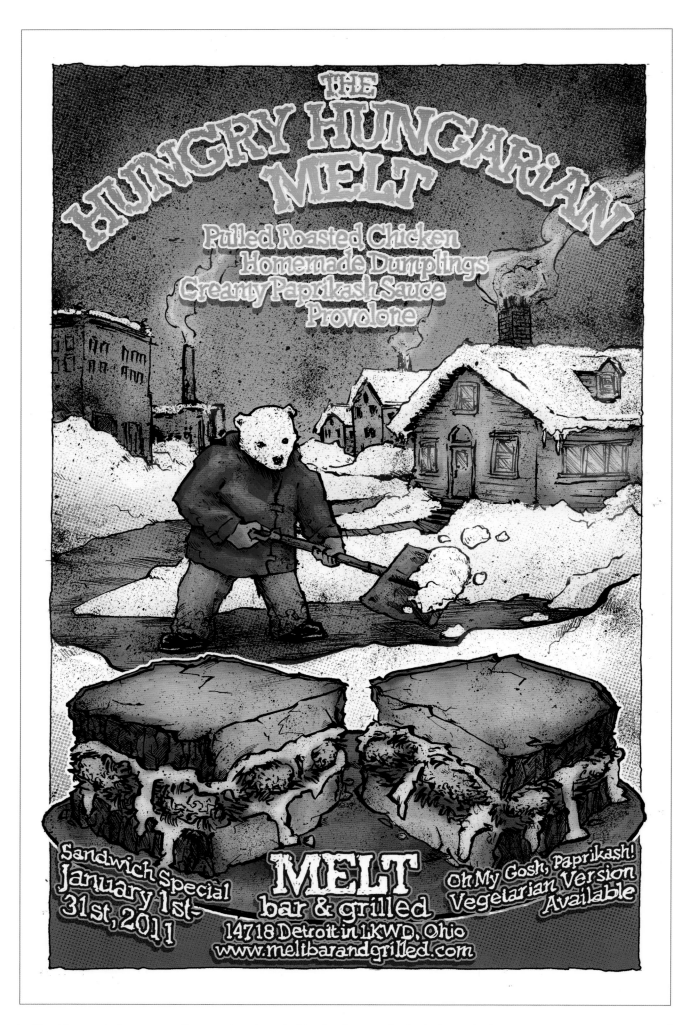

Breaking again from pop culture posters, I wanted to develop a series featuring polar bears. This sketch reminded me of my childhood, shoveling snow for cash while seeing the warm glow from inside a house.

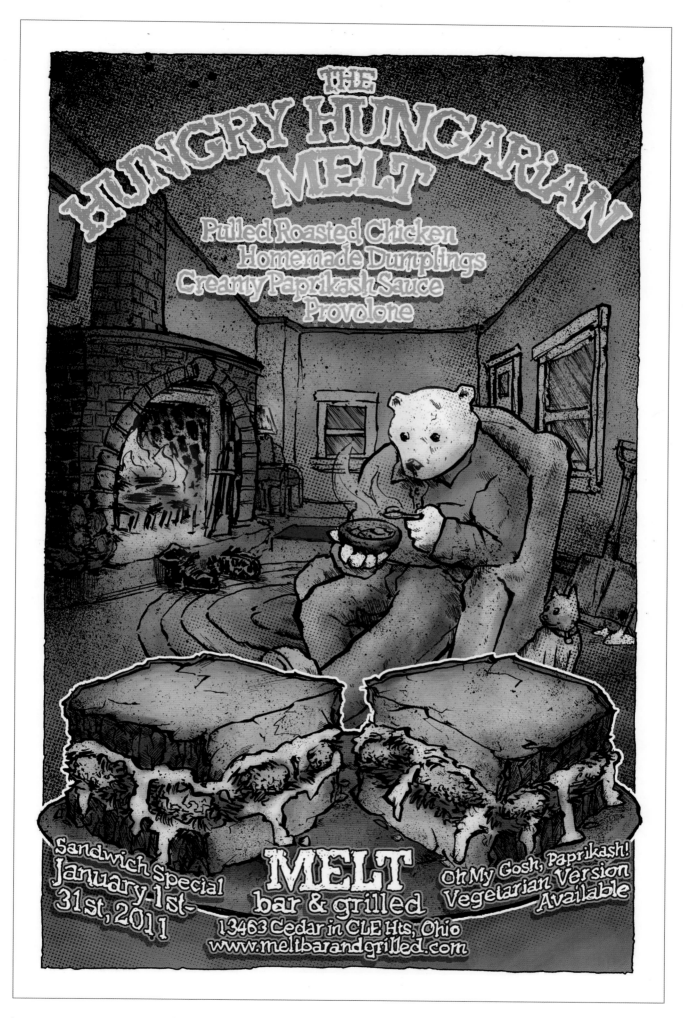

Continuing from the poster at left, the kid bear is coming in from the cold (so rewarding), with comfort food waiting.

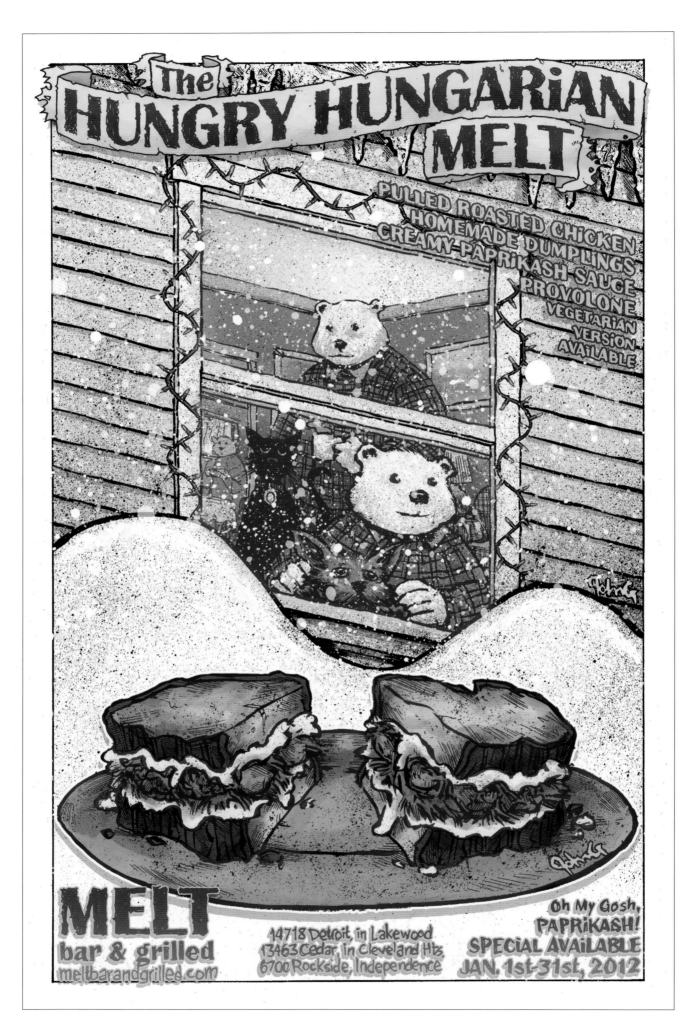

One year later the bear family is growing, and now includes a cat and dog.
I always loved watching snow fall – it's quite mesmerizing and romantic.

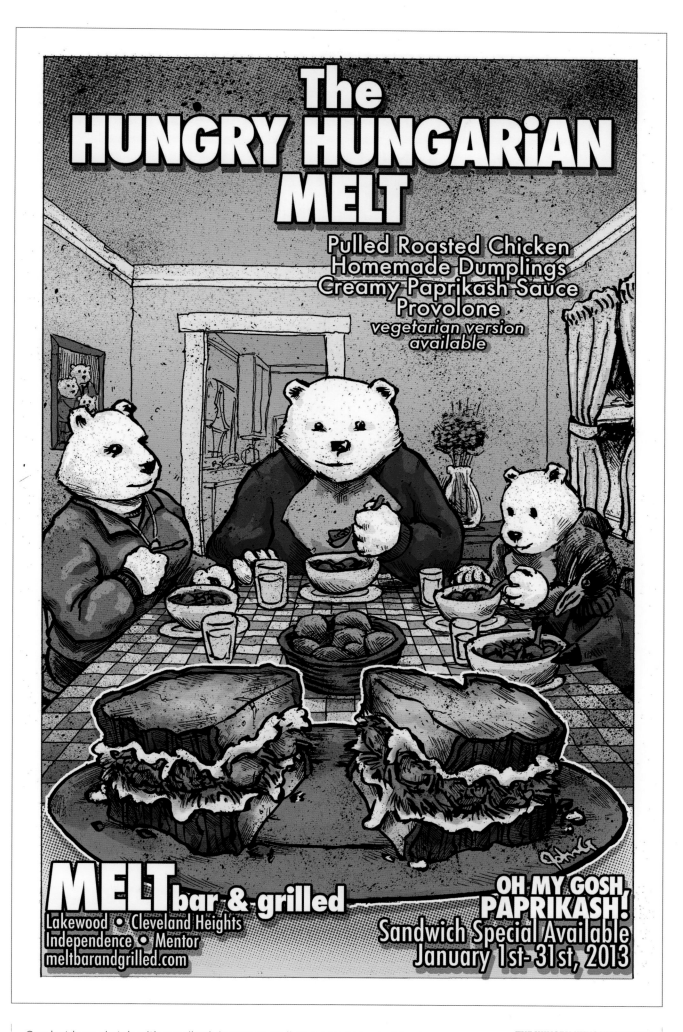

One last bear sketch with paprikash in tow, as well as a new penguin friend.

A classic shot from *Dazed & Confused*. "You just gotta keep livin' man, L-I-V-I-N."

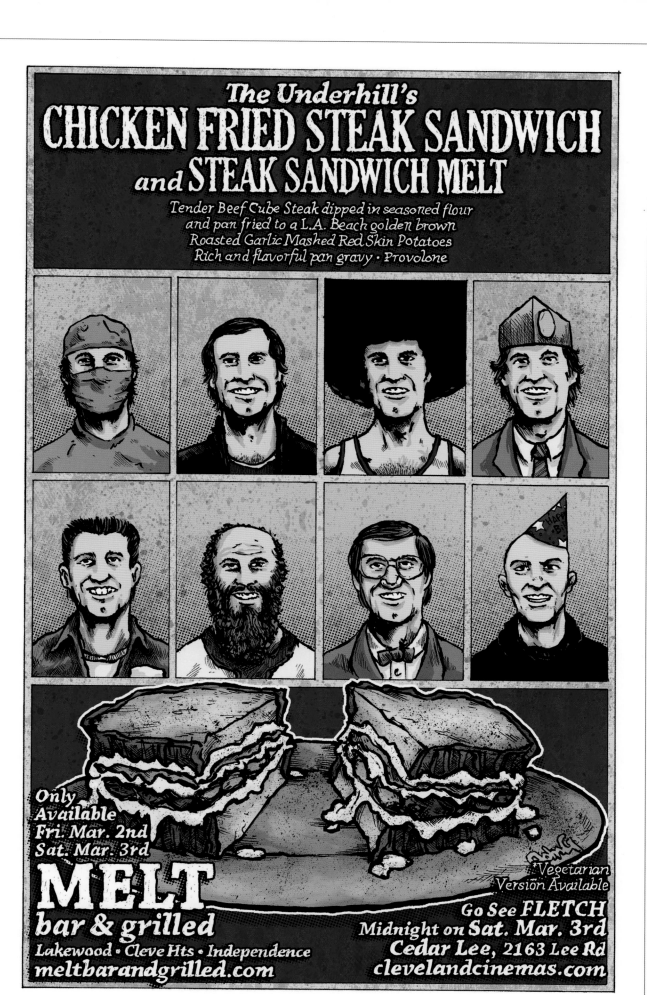

Patterned after Chevy Chase's *Fletch*, with Matt Fish appearing in a birthday tribute as one of Fletch's alter egos.

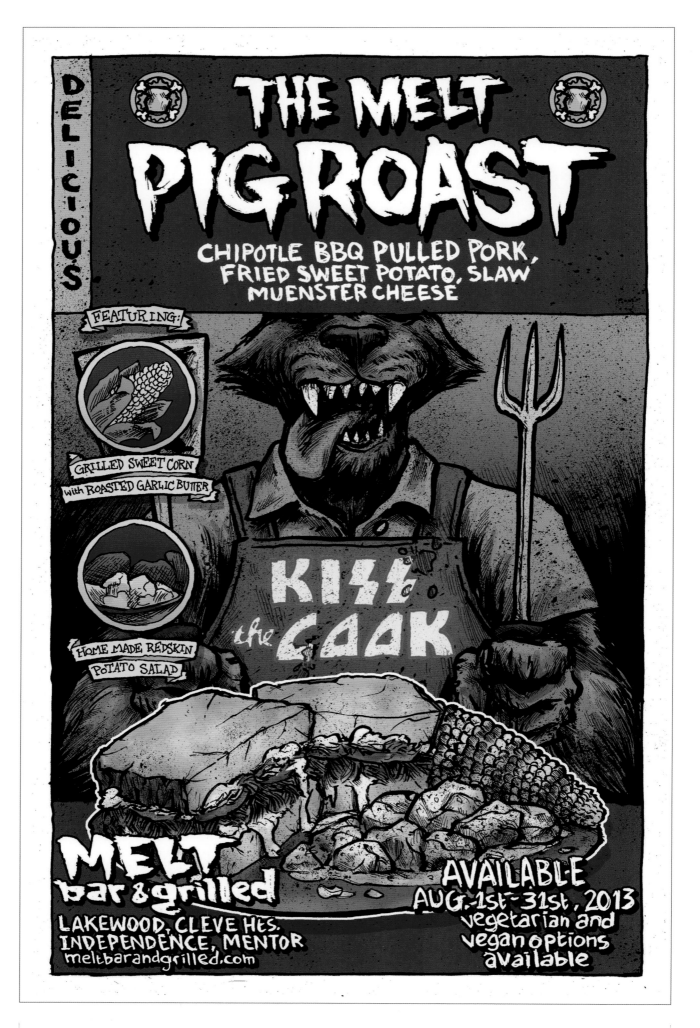

The "Big Bad Wolf" reimagined as a horror comic.

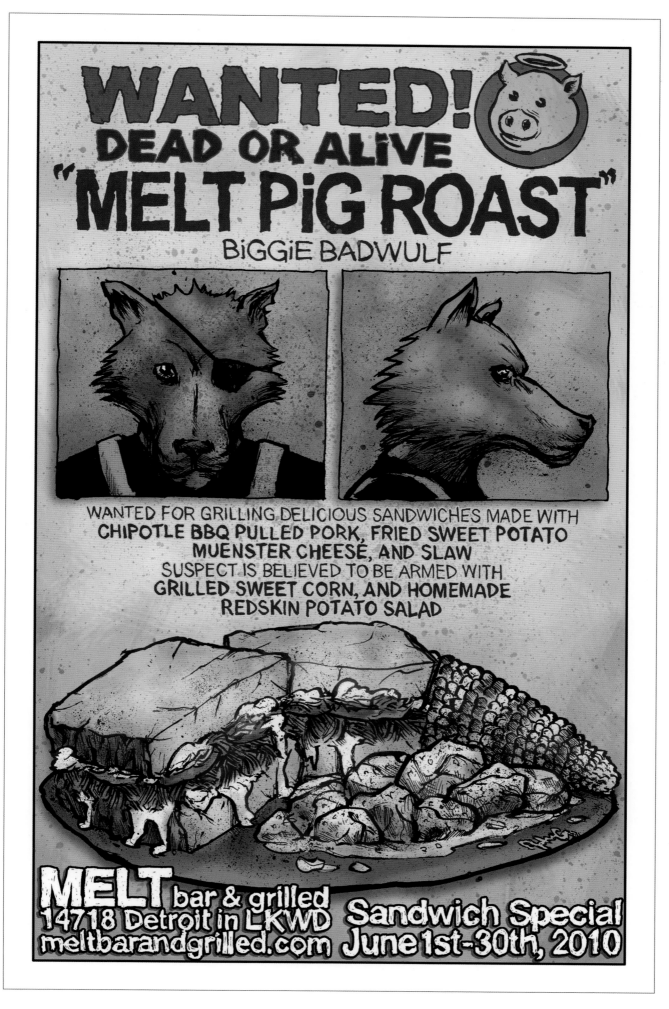

Continuing from left, "Biggie Badwulf" now featured on a wanted poster.
Note the pig halo, whose death was allegedly at the hands (paws) of Biggie.

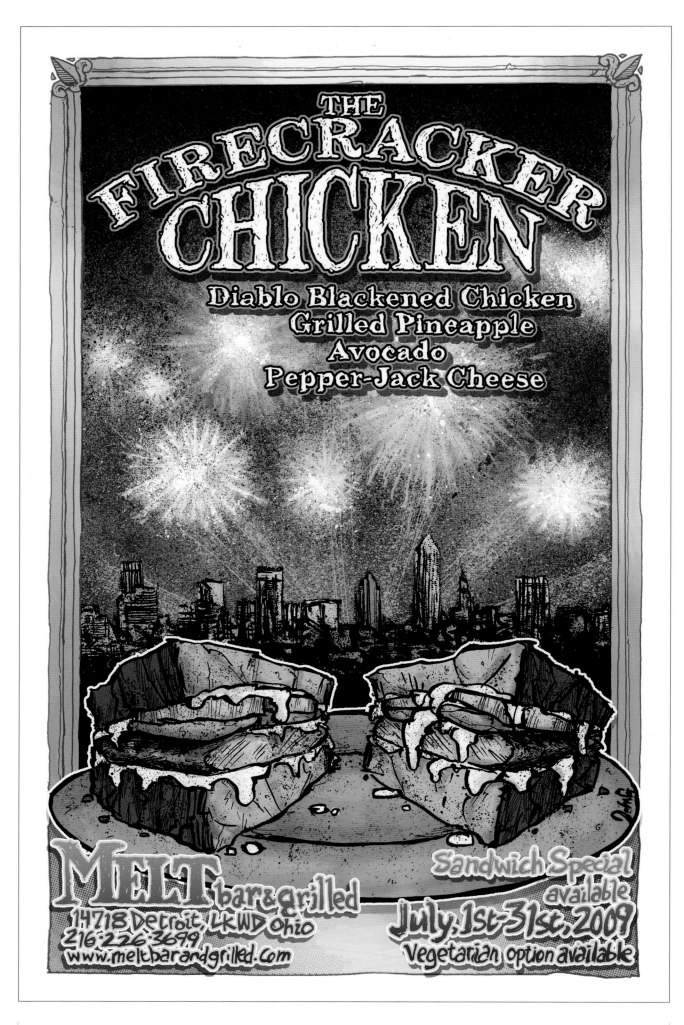

A straightforward "framed version" of a Rust Belt skyline on July 4th.

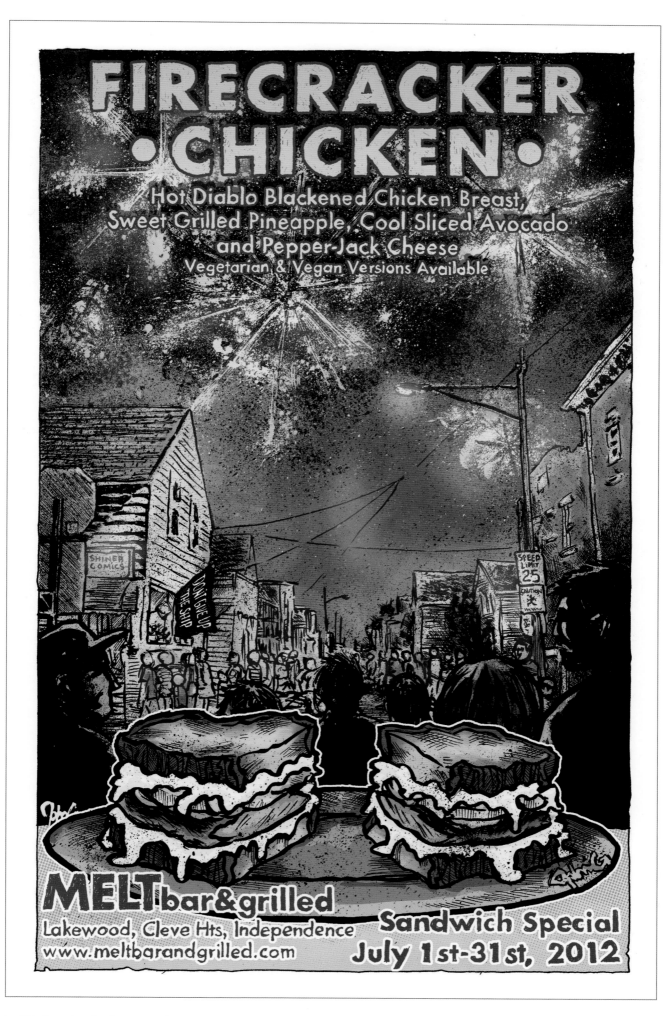

This is a sketch of my neighborhood, the Near West Side, with my house on the left in the foreground (see the mock "Shiner Comics" company name). Please call before a visit.

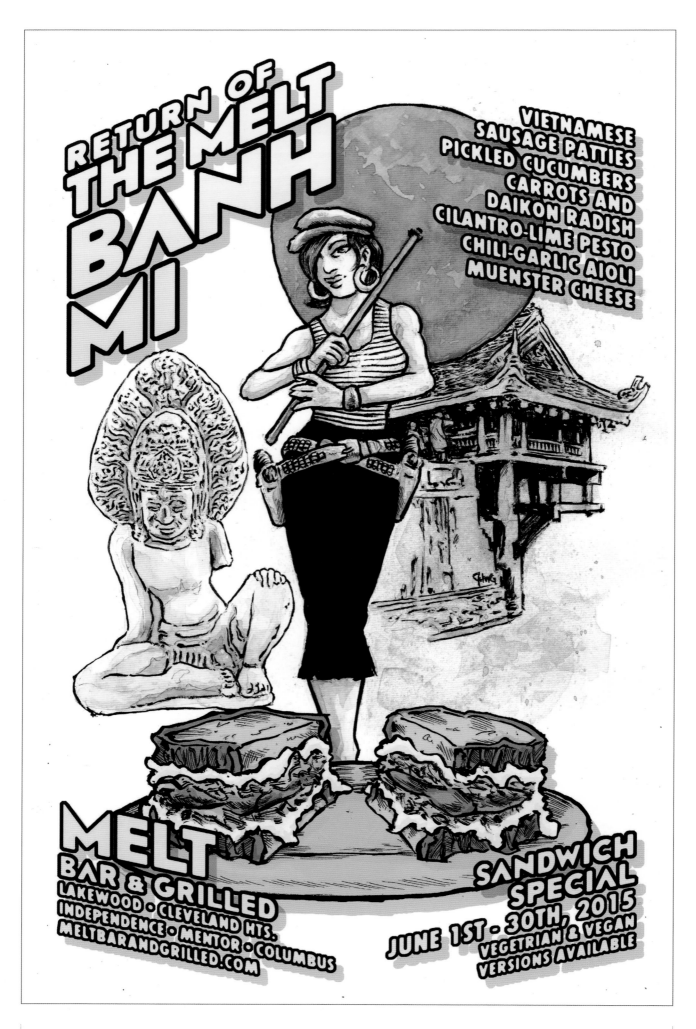

Just your regular, everyday Vietnamese-style hipster gunslinging exploitation poster.

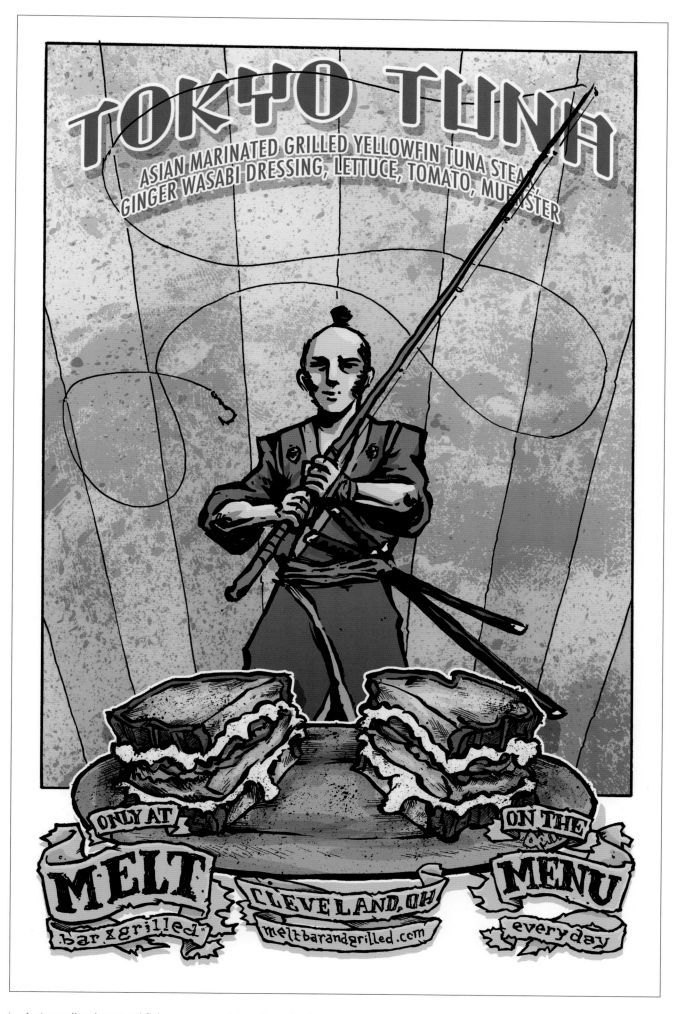

A streamlined samurai fisherman meant to mirror the less detailed approach used for the Melt Banh Mi on the left.

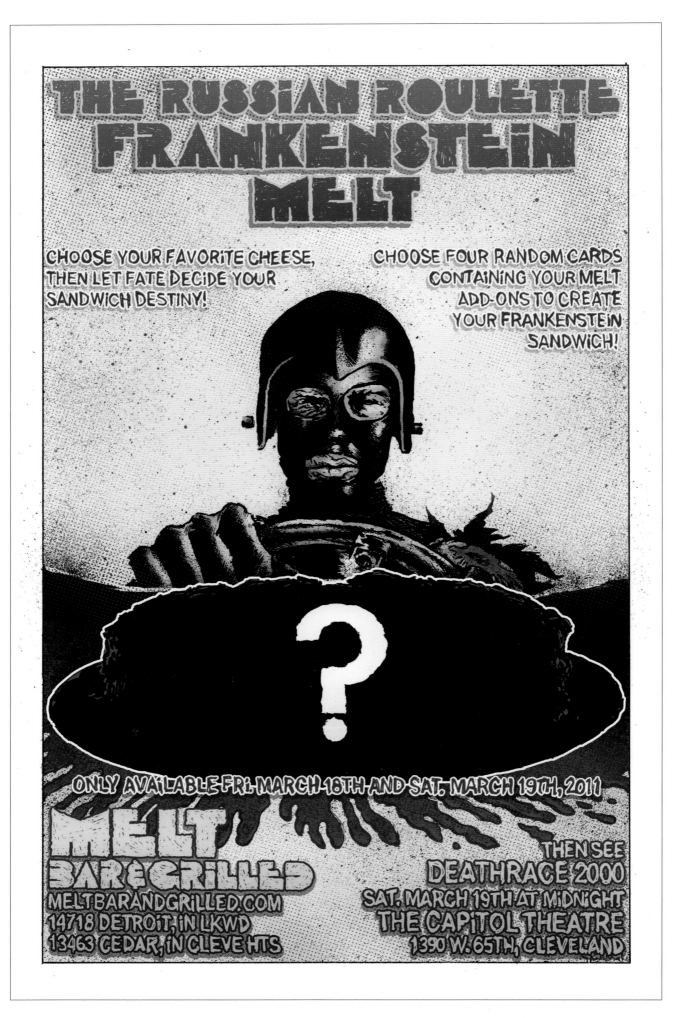

Similar to The Frankenclueless Melt (see page 54) where
random ingredient cards determined your sandwich fate.

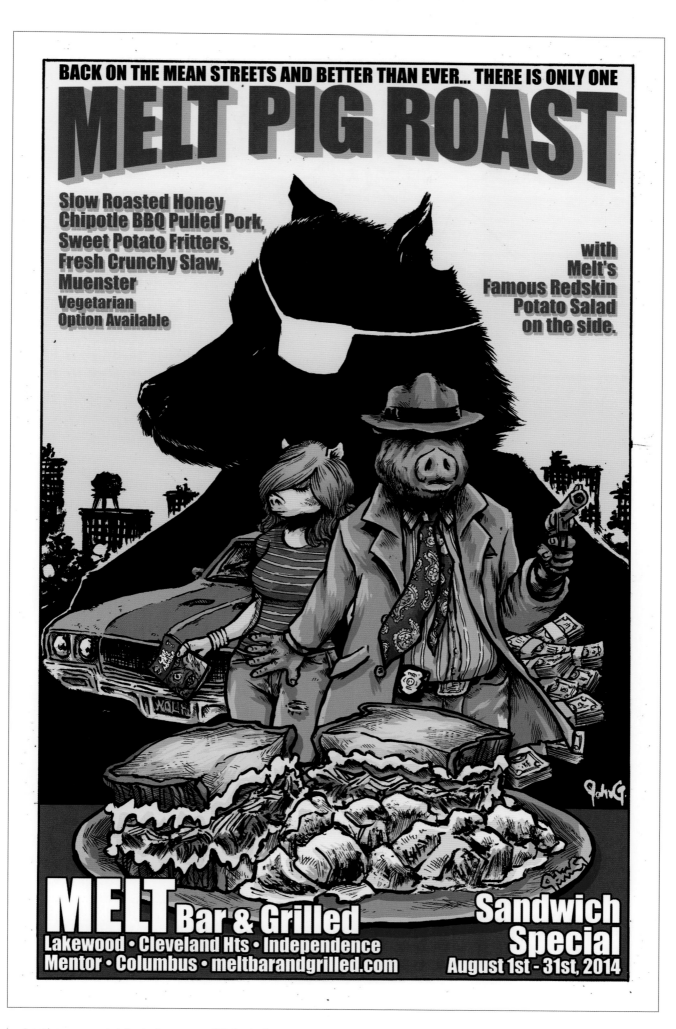

Another neo-noir tribute (see page 85) featuring a pig detective + a comic-reading damsel in distress.

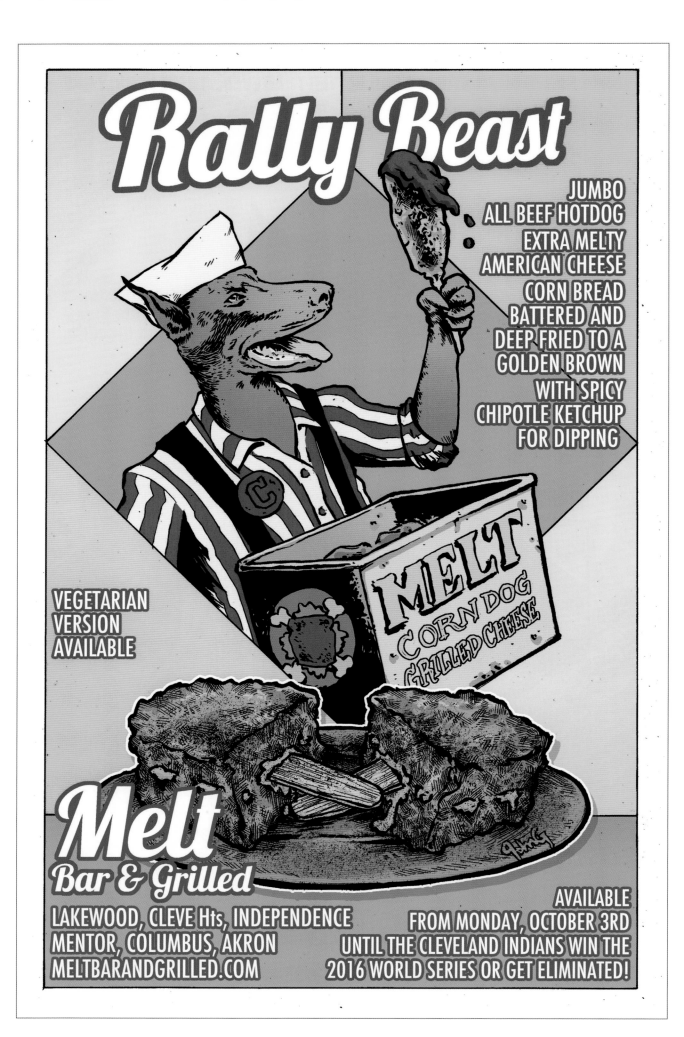

The Cleveland Indians finally returned to the World Series in 2016, so Melt ran a sequence of baseball-related specials, including the Rally Beast.

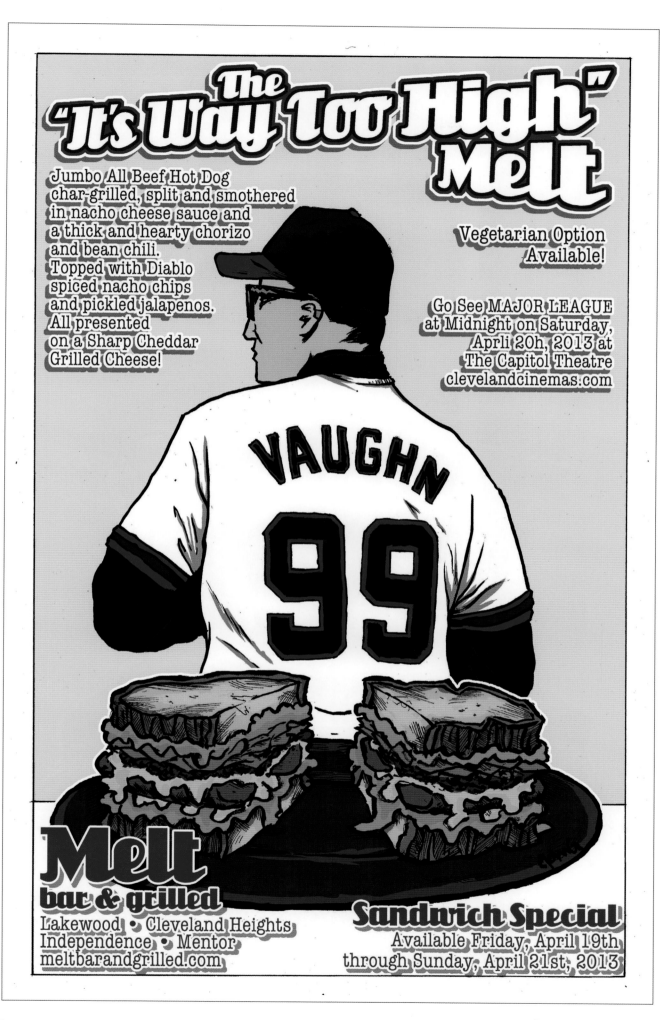

A *Major League* tribute. As a 10 year-old my Lakewood Rec Little League jersey number was 99 (aka the same number as "Wild Thing").

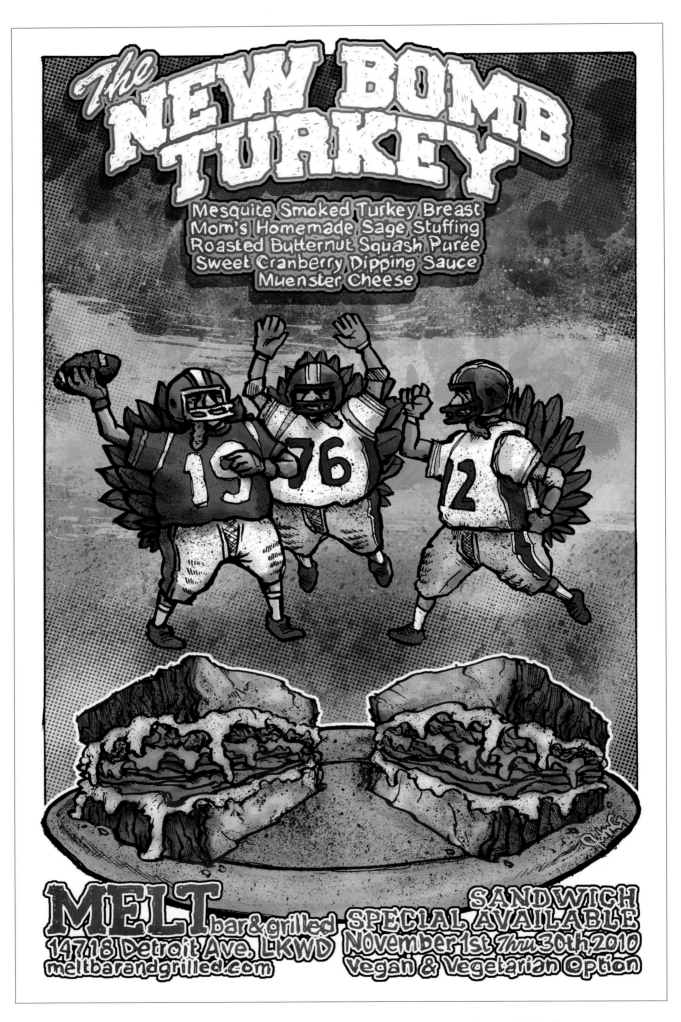

Classic rivalry between the Cleveland Browns and the Pittsburgh Steelers. Here you have mid-'80s lineup Bernie Kosar (#19) passing and Matt Bahr (#9) receiving. Although... Bahr was mainly a placekicker. Don't fault me for not being a Browns aficionado.

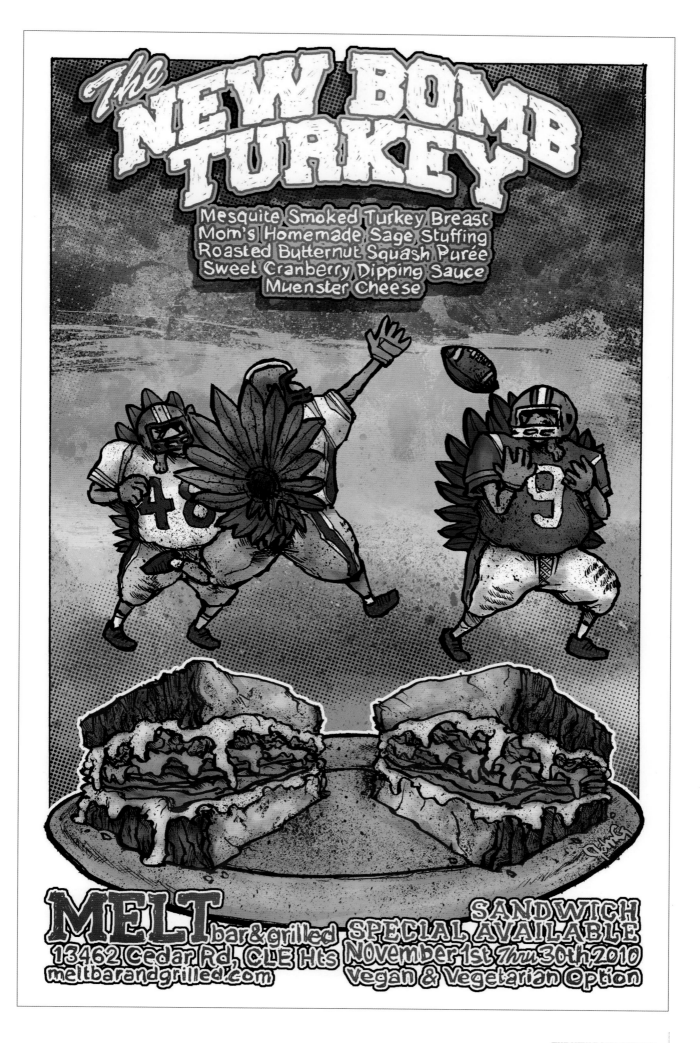

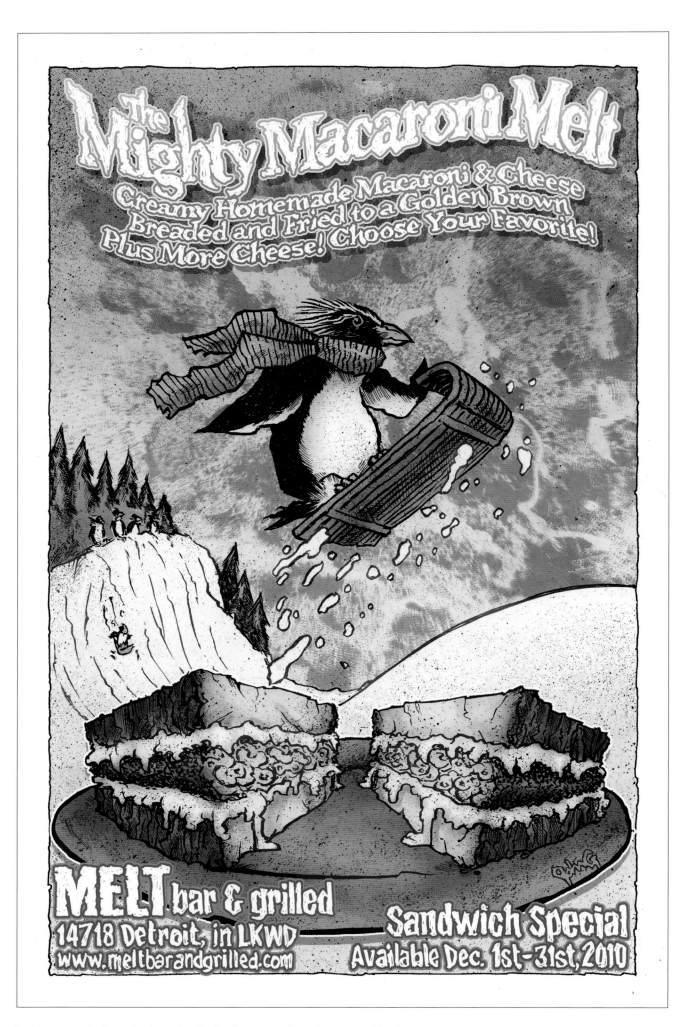

The penguin from the bear family finally gets a diptych poster of his/her own!
The character is patterned after an actual macaroni penguin species.

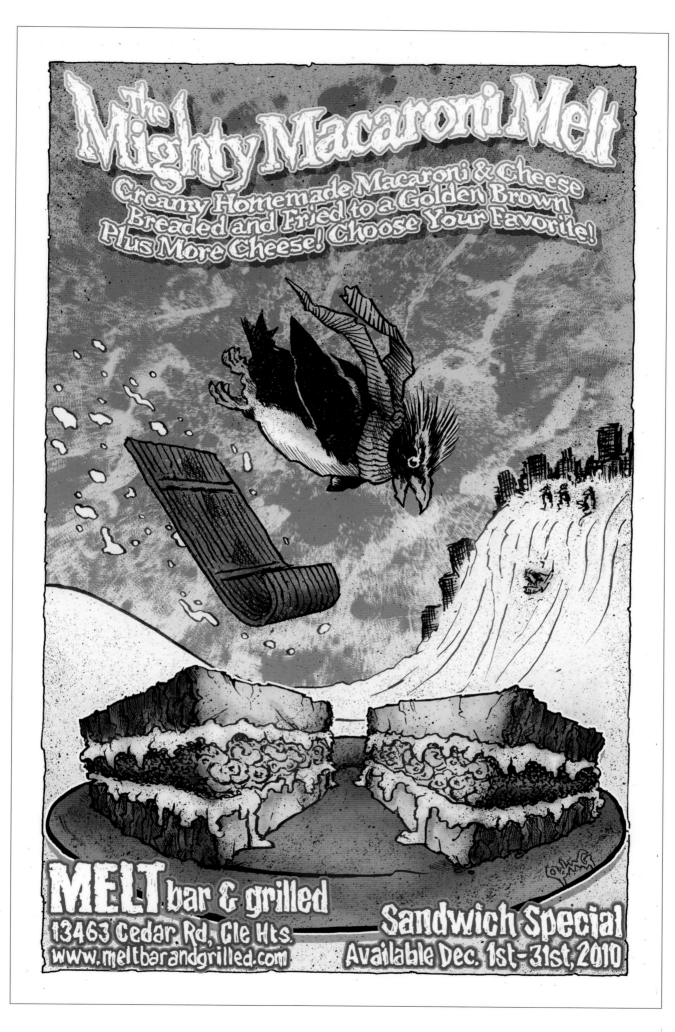

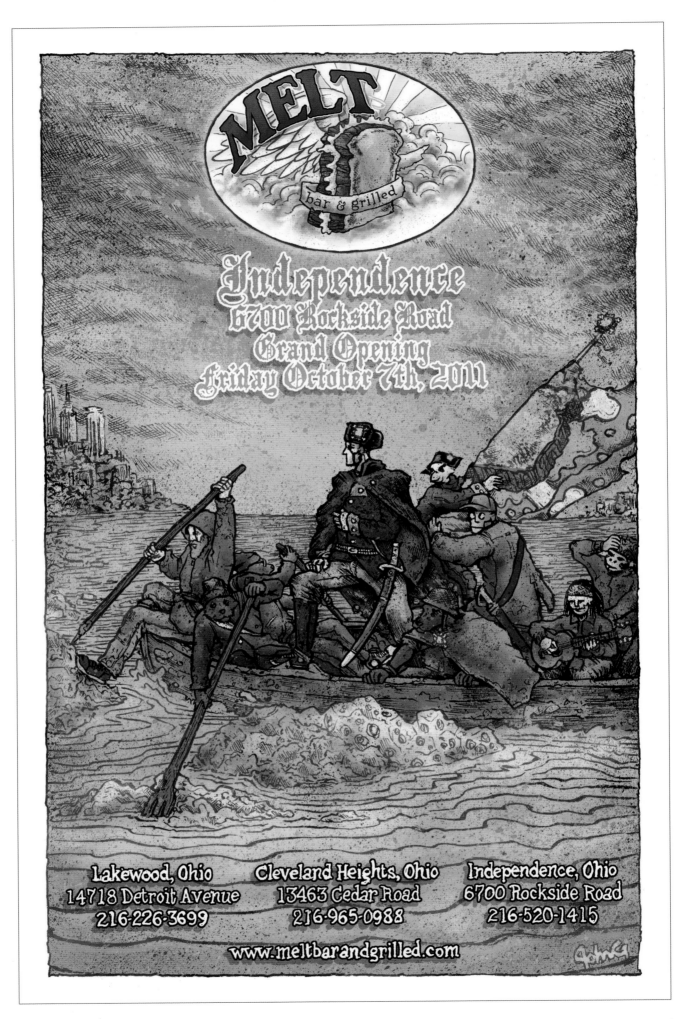

Matt "Washington" Fish crosses the Cuyahoga "Delaware" River. As a robot. In a river of cheese.

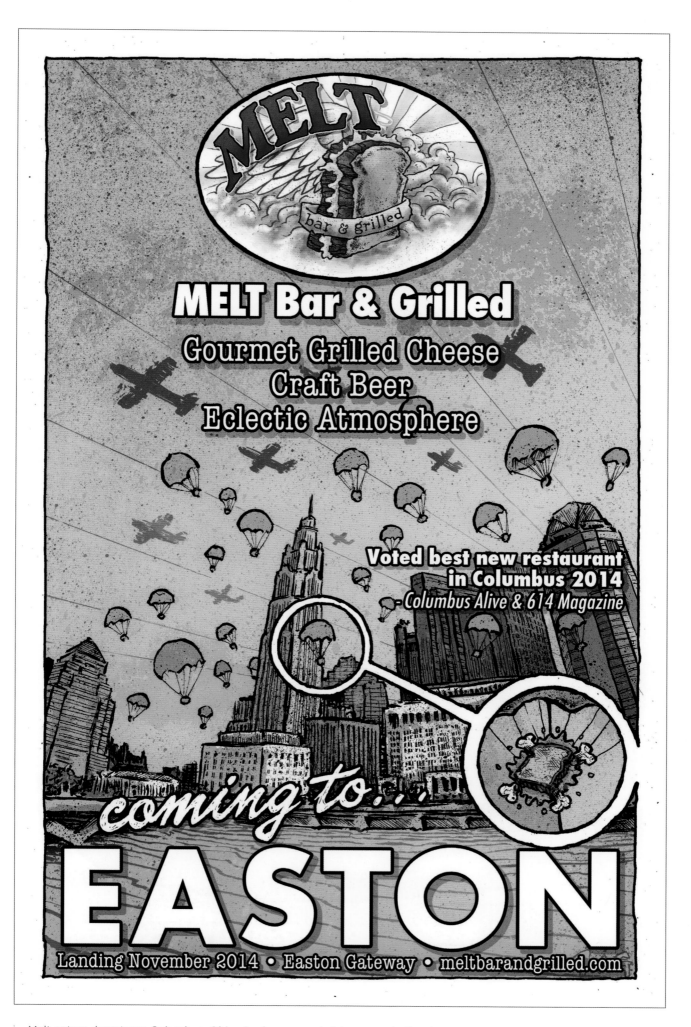

Melt enters downtown Columbus, Ohio via cheese sandwiches parachuting in.
Think *Red Dawn*, but much more fun. *Bread Dawn*.

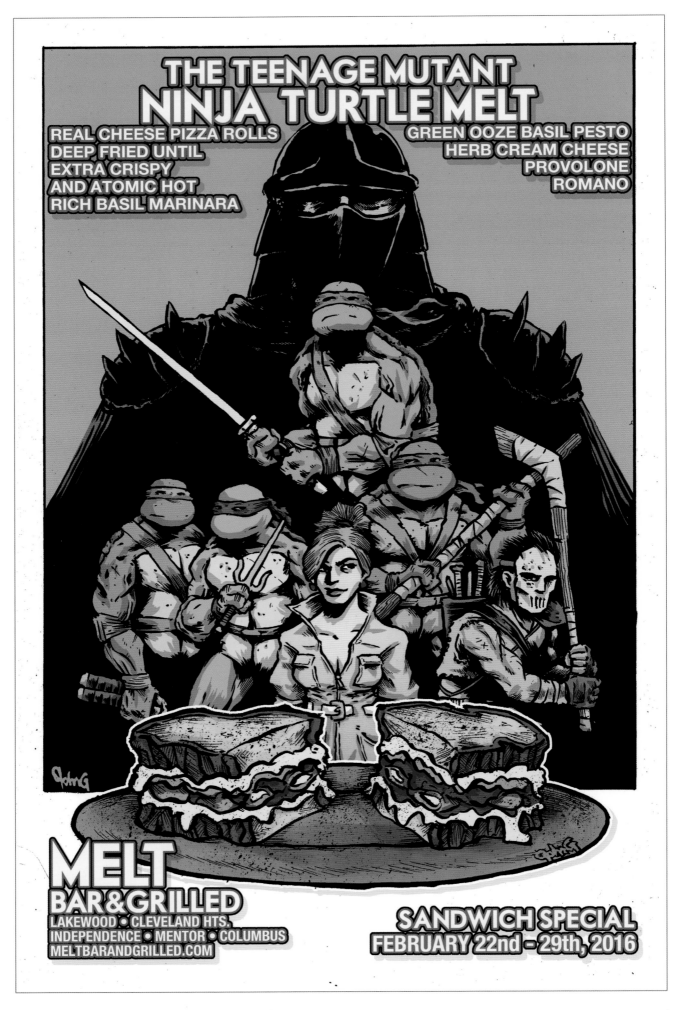

The Ninja Turtles return. Very loosely based on the *Return of the Jedi* theatrical poster.

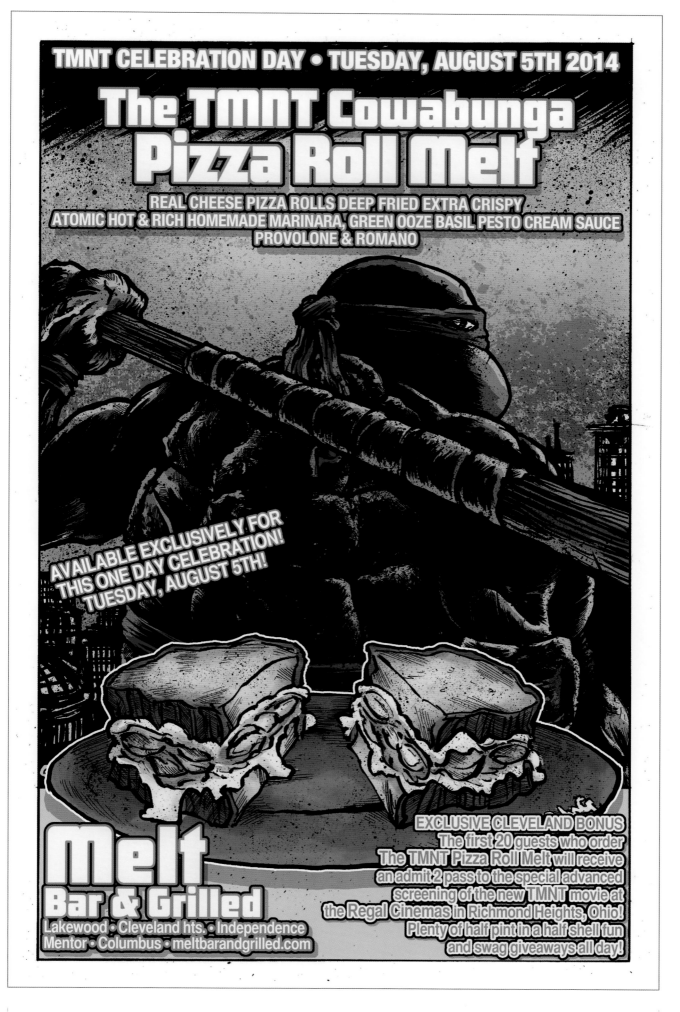

Donatello!

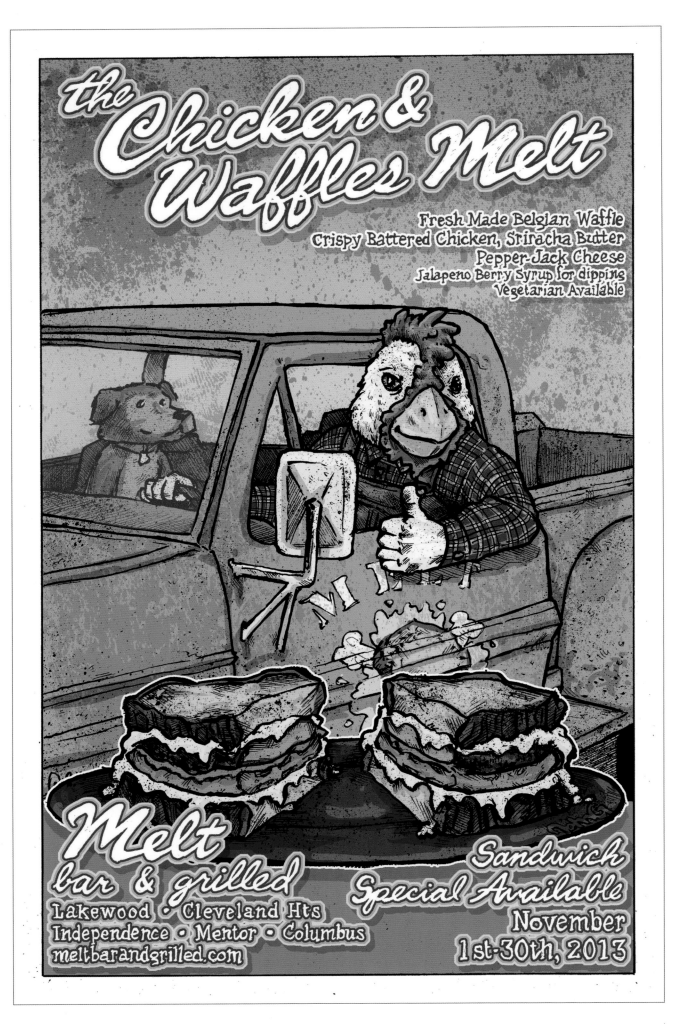

I wanted to showcase the rural style of Ohio in a poster, which certainly has a *Footloose* feel to it.

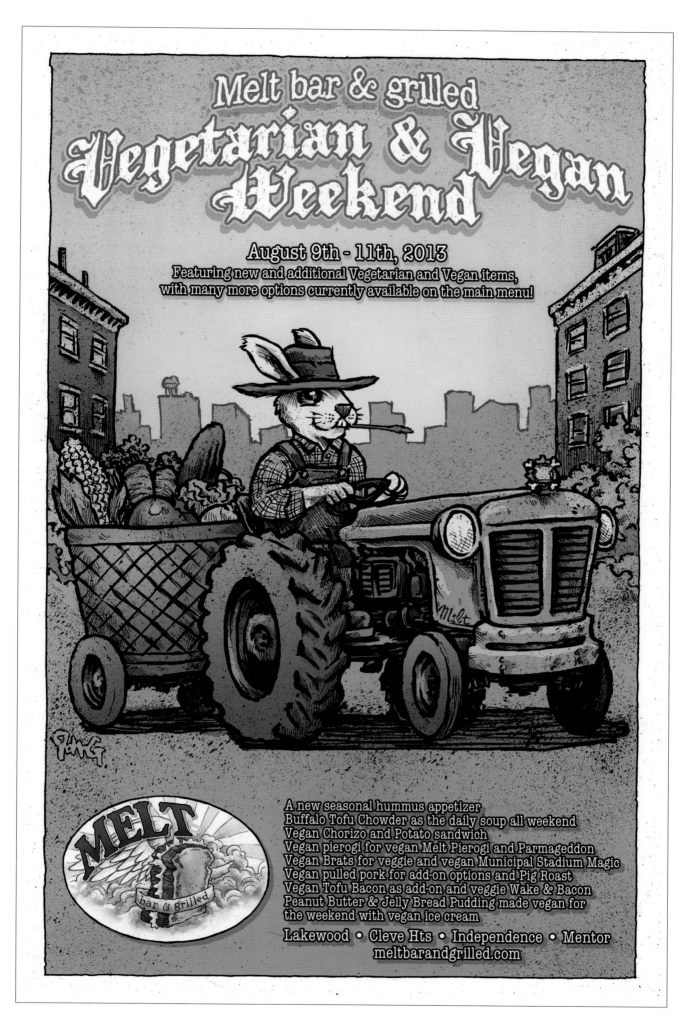

Melt embraces vegetarians and vegans every day of the week, but ups the ante on designated weekends.

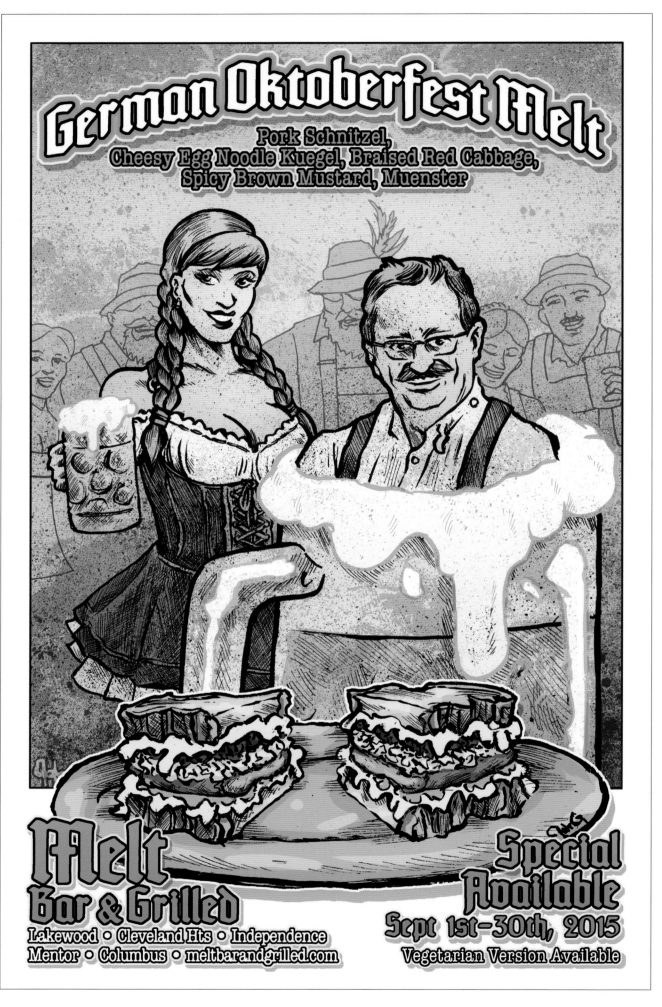

A parody of Munich's actual mayor, Christian Ude (from 1993 to 2014), enjoying a pint and more at Oktoberfest.

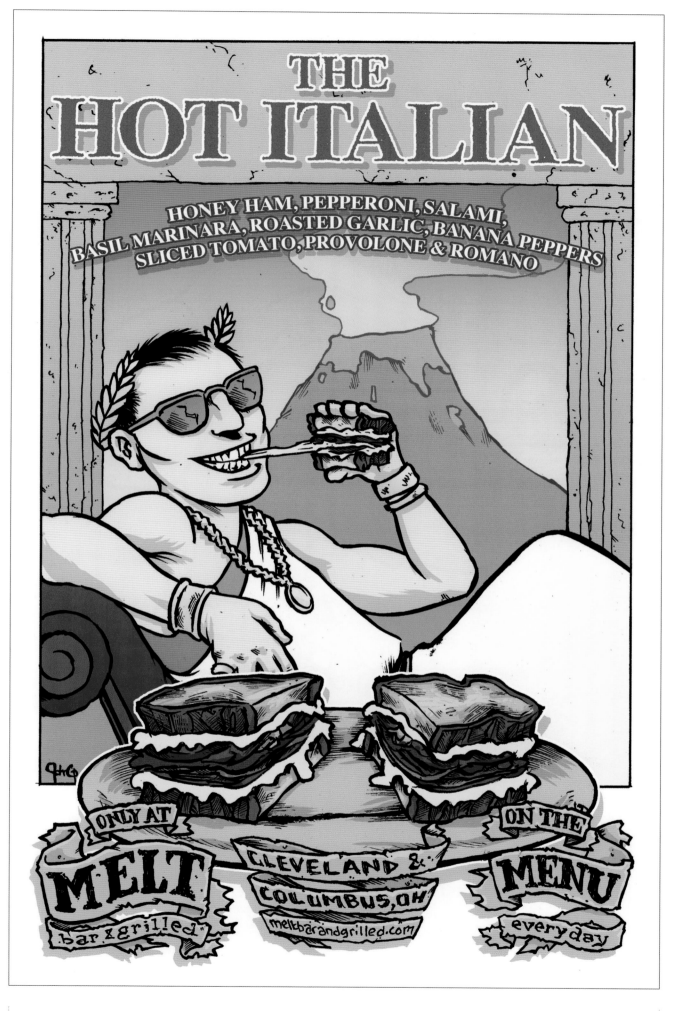

Mount Pompeii meets the Roman Empire meets *Jersey Shore*.

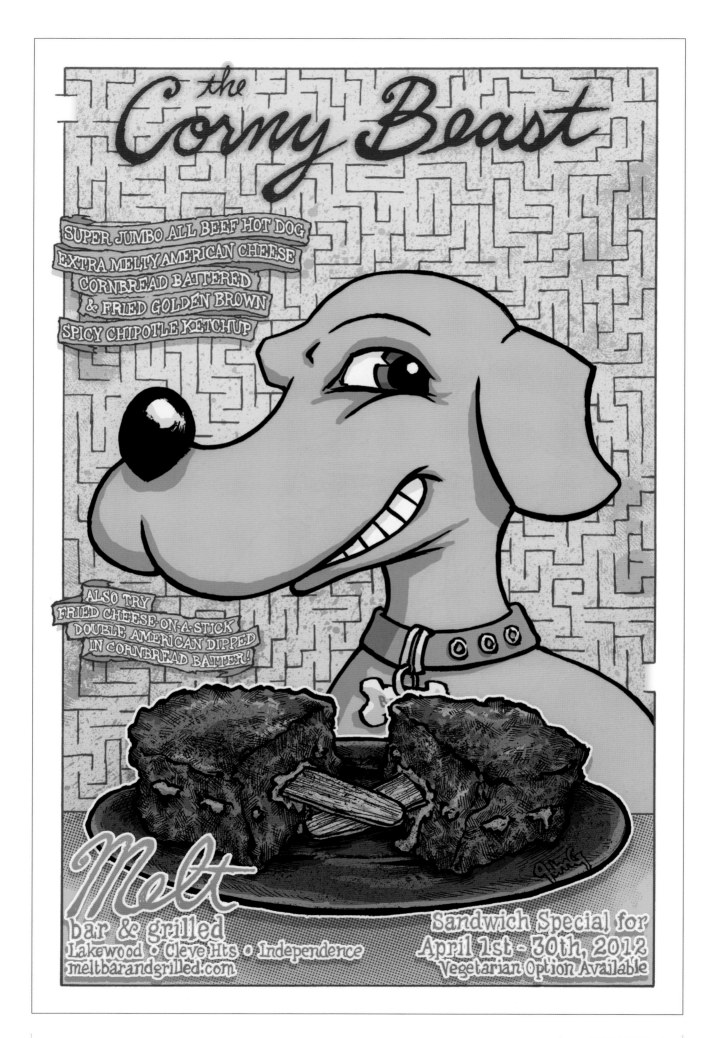

Your very own corny activity page! It was fun to draw this maze (maize) of fun.

THE CORNY BEAST

162

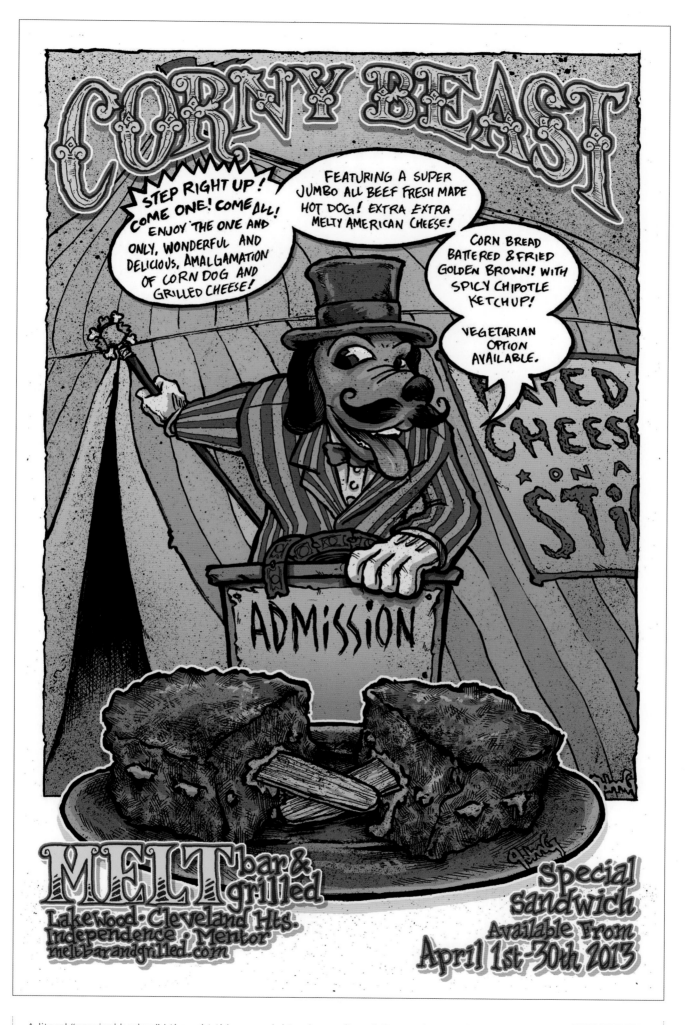

A literal "carnival barker." I thought this was mighty clever after all these takes on the Corny Beast. **THE CORNY BEAST**

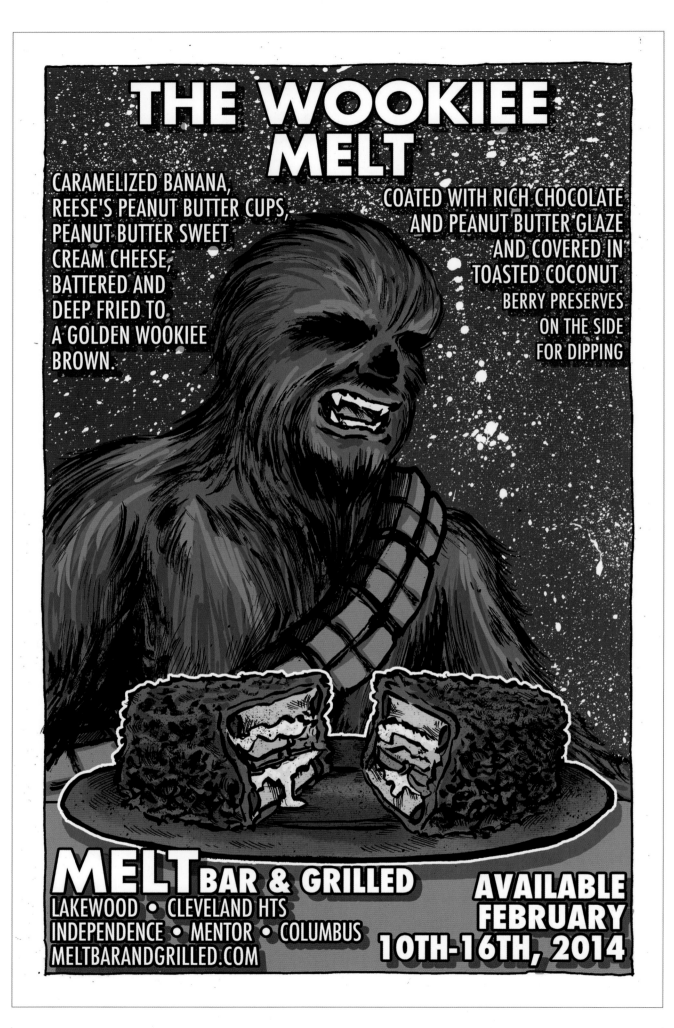

Easily one of the hardest posters to draw due to Chewie's intricate fur detailing.

THE WOOKIEE MELT

164

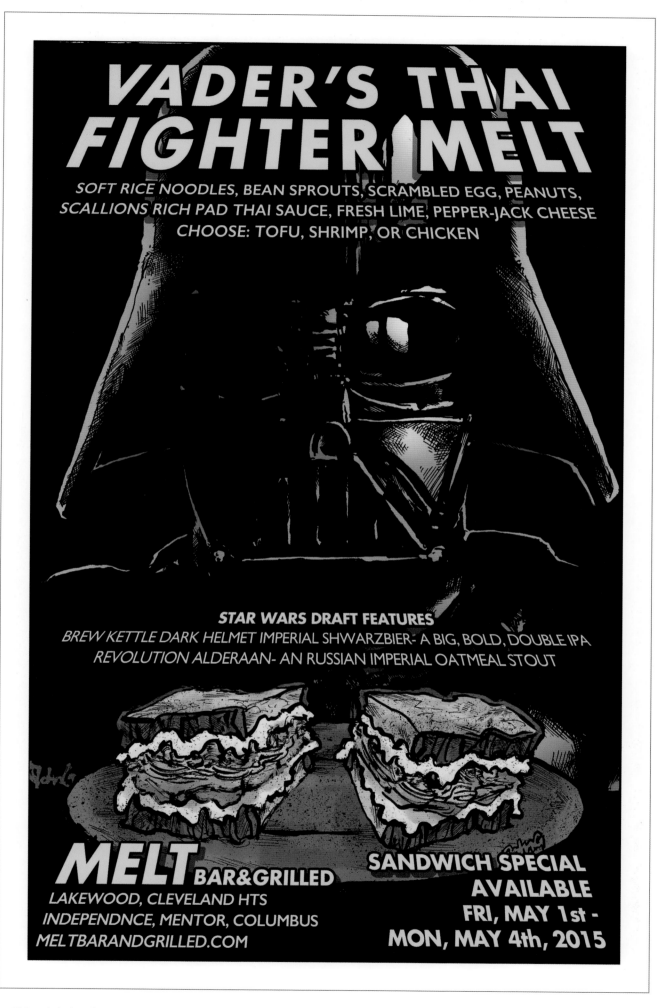

This might be the only true portrait in the book
(vs. my typical stylized cartoon take on a character).

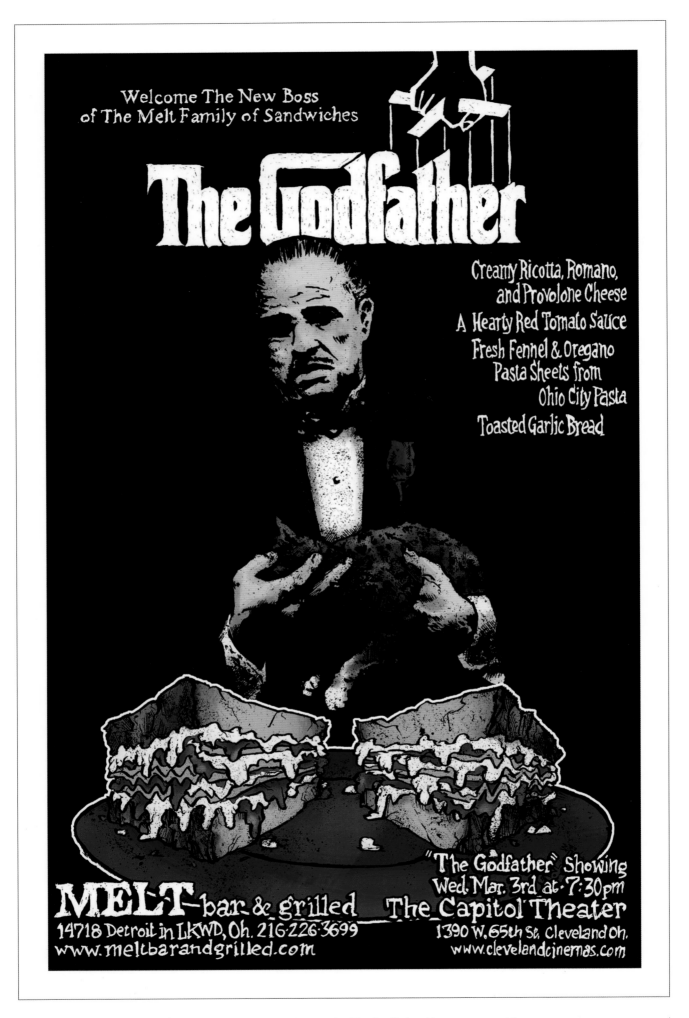

Straightforward praise for one of the best pictures ever made, *The Godfather*. Keep an eye out for a framed, theatrical-sized version of this print, as it was recently stolen from the Melt Independence location.

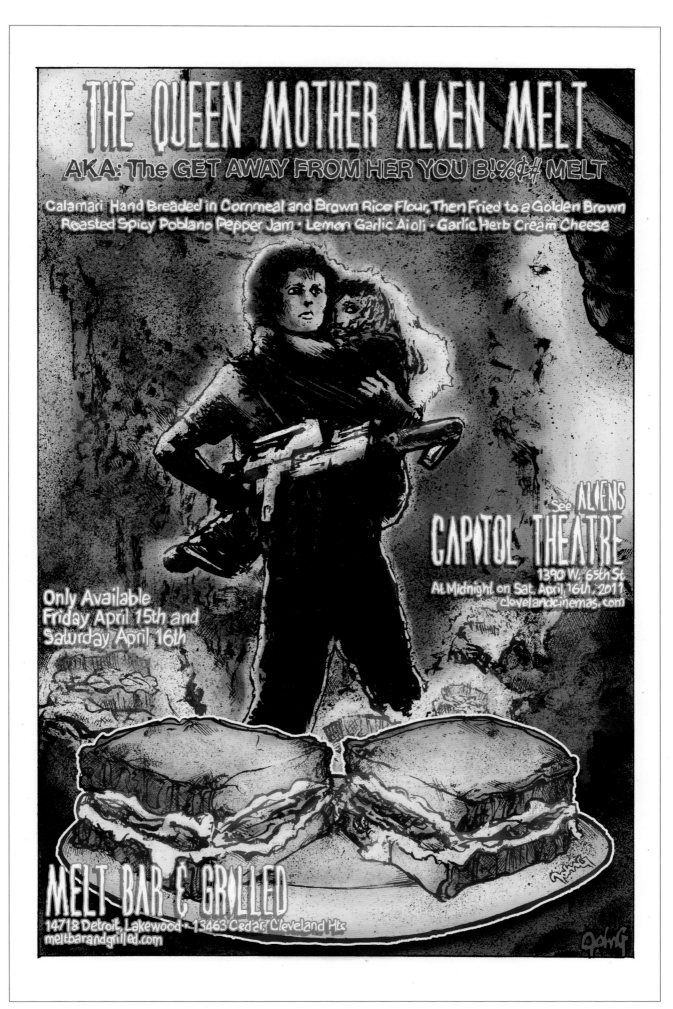

Finally a way to include a curse word in the title of a sandwich!
Perhaps also one of the most crowd-pleasing lines of all time in a film.
I learned a few choice swear words as a kid by watching this movie.

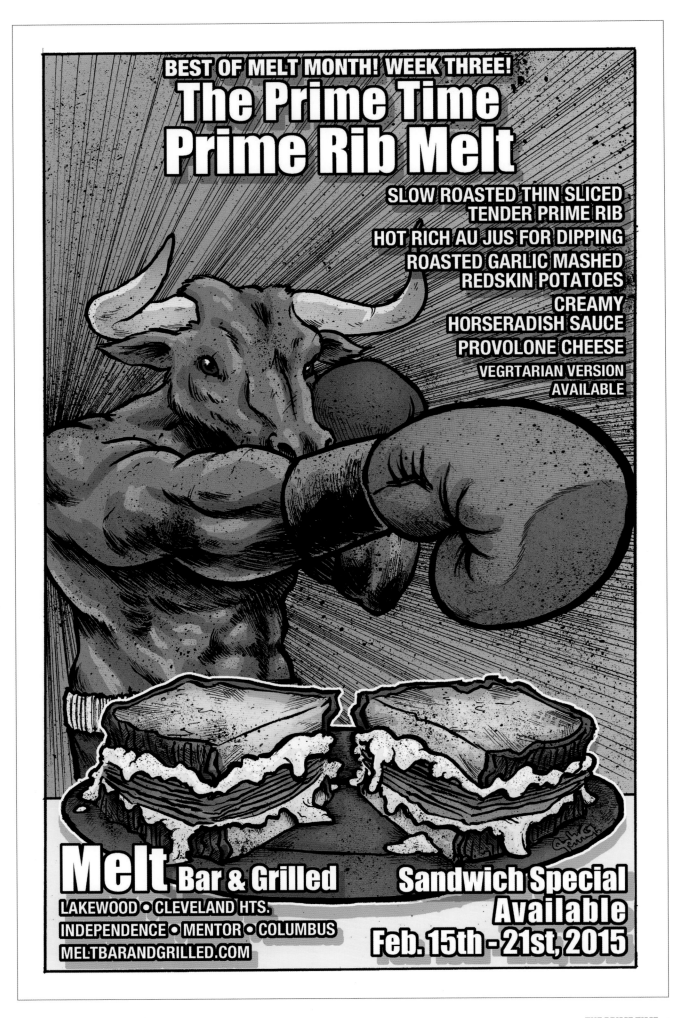

I rarely draw action sequences. The speed lines were directly influenced by Japanese manga.

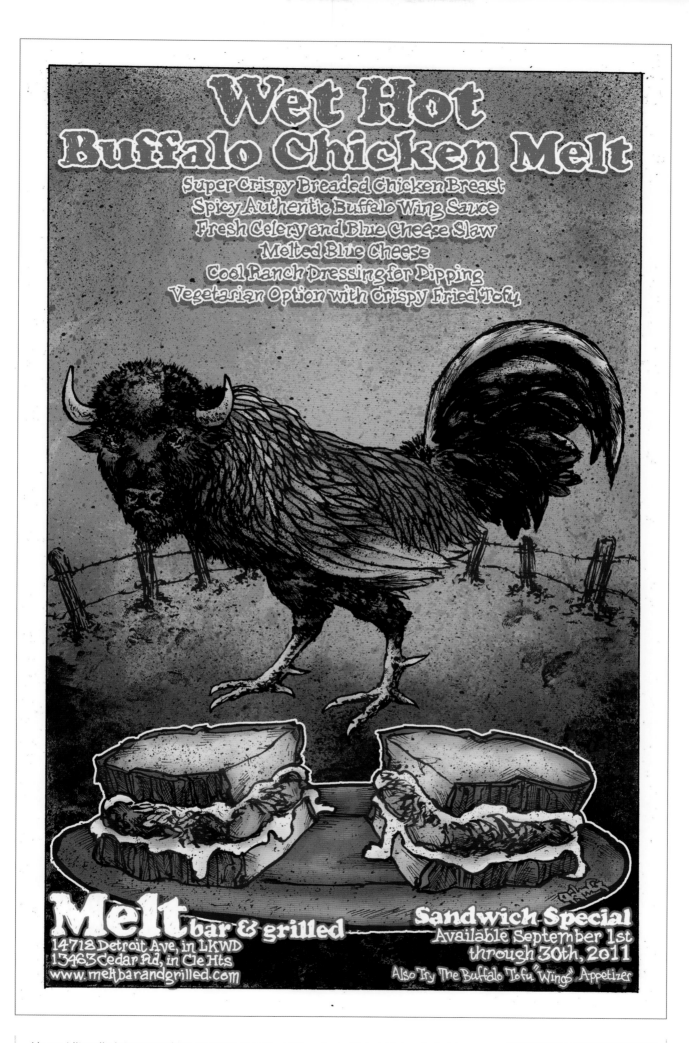

Above I literally interpreted interpreted the absurdity of a buffalo/chicken hybrid.

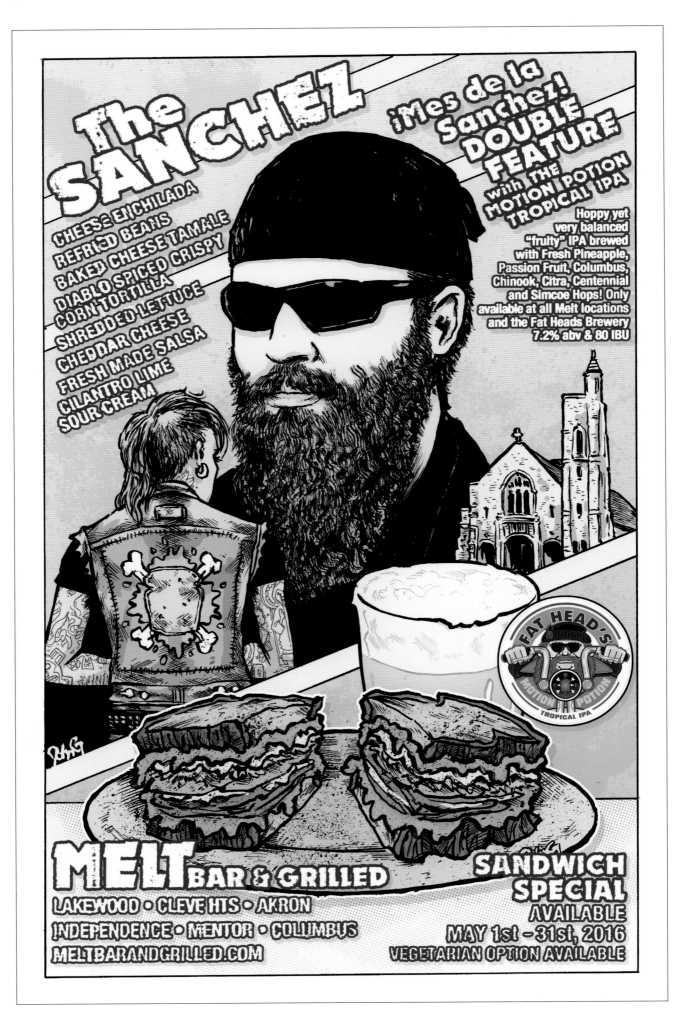

The Director of Operations from Melt returns (see page 109).
Sometimes it's a challenge to include so much text in a creative way.

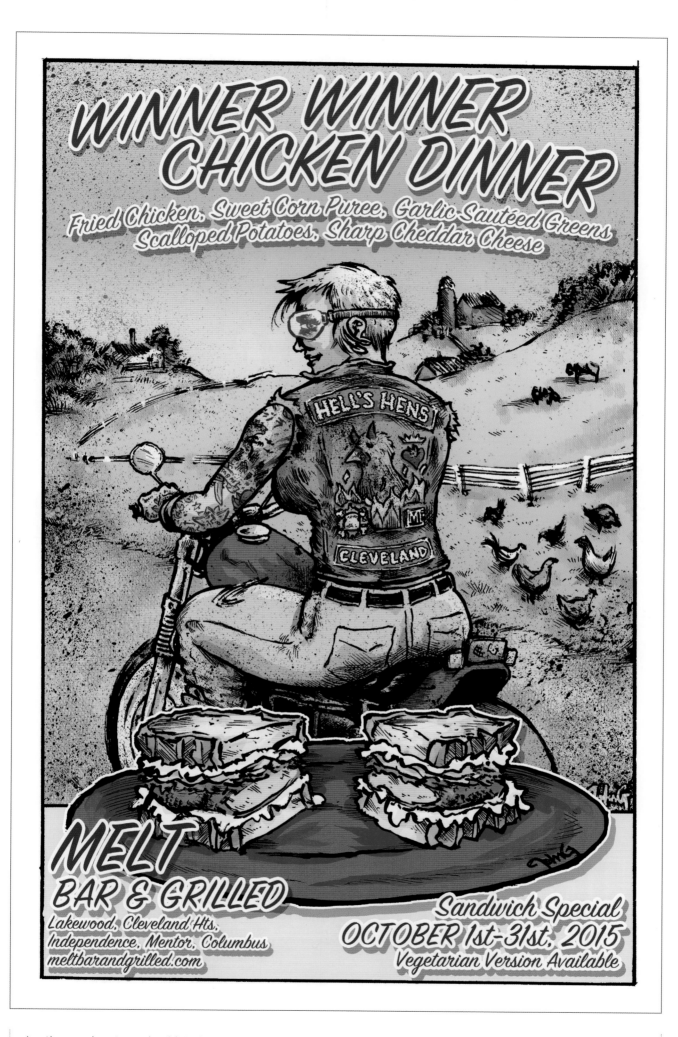

Another rural motorcycle girl (quite common in Ohio). A member of Hell's Hens!

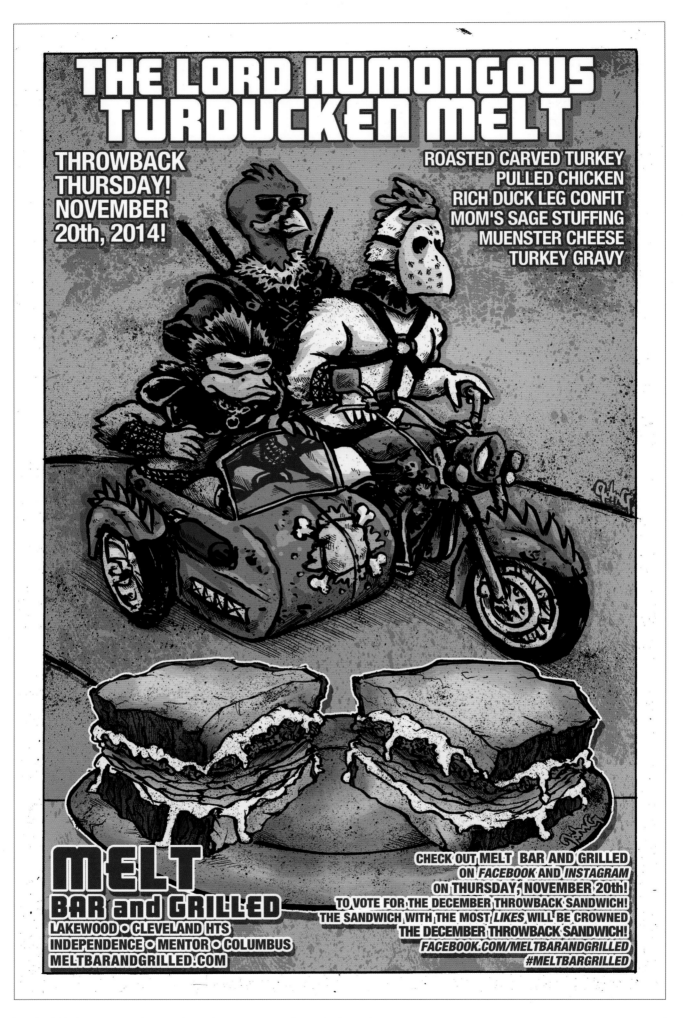

The idea here was *"The Road Warrior* vs. *Looney Tunes,"* where the characters are in search of a quick sandwich instead of guzzolene.

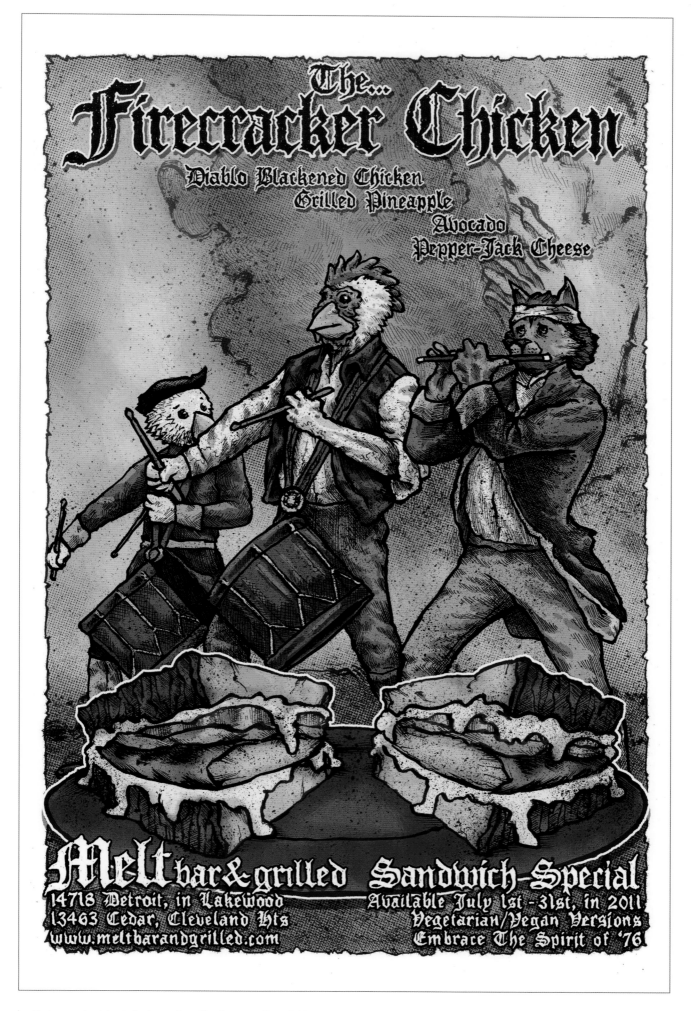

Not so coincidentally based on the famous Revolutionary War painting *Spirit of '76* by Archibald Willard.

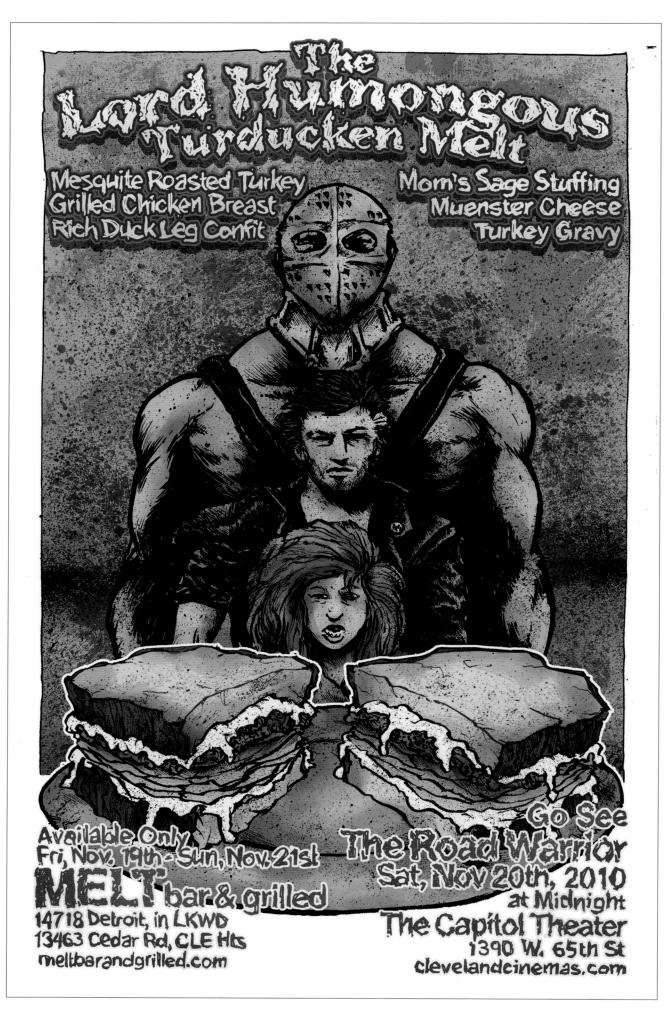

The Road Warrior cast drawn as a set of nesting Russian Dolls (a play off of the turducken).

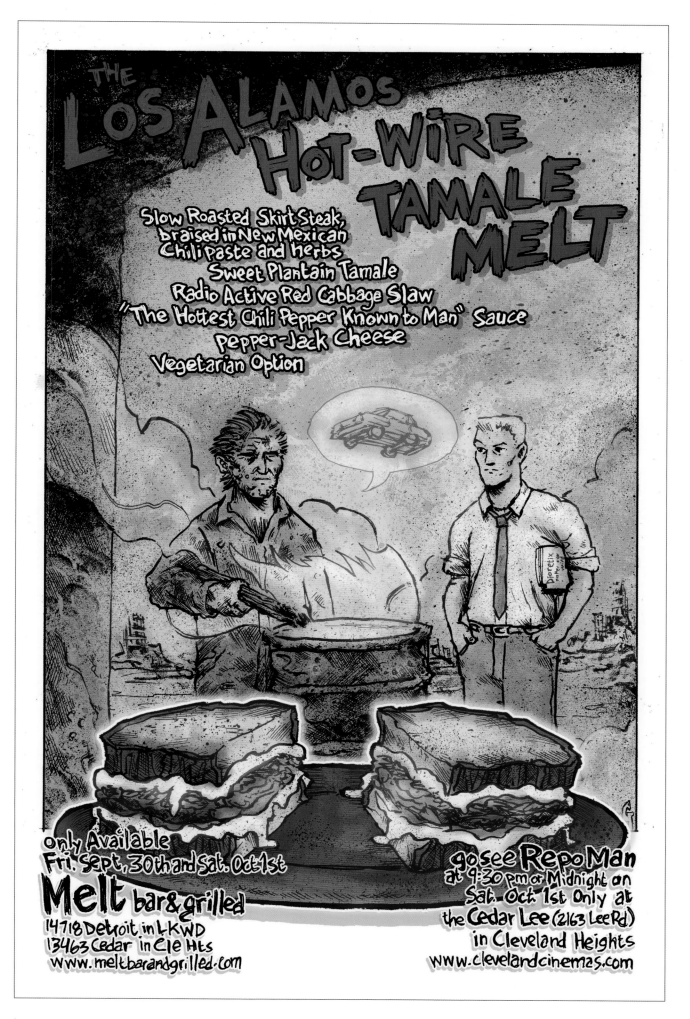

Based on a scene from the cult flick *Repo Man*. If you've seen it, you'll get it. If not, see it. It's 98% on Rotten Tomatoes. This poster was given to Emilio Estevez when he was in town promoting his 2010 flick *The Way*.

THE LOS ALAMOS HOT-WIRE TAMALE MELT

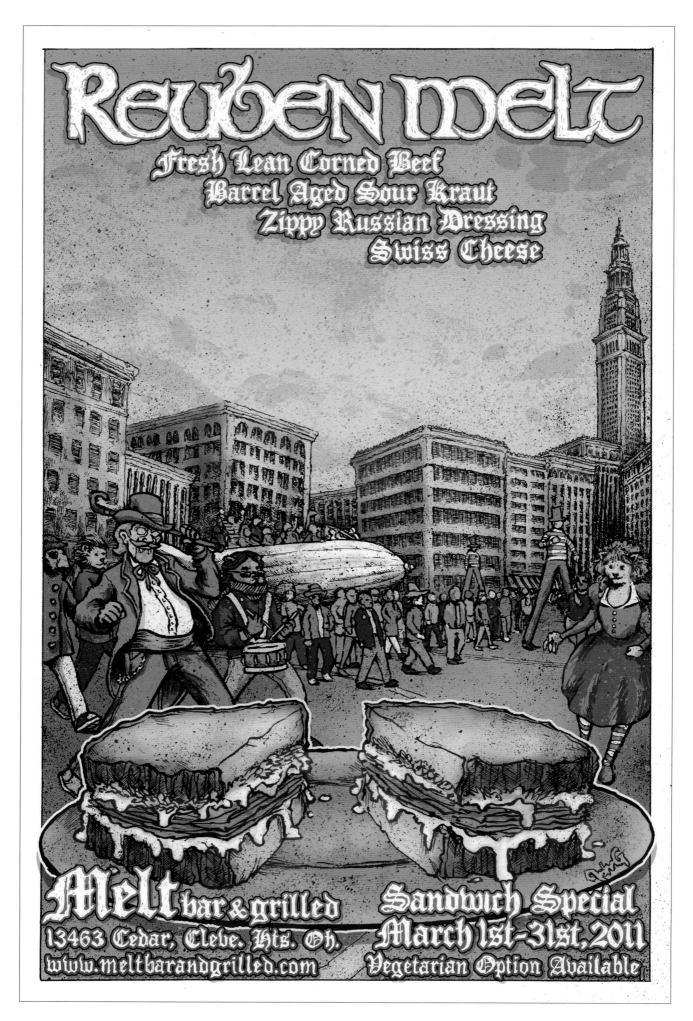

My depiction of an old school St Patrick's Day parade in Public Square, featuring the Rocket ride from the long-defunct Euclid Beach Park.

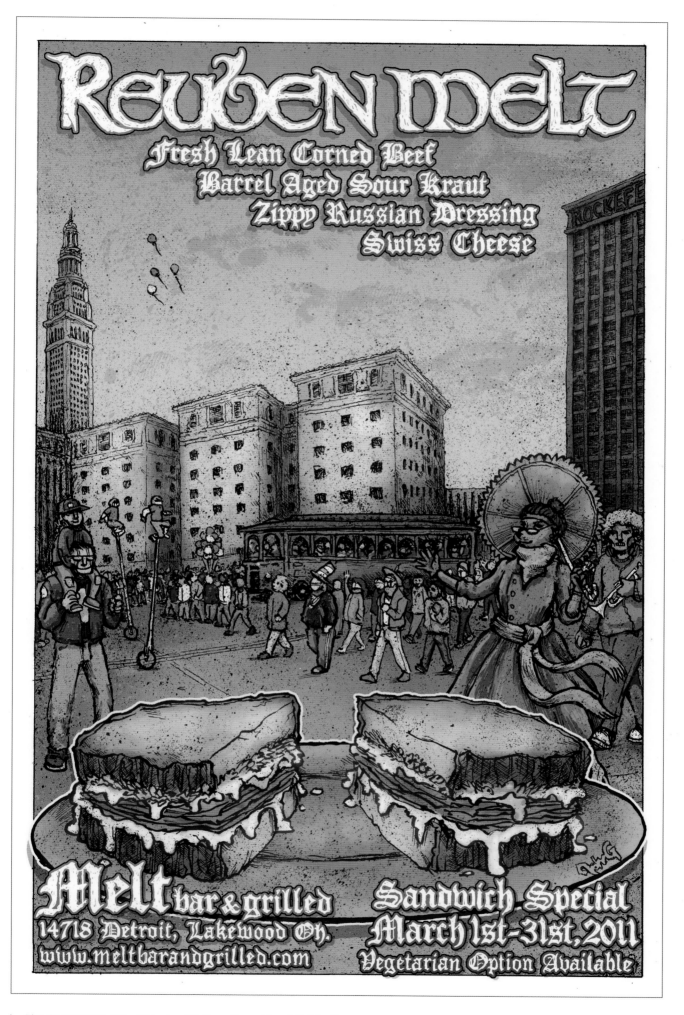

The St Patrick's Day diptych with the other side of Public Square, complete with tourist magnet Lolly the Trolley.

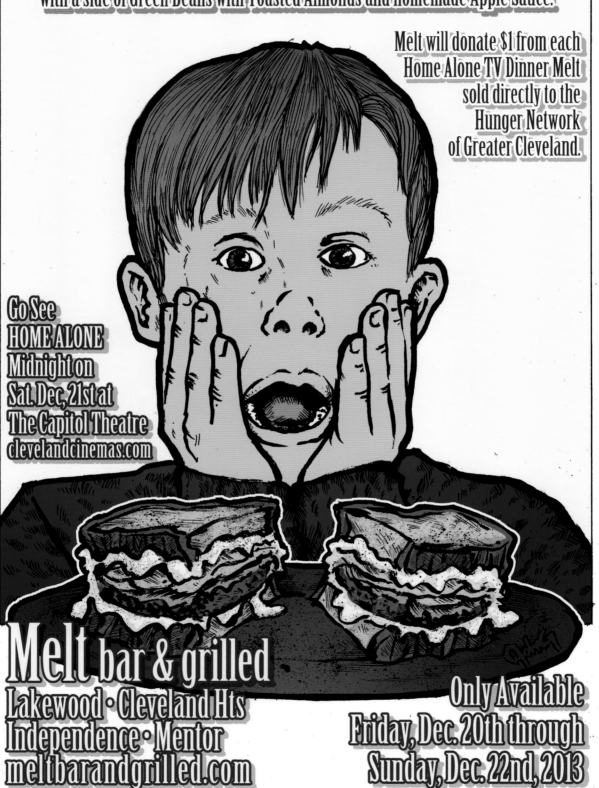

A faithful take on the *Home Alone* (Kevin!) poster. Also a smartly-designed "TV dinner" meal that included a charitable donation with purchase.

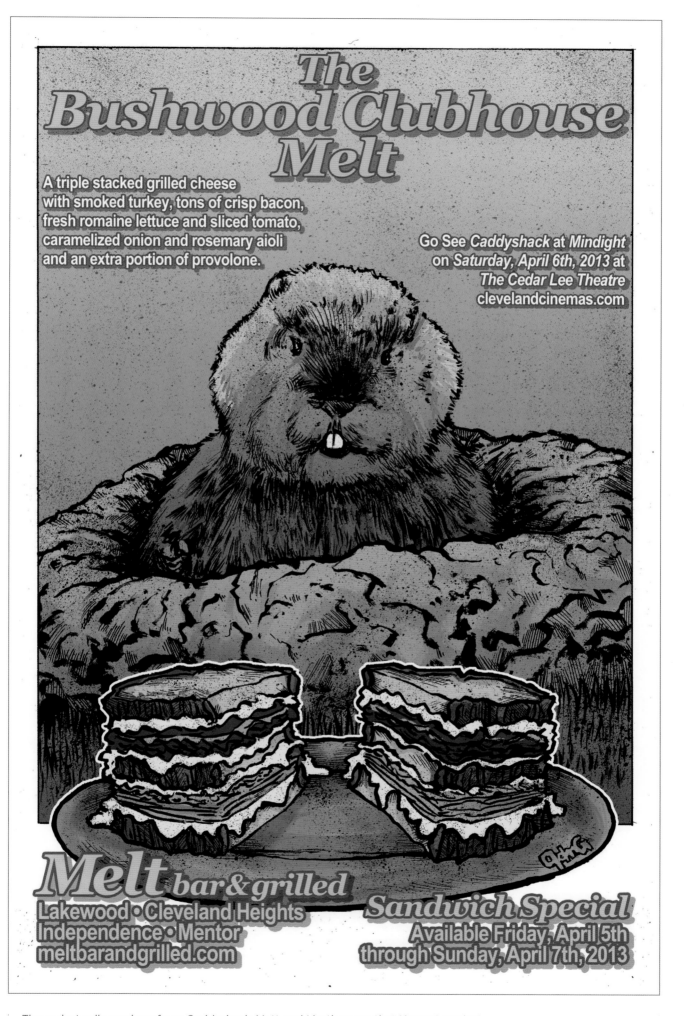

Those dastardly gophers from *Caddyshack*. Matt and I both agree that Kenny Loggins' "I'm Alright" should have been played on a loop as this special was served.

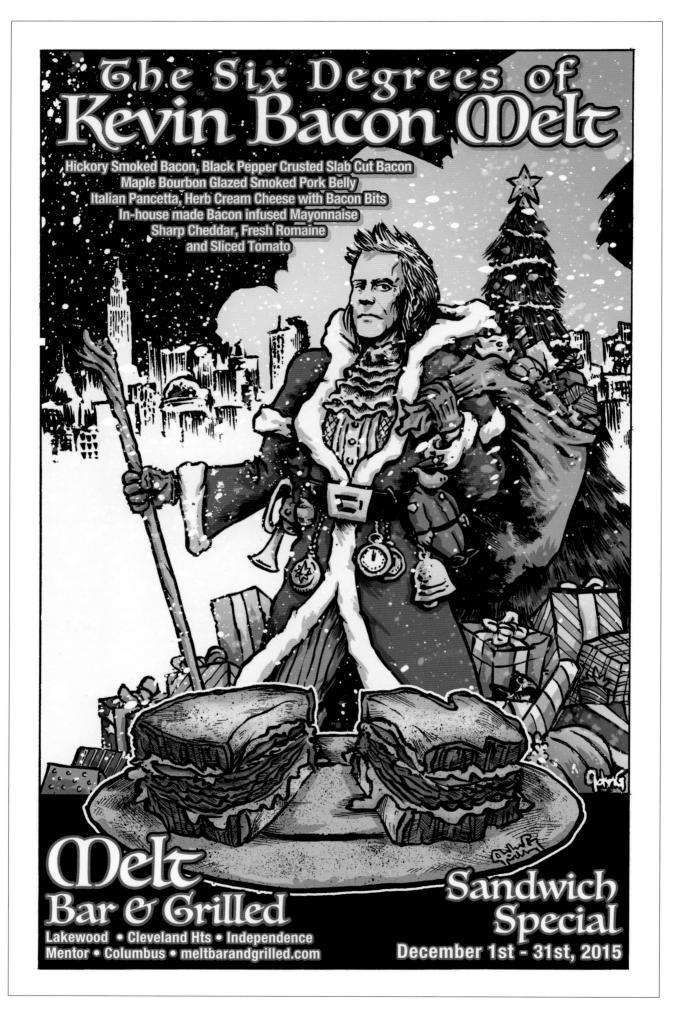

Kevin Bacon is so cool he was recreated here as Father Christmas,
with a bit of holiday edginess (see the stuffed pig cop toy).

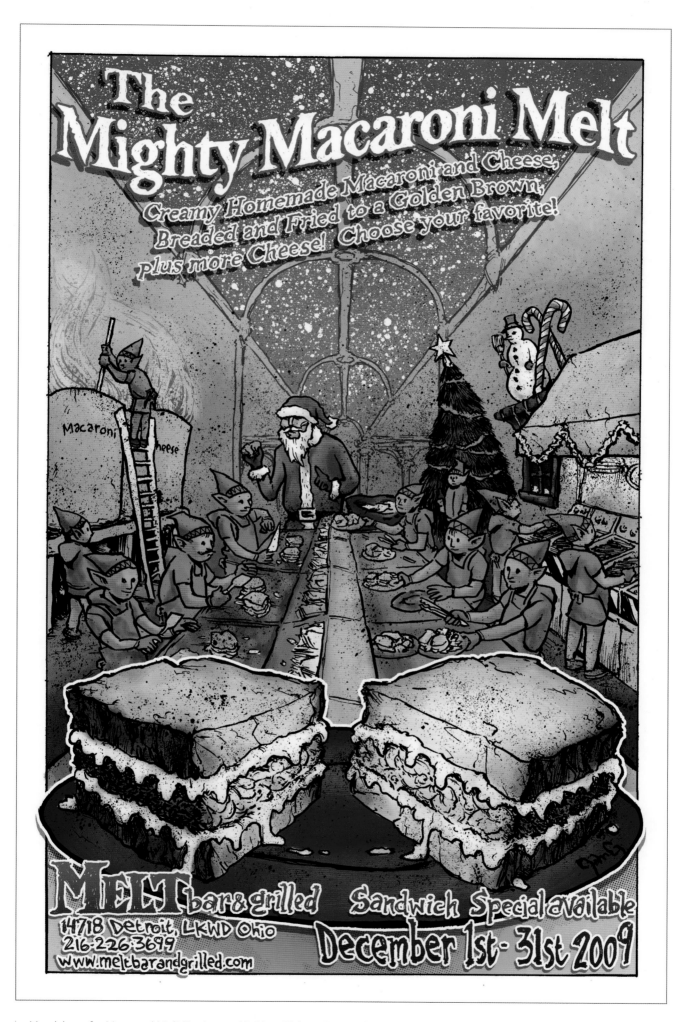

My vision of a Macaroni Melt Factory, with Matt Fish as Santa Claus.
Who doesn't want a stocking full of mac and cheese?

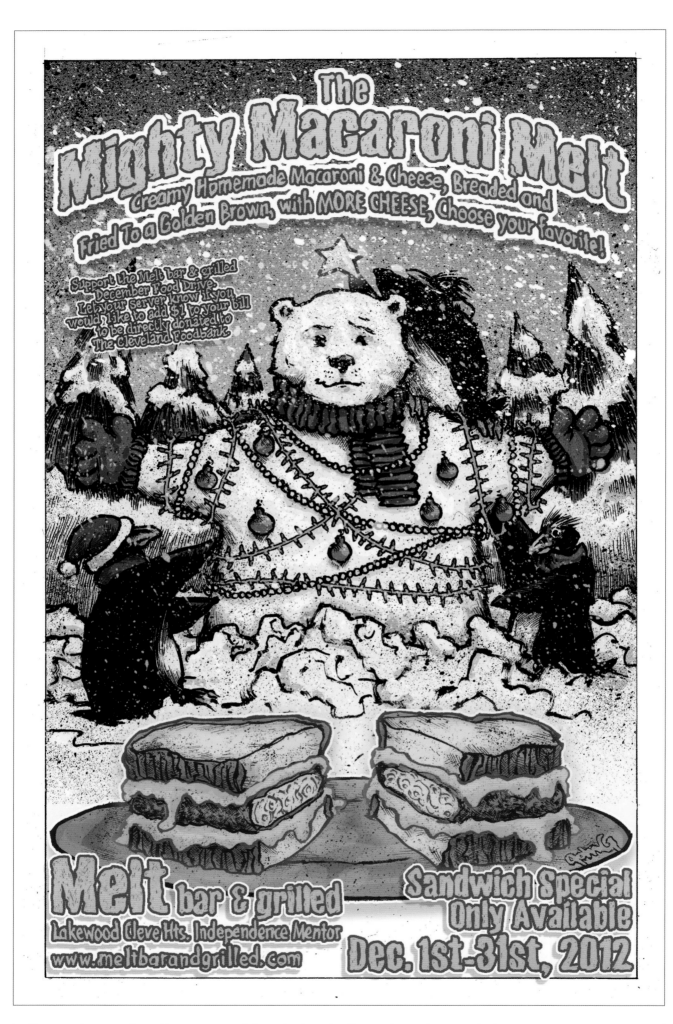

Those pesky penguins taking over one of the polar bear family members. This reminded me of the scene in *Scrooged* when Alfre Woodard's son was decorated as a tree.

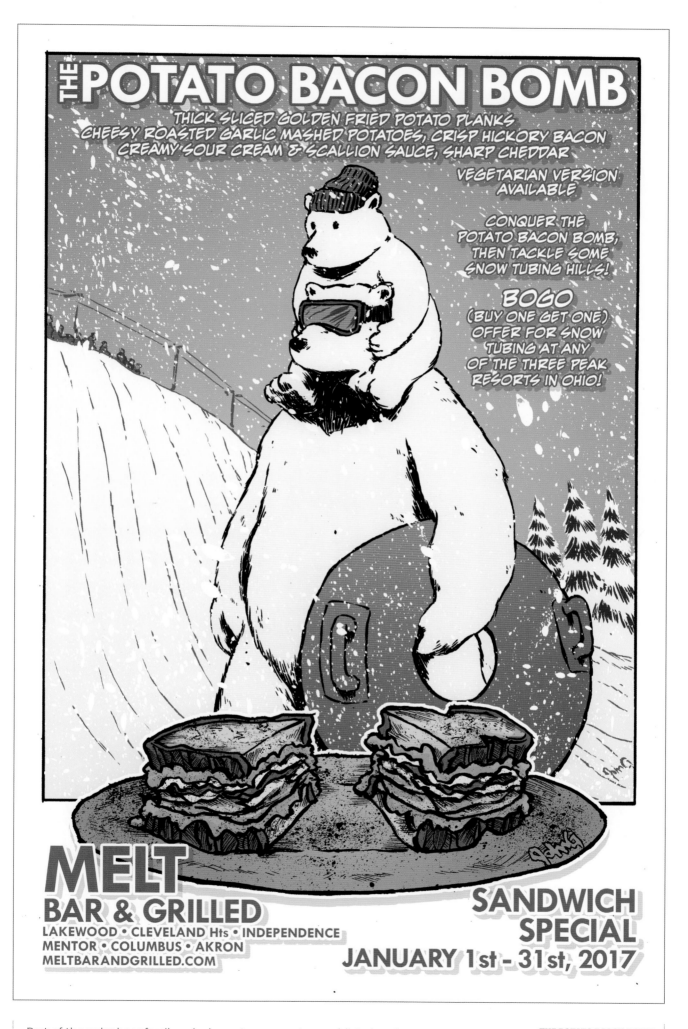

Part of the polar bear family enjoying extreme sports on a blistering day out.

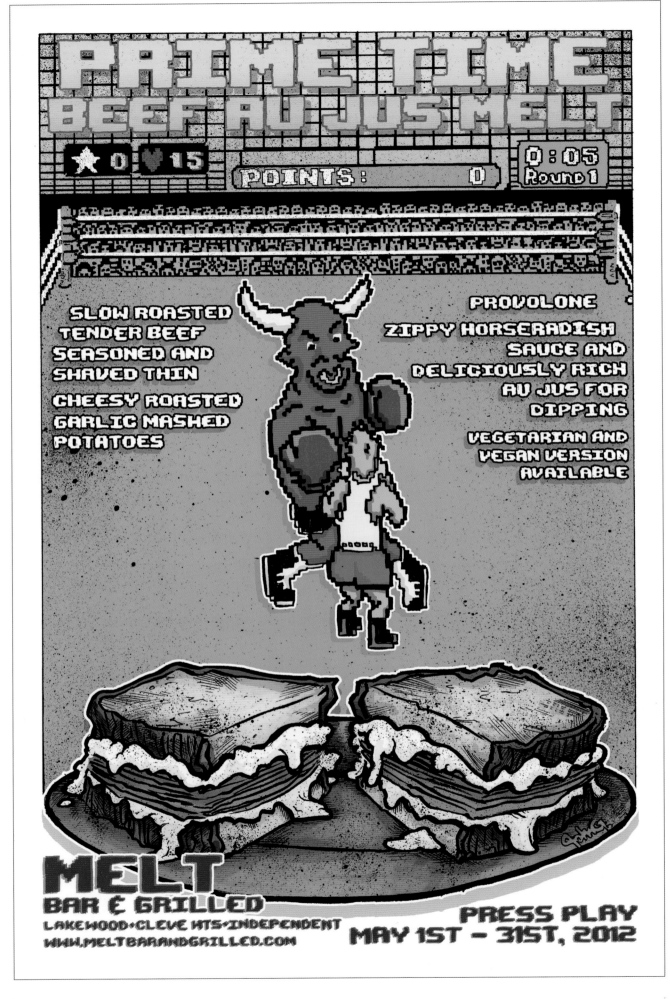

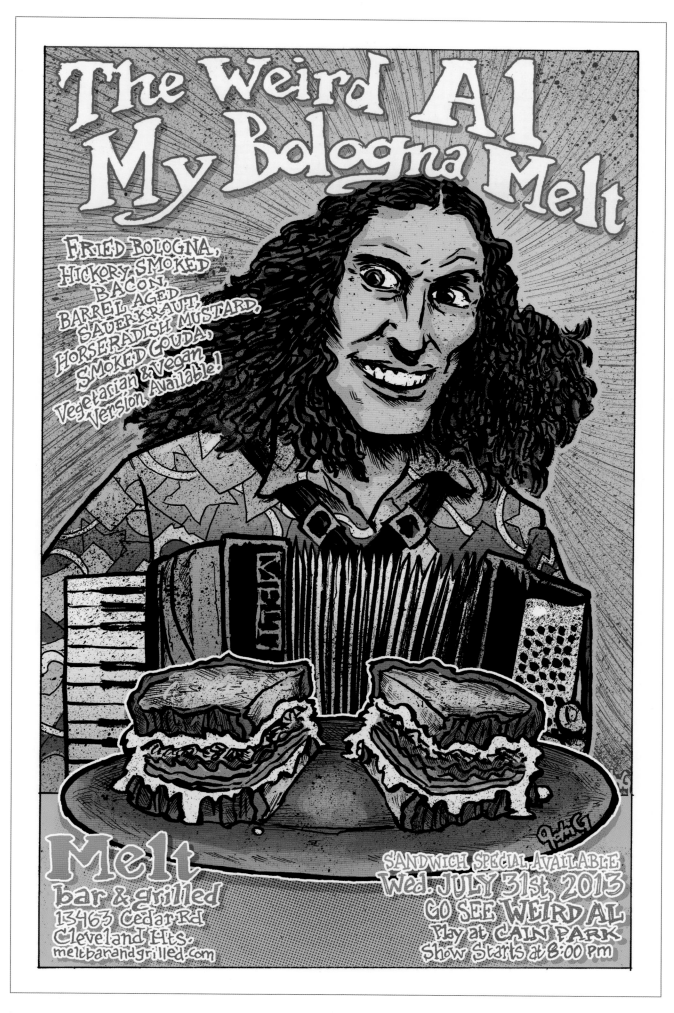

Weird Al actually dropped by Melt (which had his fans slack-jawed) before his show to try a vegan version of the sandwich! The special was based on his first single "My Bologna" (nee "My Sharona").

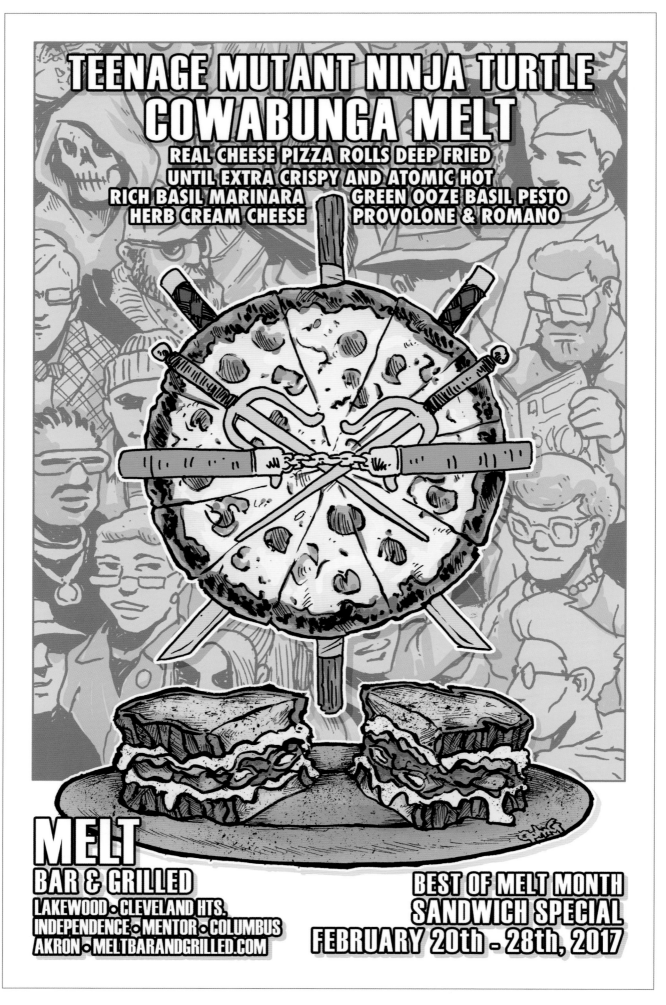

Melt's "best of month" sandwiches fashioned as logos.
Here you have all four TMNT weapons, and a pizza, as one base logo.

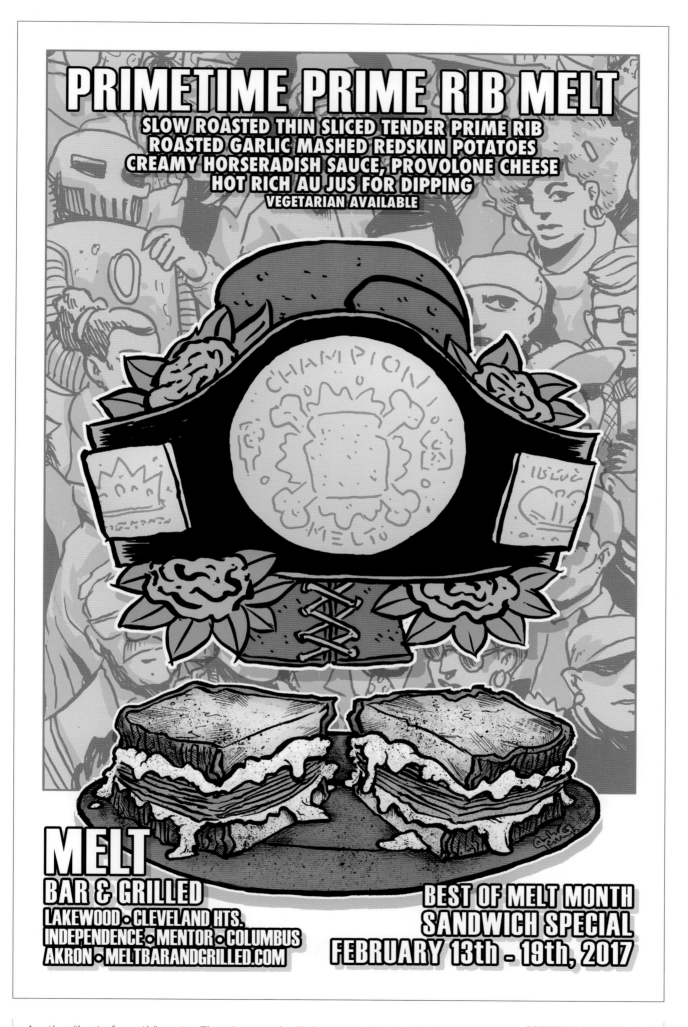

Another "best of month" poster. The winner and still champion Prime Rib Melt.

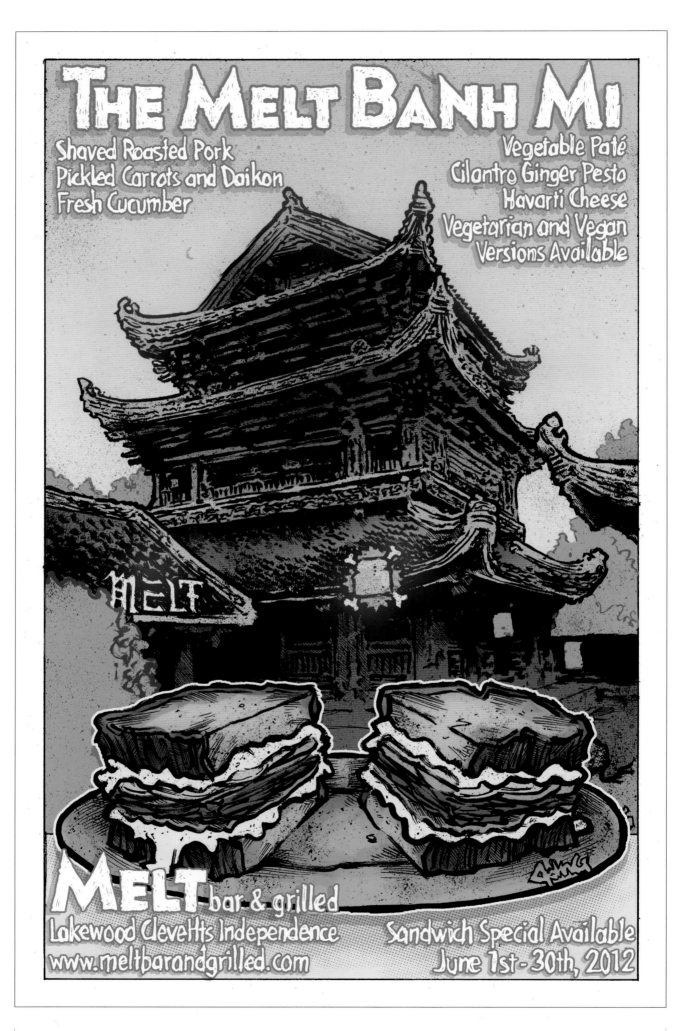

My continued daydreaming of Melt restaurants in other cultures. Above is Melt in Asia.

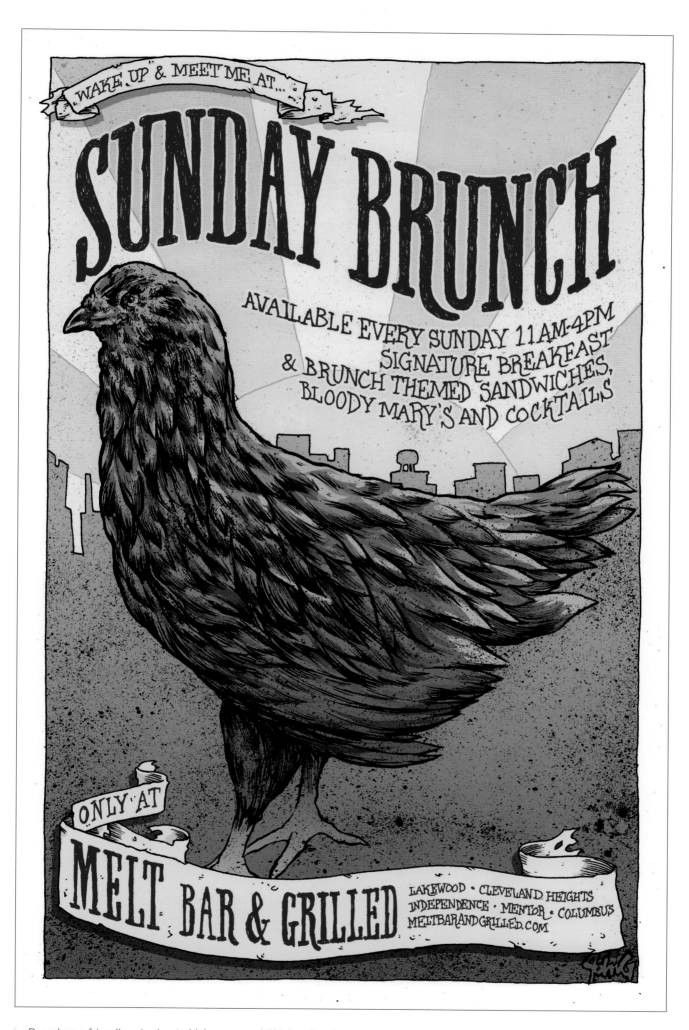

Based on a friend's actual pet chicken, named Chicken Tender
(and FYI – never eaten). One of my favorite drawings.

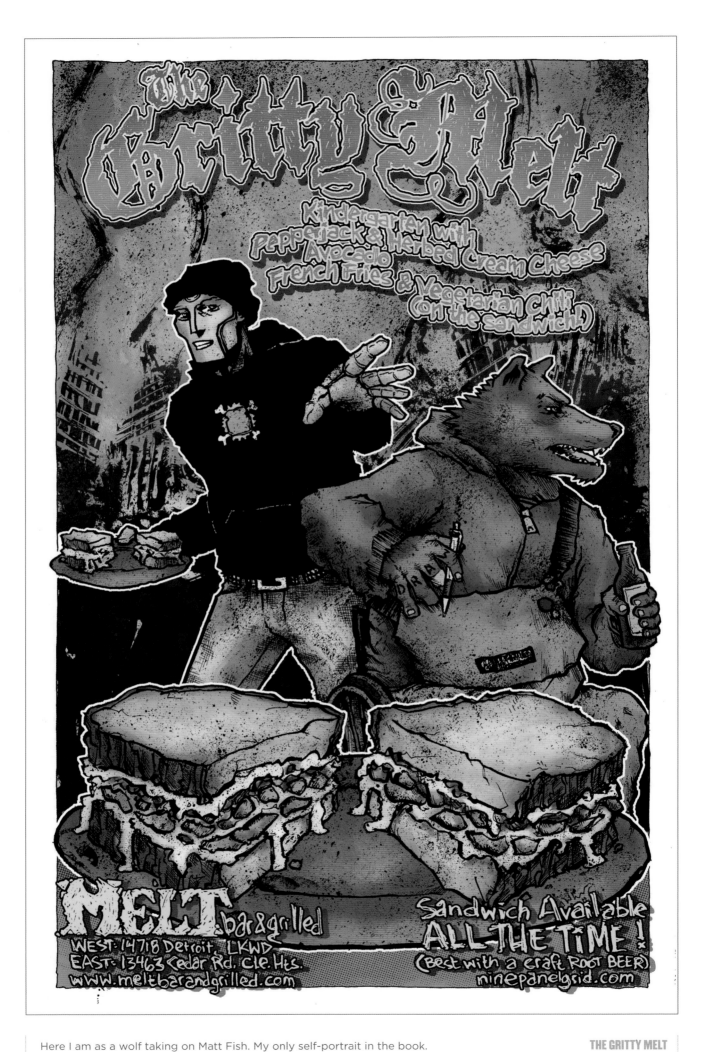

Here I am as a wolf taking on Matt Fish. My only self-portrait in the book.

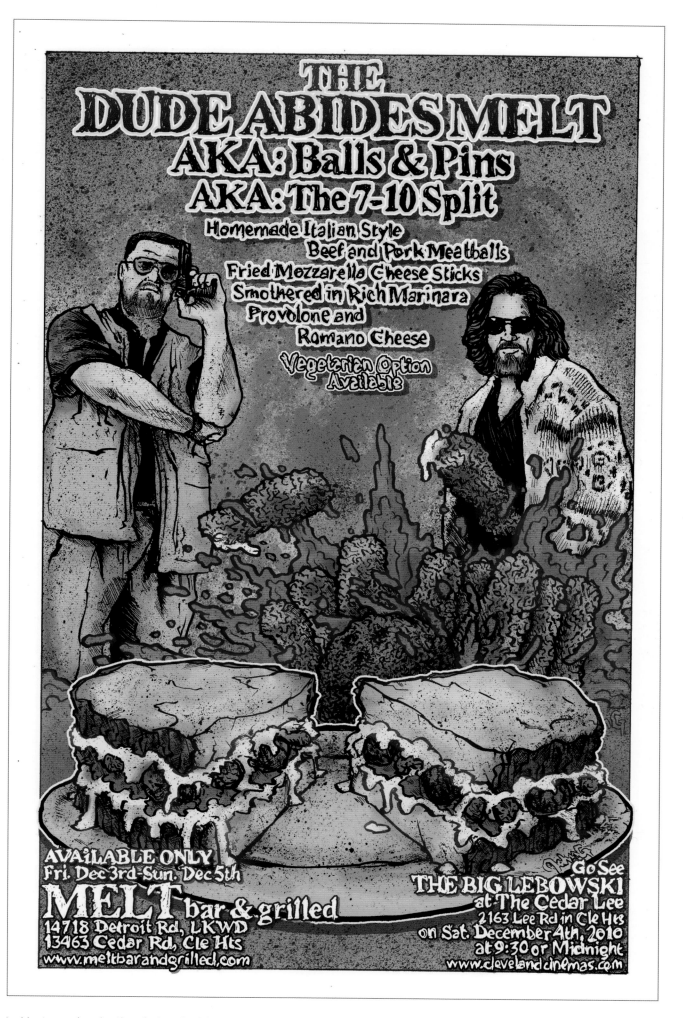

Most people miss the obvious in this poster— the meatball/cheese sticks bowling game. A sandwich so good it deserved three names.

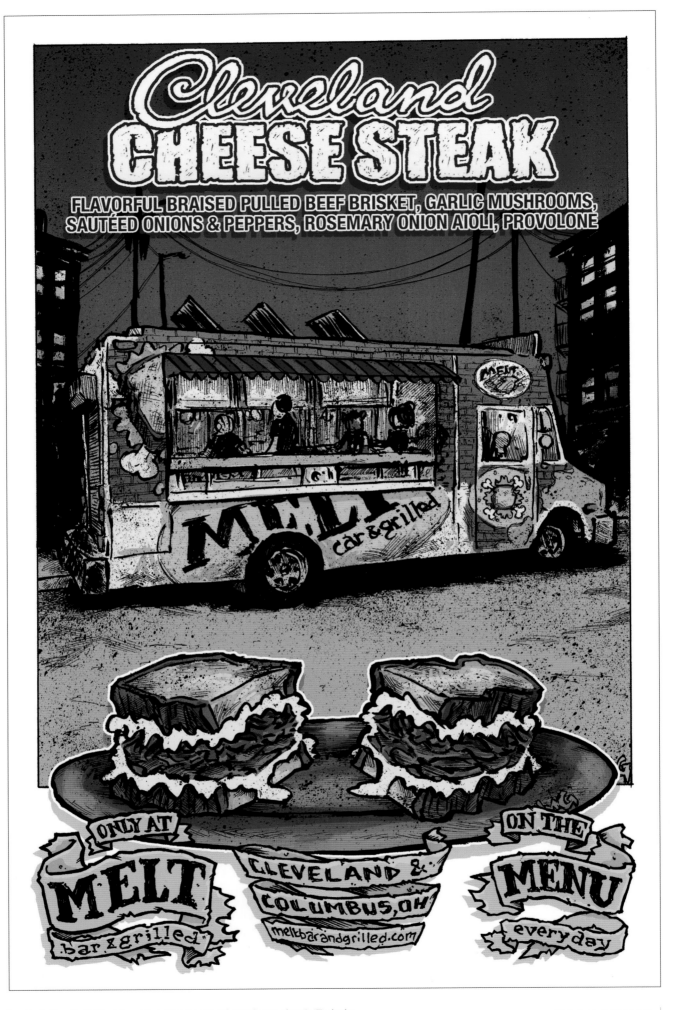

Melt Bar & Grilled hasn't owned a food truck (to date). To help influence the matter I created a Melt "Car & Grilled" design.

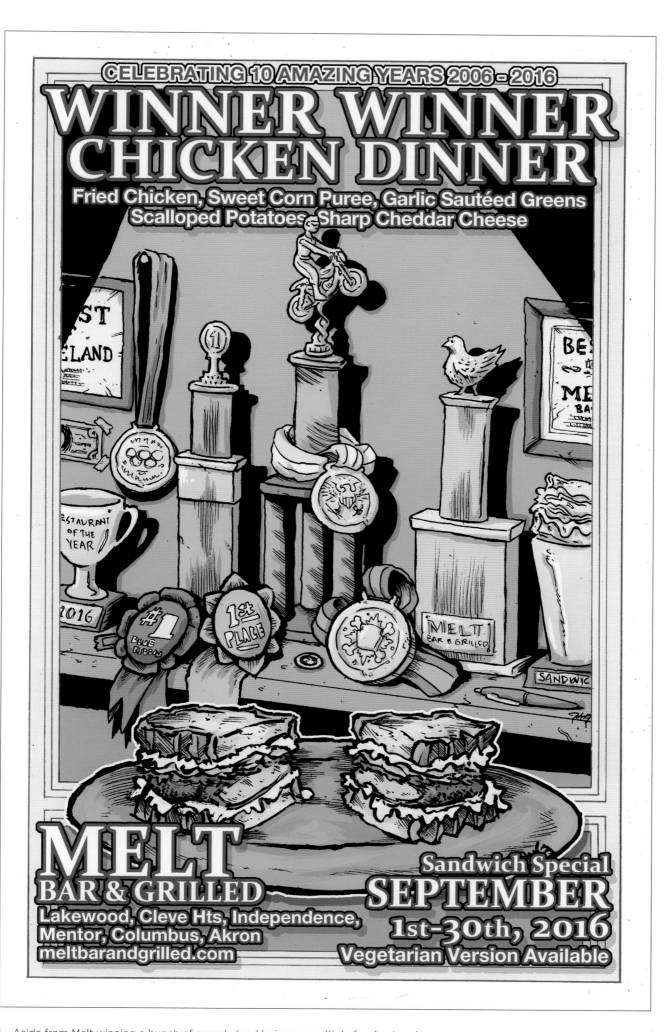

Aside from Melt winning a bunch of awards (and being on multiple food network programs) over the years, this was also an effort to bring back "the biker girl" from an earlier take on WWCD (see page 109).

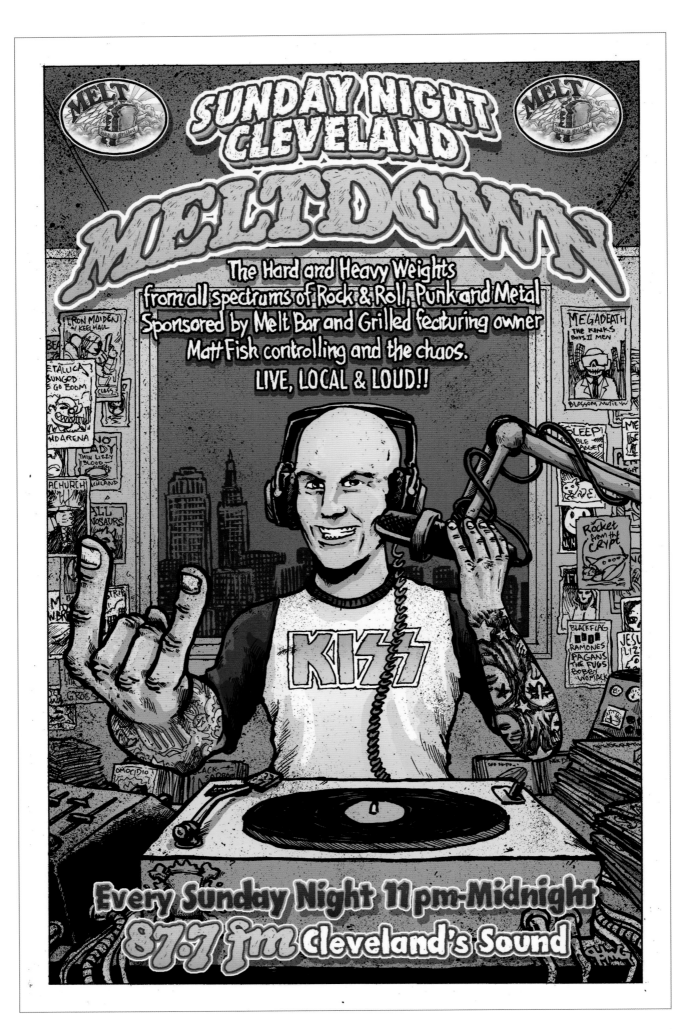

Matt Fish regularly used to tell me that "heavy metal is a way of life," and I wanted that concept to come through here.

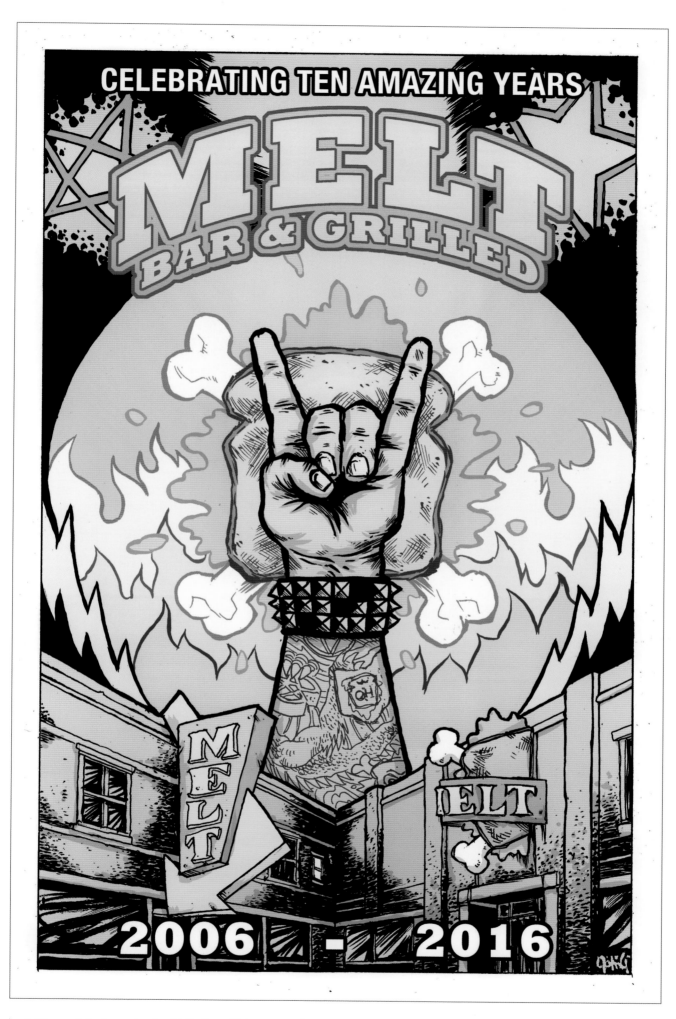

A 10-year tribute poster for Melt. Over 250 posters deep and currently over 1 million sandwiches served per year. That's a lot of cheese.

PROCESS

1 ROUGHS

2 PENCILS

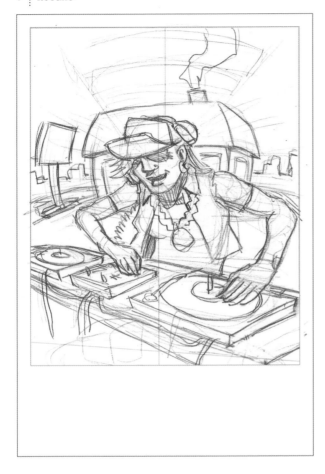

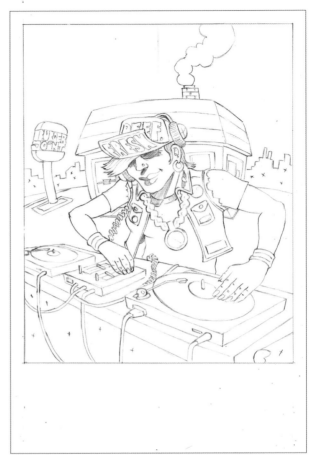

3 INKS

1 ROUGHS

I always start mapping out ideas with three or four concepts quickly sketched on half-size paper (5.5" x 8.5"). These are really rough, just to get the ideas nailed down. I may redraw individual elements over and over until they look just right.

2 PENCILS

I select the best rough and enlarge it to 200% (11" x 17"). Then, using a light box, I trace the drawing onto a piece of drawing board. I keep this stage anywhere from really loose to really tight.

3 INKS

I start with the thicker lines, drawing with a brush and ink. Then I go in with technical pens to add details and textures. Finally, I clean up any botched lines with a whiteout pen.

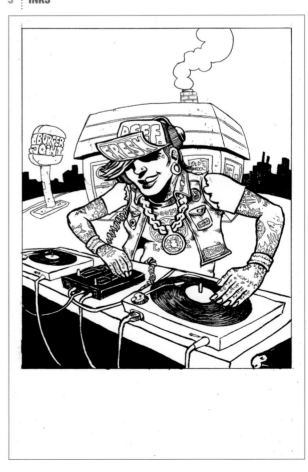

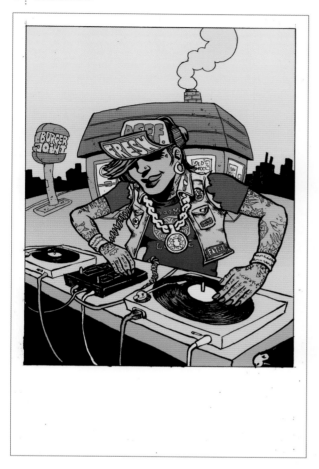

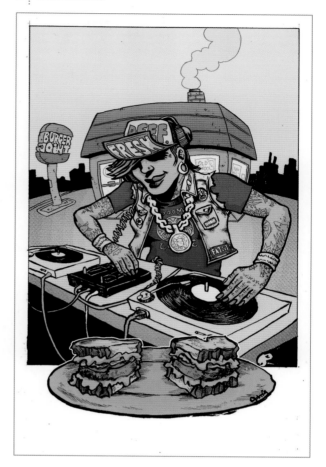

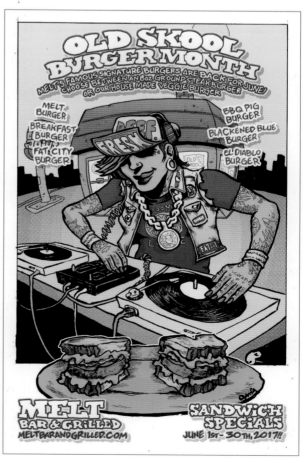

4 COLOR FLATS

I scan the drawing and use Photoshop to color in the line art. As you can see throughout this book, coloring and rendering styles vary from simple (like this one) to complex and heavily layered.

5 COLOR DETAILS

I then add extra texture, shadows, and other color details (tattoos, patches, jewelry, etc.). I also draw each sandwich separately, then drop them in.

6 FINE-TUNING

I add the lettering, which is sometimes hand-drawn, and tweak the final details. All in all, it takes anywhere from 10 to 18 hours to get a print-ready Melt poster. And that's before getting notes from Matt Fish or fixing any spelling mistakes!

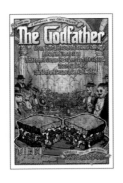
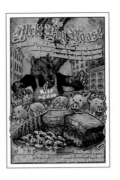
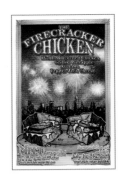

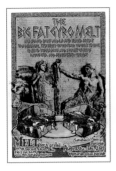
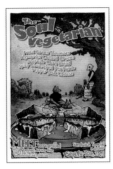
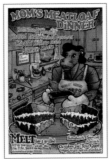
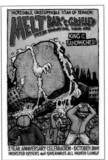
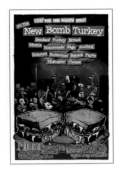

CHRONOLOGY

ALL OF THE MELT POSTERS IN ORDER OF THEIR RELEASE. INCLUDES AN ADDITIONAL 50 IMAGES.

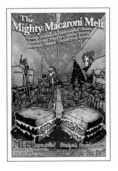
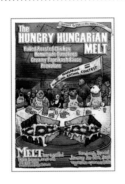
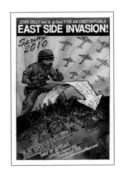
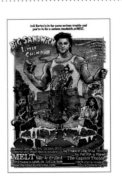
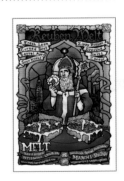

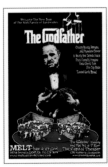
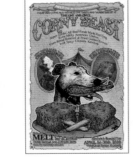

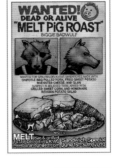
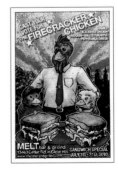

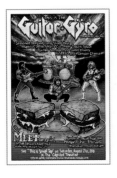
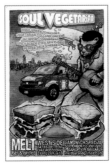
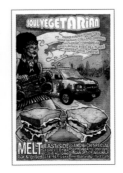
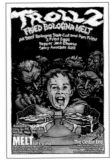
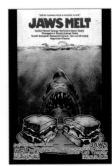

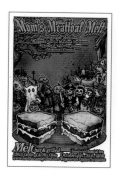
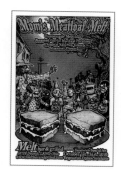
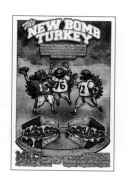
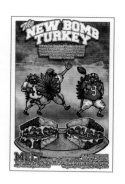
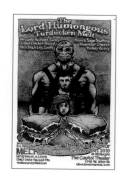
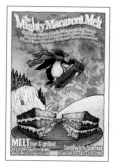
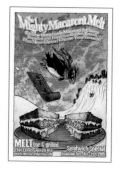
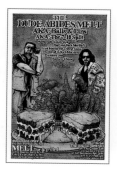
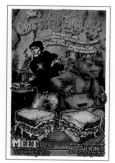
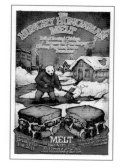
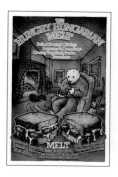
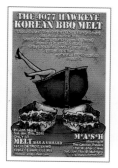
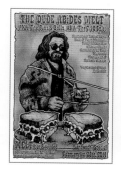
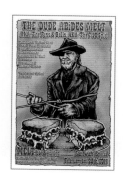
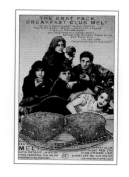
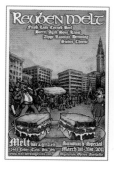
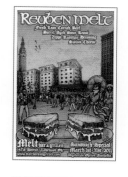
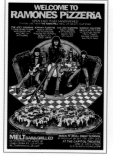
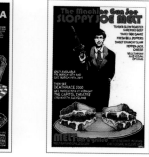

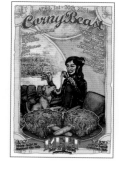
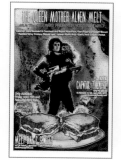

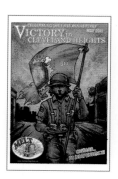
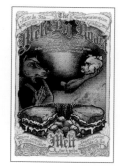

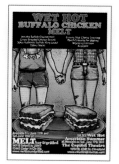

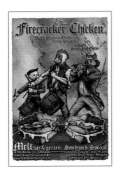
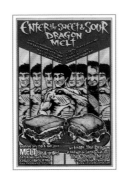
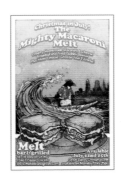
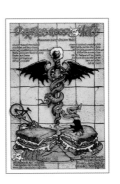
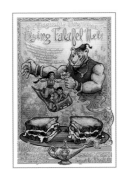
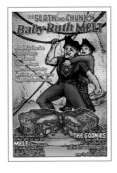
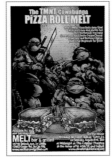
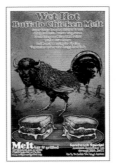
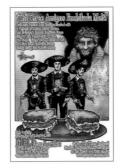
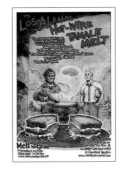
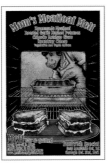
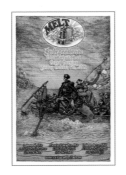
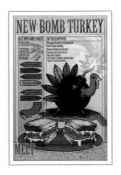
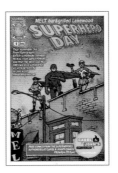
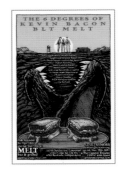
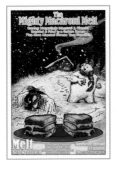
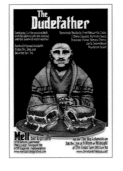
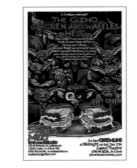
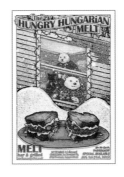
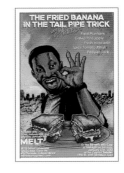
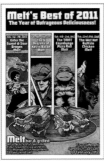
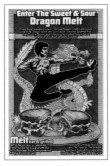
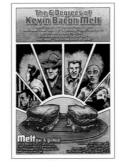
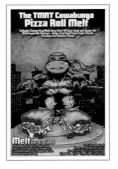
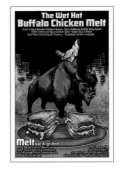
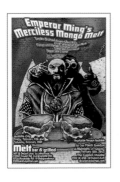
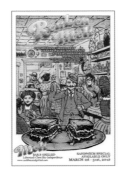
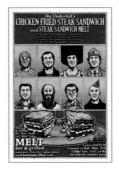
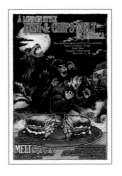

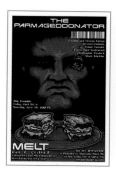
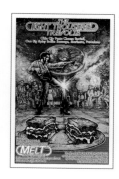
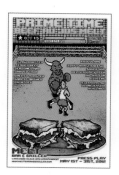
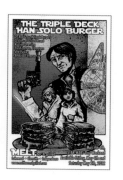
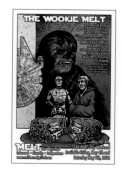
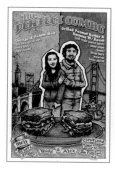
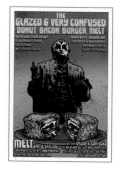
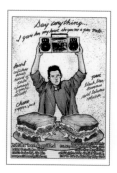
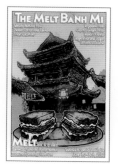
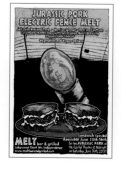
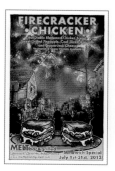
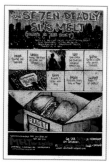
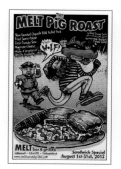
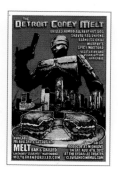
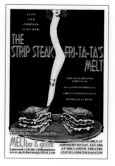
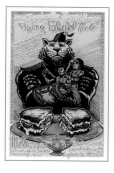
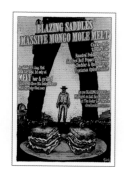
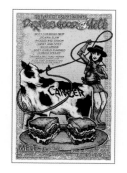
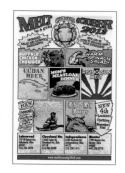
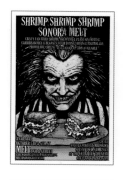
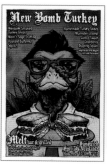
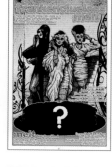
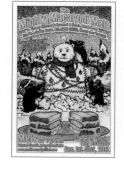
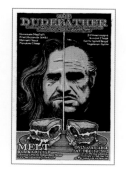
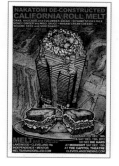
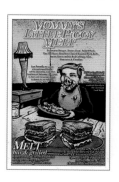
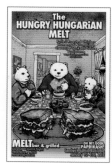

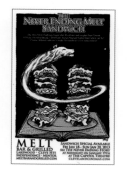
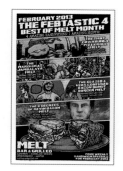

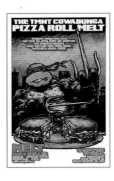
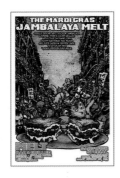
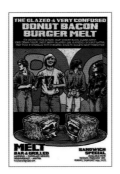
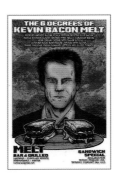
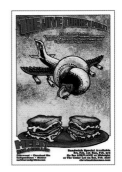
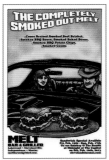
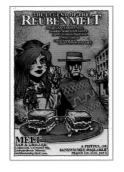
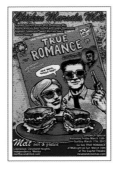
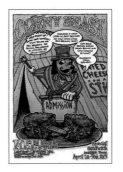
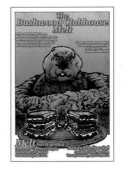
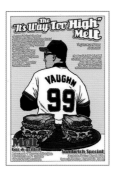
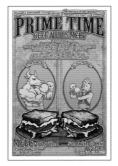
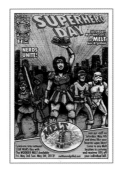
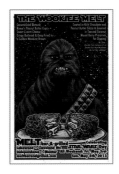
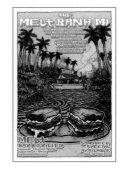
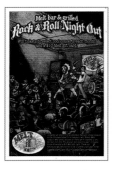
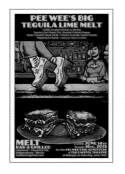
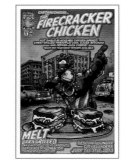
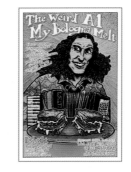
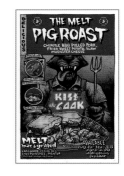
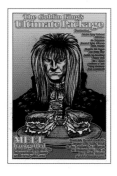

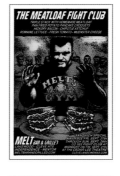
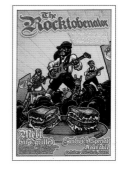
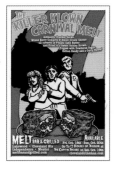
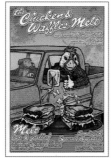
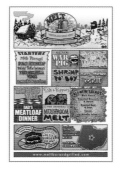
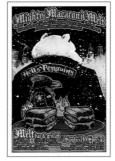
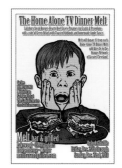

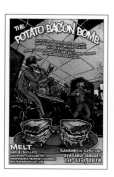
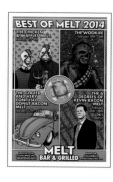
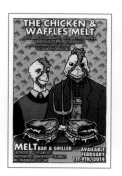
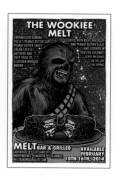
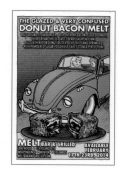
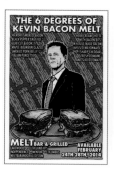
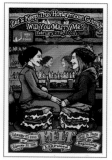
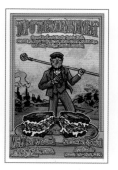

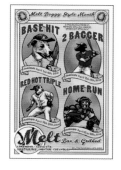
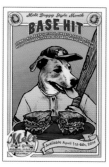
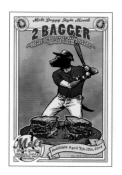
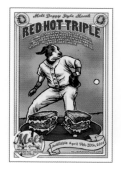
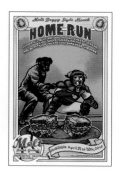
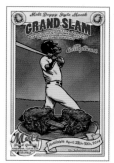
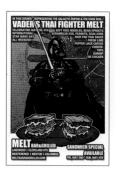
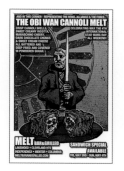
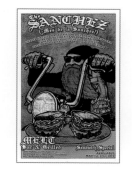
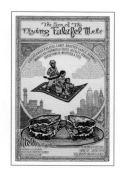
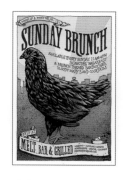

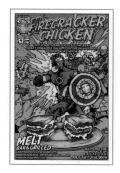
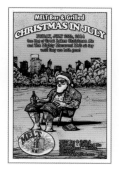
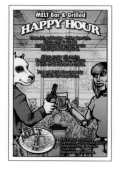
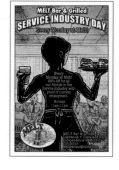
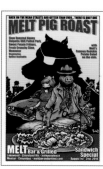
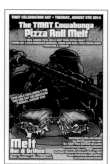
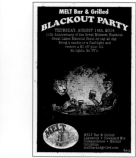
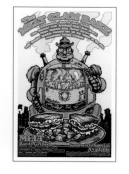
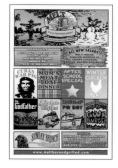

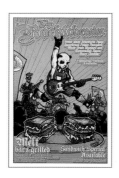
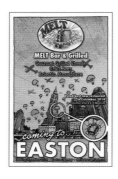
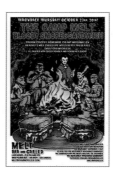
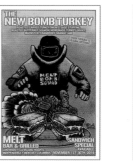
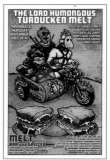
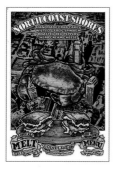
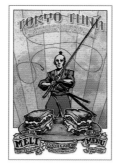
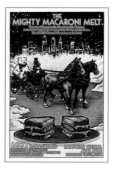
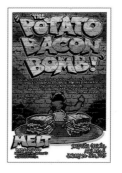
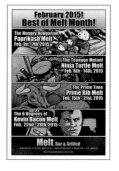
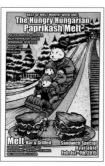
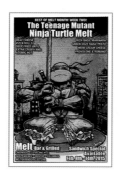
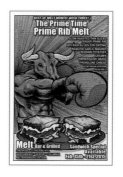
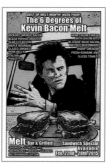
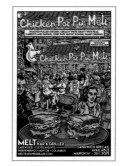
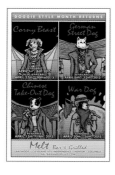
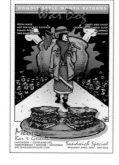
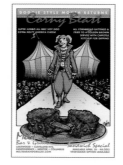
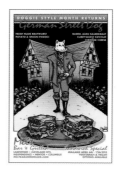
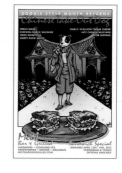

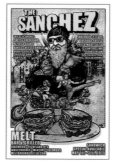
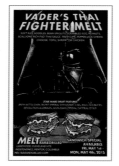
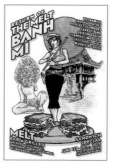
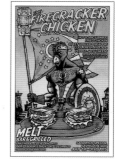
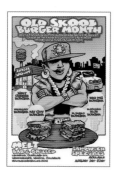
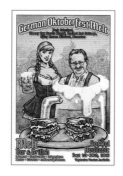
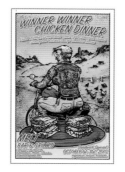
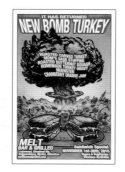
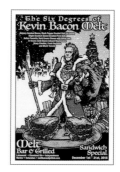

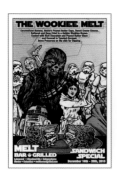
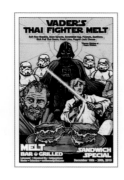
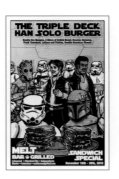
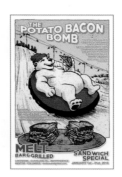
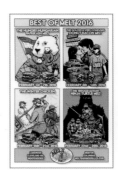

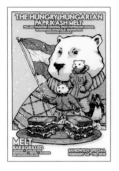
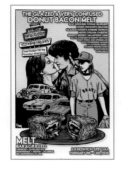
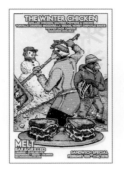
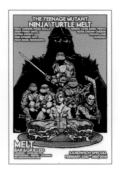
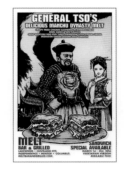

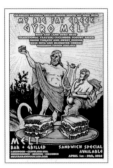
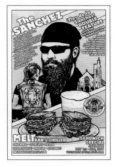
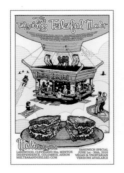
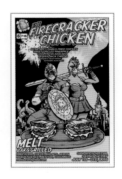
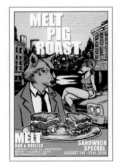

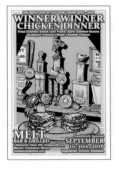
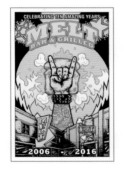
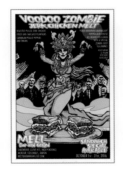
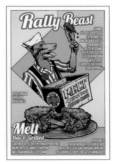
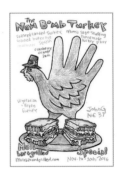

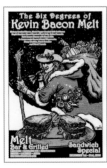
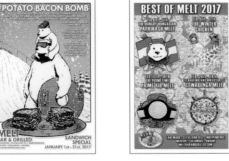
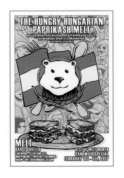
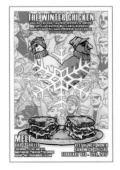

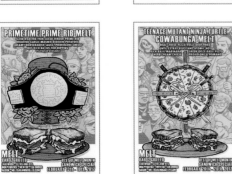
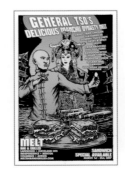
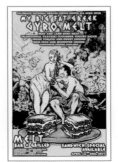
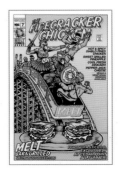

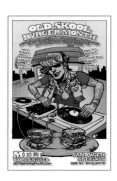
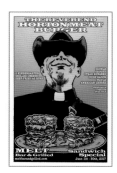
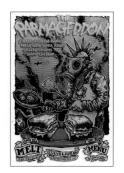
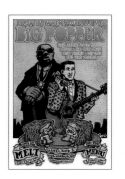
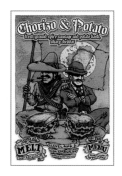
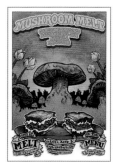
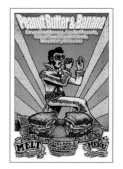
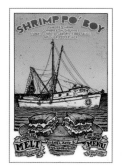
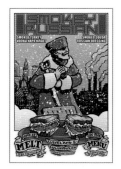
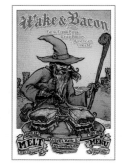
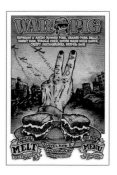
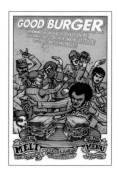
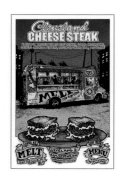
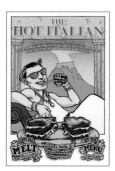
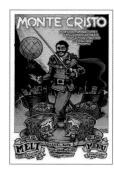

Photo by Laura Wimbels

JOHN G IS AN ILLUSTRATOR, COMICS CREATOR, AND HEAD OF CLEVELAND-BASED SHINER COMICS.

Since the late '90s, he's been building a humble following, creating hundreds of ridiculous and vivid posters/illustrations for a variety of clients including Melt Bar & Grilled restaurants, Cleveland Cinemas, *Scene Magazine,* as well as several local and national bands and music venues.

Together with Jake Kelly, he created and published *The Lake Erie Monster*, a Rust Belt-centered horror anthology comic. He also cofounded and continues to run Genghis Con, an award-winning annual small press and underground comics convention in Cleveland.

In 2015, TurnStyle Films debuted *Draw Hard*, a short documentary about John G and his work, which has since been selected for the 2016 Cleveland International Film Festival and took home the Jury Award for Best Ohio Short Film.

In 2016, he was one of 40 artists awarded the Creative Workforce Fellowship grant by the Community Partnership for Arts and Culture (CPAC).

John G's favorite Melt sandwiches are The Firecracker Chicken, The Good Burger, and The Gritty Melt.

Sandwich Anarchy: The Cult Culinary Posters of Melt Bar & Grilled

Copyright © 2017 by John Greiner

Editors: Matthew Chojnacki / Marie Maude Polychuck
Layout: Shane Lewis / Desiree Nuss
Photography: Laura Wimbels

Published by 1984 Publishing. All rights reserved.

Library of Congress Control Number: 2017909820
ISBN: 978-0-9978138-5-2

1984 Publishing
P.O. Box 770412
Cleveland, Ohio 44107
1984Publishing.com
info@1984Publishing.com

Shiner Comics
1294 W. 69th
Cleveland, Ohio 44102
ShinerComics.net
ShinerComics@gmail.com

Melt Bar and Grilled
P.O. Box 771150
Lakewood, Ohio 44107
MeltBarAndGrilled.com
info@MeltBarAndGrilled.com

Printed and bound in The United States of America.

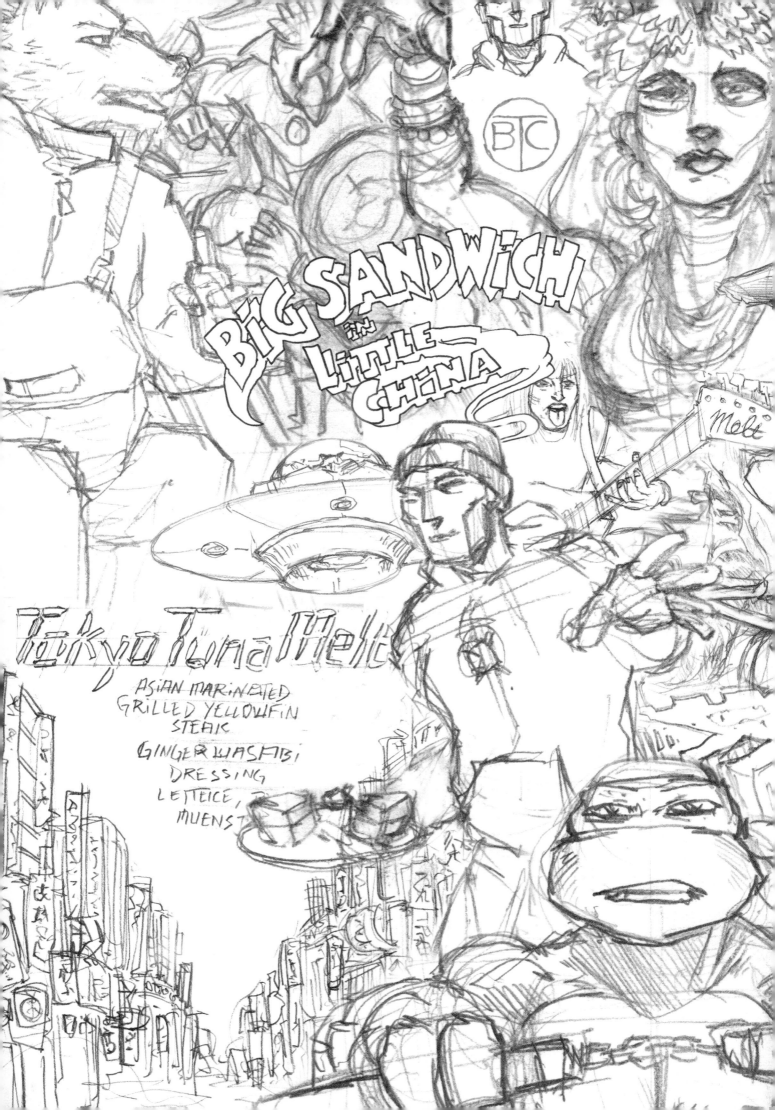